FILM STUDIES

An Introduction

Warren Buckland

First published in Great Britain in 2015 by John Murray Learning. An Hachette UK company.

Based on material previously published as Understand Film Studies, 2010

This edition published in 2015 by John Murray Learning

Copyright © Warren Buckland 2015

The right of Warren Buckland to be identified as the Author of the Work has been asserted by him in accordance with the Copyright, Designs and Patents Act 1988.

Database right Hodder & Stoughton (makers)

The Teach Yourself name is a registered trademark of Hachette UK.

All rights reserved. No part of this publication may be reproduced, stored in a retrieval system or transmitted in any form or by any means, electronic, mechanical, photocopying, recording or otherwise, without the prior written permission of the publisher, or as expressly permitted by law, or under terms agreed with the appropriate reprographic rights organization. Enquiries concerning reproduction outside the scope of the above should be sent to the Rights Department, John Murray Learning, at the address below.

You must not circulate this book in any other binding or cover and you must impose this same condition on any acquirer.

British Library Cataloguing in Publication Data: a catalogue record for this title is available from the British Library.

Library of Congress Catalog Card Number: on file.

ISBN 9781473608795

eISBN 9781473608801

3

The publisher has used its best endeavours to ensure that any website addresses referred to in this book are correct and active at the time of going to press. However, the publisher and the author have no responsibility for the websites and can make no guarantee that a site will remain live or that the content will remain relevant, decent or appropriate.

The publisher has made every effort to mark as such all words which it believes to be trademarks. The publisher should also like to make it clear that the presence of a word in the book, whether marked or unmarked, in no way affects its legal status as a trademark.

Every reasonable effort has been made by the publisher to trace the copyright holders of material in this book. Any errors or omissions should be notified in writing to the publisher, who will endeavour to rectify the situation for any reprints and future editions.

Cover image @ Shutterstock

Typeset by Cenveo® Publisher Services.

Printed and bound in Great Britain by CPI Group (UK) Ltd., Croydon, CR0 4YY.

John Murray Learning policy is to use papers that are natural, renewable and recyclable products and made from wood grown in sustainable forests. The logging and manufacturing processes are expected to conform to the environmental regulations of the country of origin.

Hodder & Stoughton Ltd Carmelite House 50 Victoria Embankment London EC4Y 0DZ www.hodder.co.uk

10078581

Luton Sixth Form College Learning Resources Centre

791.43015

Luton Sixth Form College Learning Resources Centre

Luton Sixth Form College Bradgers Hill Road Luton LU2 7EW

Telephone 01582 432480 email: library@lutonsfc.ac.uk

Retun on or before the last date stamped below

2 9 SEP 2022

1 WEEK LOAN

Luton Sixth Form College

This book is dedicated to the memory of my father

Contents

	Acknowledgements Introduction	vii ix
1	Film aesthetics: formalism and realism Mise-en-scène Set design Mise-en-shot Film sound Theoretical analysis of film aesthetics	1
2	Film structure: narrative and narration Narrative structure Restricted and omniscient narration	31
3	Film authorship: the director as auteur The origin of the auteur policy Style and themes in Alfred Hitchcock's films The cinema of Wim Wenders The cinema of Kathryn Bigelow The contemporary auteur	77
4	Film genres: defining the typical film Problems in the study of genres Genre film as myth New studies of melodrama Film noir 1950s science fiction	119
5	The non-fiction film: five types	
	of documentary Expository documentary Observational documentary Interactive documentary Reflexive documentary Performative documentary	153

6	The reception of film: the art	
	and profession of film reviewing	179
	The four functions of film reviewing	
	The four components of film reviewing	
	Evaluation	
	Three reviews of Interstellar	
	Taking it further	201
	Film studies on the internet	
	Bibliography	205
	Index	217

Acknowledgements

Most of this book has grown out of lectures that have been 'tested out' on undergraduate students at the University of East Anglia, Liverpool John Moores University, the University of Amsterdam and Oxford Brookes University. The need to present points that are obvious to the lecturer/writer (points that have, in fact, been acquired over years of study) but which are new to the listener and reader requires a determined effort to be concise and informative at the same time. I hope I have gone some way to achieving these qualities in this book. This book, therefore, owes a great deal to the students who sat through the original lectures. Their reactions helped me to transform my notes into the following chapters.

On a more personal note, many friends and colleagues have read individual chapters, and have offered critical and creative suggestions for revision. I would, therefore, like to thank Glen Creeber, Sean Cubitt, Kevin Donnelly, Thomas Elsaesser, Sibel Karabina, Peter Krämer, Julie Maclusky, Steve Marchant, Alison McMahan, Brian O'Leary and Lydia Papadimitriou for their comments and suggestions. I would also like to thank Philip French and *The Observer* for allowing me to reproduce Philip French's review of *The English Patient*.

Acknowledgements

The Other of the property of t

Introduction

To study the cinema: what an absurd idea!

Christian Metz

In this book I hope to show you that studying the cinema is not an absurd idea (Metz, the French film scholar, made his living out of studying the cinema, so of course he did not think it was an absurd idea either). To study film should not be thought of as an activity inferior to studying other arts, such as theatre, painting or opera, for two reasons. Firstly, film occupies a dominant place in society and because film is a popular medium, it should be studied seriously. Secondly, if the film student adopts a serious, responsible and critical approach to film, then film studies becomes as important as any other type of study. I use the term 'film student' in the broadest sense - that is, anyone who wants to develop an interest in analysing, comprehending and evaluating films; the term does not just refer to those who study in higher education. Ultimately, it is the student's attitude that justifies the study of film, not the nature or popularity of film. If the student takes his or her task seriously, then studying Steven Spielberg's film The Lost World: Jurassic Park becomes as important and legitimate as studying Shakespeare's play Hamlet, Hans Holbein's painting The Ambassadors or Mozart's opera The Magic Flute.

Metz also wrote that 'The cinema is difficult to explain because it is easy to understand'. In this book I hope to show you that the cinema is not so difficult to explain once you become familiar with the main critical tools film scholars use to analyse films. As a secondary aim, we shall look at films that are not easy to understand and we shall see what makes them difficult. By analysing the complex nature of difficult films, we should be able to appreciate them more.

In studying films, film scholars and film critics end up describing and/or analysing them. With *description*, we repeat in words

what we see in a film. We can describe the content of the film (what we see): for example, in *Jurassic Park*, we can describe the moment when Grant (Sam Neill) walks beside a brachiosaur, and stares up at it in wonderment. Or we can describe the film's form (how the film is constructed): in the same example, we can describe how the camera pans and tracks to the right as Grant and the brachiosaur move. Description is a necessary, but not a sufficient, condition for writing about film. The writer simply ends up repeating what the film shows.

We need to supplement description with *analysis*. Analysis involves examining a film's overall form or structure – that is, the film's design. We look for patterns that give significance to films, or individual scenes. The art critic Clive Bell came up with the term 'significant form' to indicate what he believes distinguishes good art from bad art. When we say that a film has 'significant form', we mean that the whole is more than the sum of its parts. The film's parts add up to create a new entity that does not exist in each part. The film scholar Stefan Sharff wrote:

Significant form is the opposite of pedestrian rendition... Images fit together so magnificently that they ascend to a higher level of visual meaning.

The Elements of Cinema, p. 7

A pedestrian film is one that is not more than the sum of its parts. The parts of a pedestrian film, when joined together, do not attain 'a higher level of visual meaning', but remain a collection of parts. To determine whether a film has significant form or not, we need to go beyond mere description and analyse how a film's individual parts fit and work together. If we can then identify 'significant form' in the way the individual parts fit together, this gives us a good reason to evaluate the film positively, by judging it a well-made film.

But how do we recognize significant form? You need to train yourself to appreciate the special qualities of a film, or each scene in a film. You need to acquire a broad knowledge of the inner workings of film (which is one of the aims of this

book), and be sensitive to the unique meaning of each camera movement or framing in each scene in a film. Not all camera movements are the same. A tracking shot in Spielberg's film *Jurassic Park* is different from a tracking shot in Max Ophuls's film *Letter From an Unknown Woman* or in Jean-Luc Godard's film *Le Weekend*. All film-makers use the same standard tools, but not in the same way. To understand the special qualities of each film, you need to develop a film-maker's perspective, his or her sensitivity to single shots and scenes in individual films.

One of the best ways to acquire a broad knowledge of the inner workings of film is to analyse the decision-making process that took place in a film's construction.

This involves looking at the various technical, stylistic and narrative options available to a film-maker and the choices that he or she makes in putting together a film or sequence of film. To emphasize a film's construction combines the study of film practice and film aesthetics. This is because we consider both the practical choices that are made when a film is constructed and the aesthetic effects these choices have on the film spectator.

For example, what is the difference between shooting a scene in one continuous take, where the camera is left rolling while the whole of the action takes place, and shooting the same scene in several shots? The first option involves the film-maker filming the action as it unfolds, uninterrupted. The second option involves breaking the action down into individual shots. Each new shot will include a change in camera position, camera angle, shot scale (the distance between the camera and the action) and so on. Film-makers have to weigh up the advantages and disadvantages of choosing one technique over another for each scene, since the choice of technique will influence the way spectators respond to the film. This is just one of the questions we shall be looking at in this book.

However, you may think that analysing a film in this way destroys the pleasurable experiences we get when we go to the cinema. My response to this point is to argue that film studies does not destroy our experiences of films but transforms them.

In his poem The Dry Salvages, T. S. Eliot wrote:

We had the experience but missed the meaning And approach to the meaning restores the experience In a different form...

The opposition Eliot sets up between experience and meaning is useful in explaining the relation between watching a film and analysing it. My aim in this book is to employ critical tools to analyse a film's meanings, which involves the spectator taking a step back from his or her experience of the film. Yet, as Eliot makes clear in his poem, the analysis of meaning will restore the experience in a different form. So my main point is that critical analysis does not destroy the spectator's pleasurable experience of a film, but transforms it. This transformed experience primarily involves developing a critical understanding of how films are made and what effects they have on you.

Peter Wollen describes what is involved in studying film:

There is often a hostility towards any kind of explanation which involves a degree of distancing from the 'lived experience' of watching the film itself. Yet clearly any kind of serious critical work ... must involve a distance, a gap between the film and the criticism... It is as though the meteorologists were reproached for getting away from the 'lived experience' of walking in the rain or sun-bathing.

Signs and Meaning in the Cinema, p. 169

This leads me to one of my main arguments about the aim of film studies. Film studies is not simply about accumulating more and more information about films, film-makers and the film industry. This is a passive form of learning. In this book I do not present you with pages and pages of facts on the cinema. Instead, you will find an emphasis on an active form of learning in which you develop critical and analytical skills – skills that can be applied to any film. I want to discourage you from merely talking about

your personal impressions of a film and simply passing judgement on it ('I liked this film' or 'I didn't like this film'). This is a very superficial way to talk about films and I hope this book will enable you to go beyond this impressionistic type of criticism.

We have already seen that the idea of 'significant form' enables critics to make an *informed* evaluation of a film, by asking: 'Do the separate parts of a film join together to create a higher level of visual meaning?' If they do, then this is justification for evaluating the film positively. By adopting this informed approach, this book is encouraging you to become a film connoisseur (more commonly known as a 'cinephile'). Just as wine connoisseurs can identify and explain very small and subtle differences in the taste of wine, so the film connoisseur can identify the subtle differences between films – especially the small differences that make a difference.

Film studies consists of a huge amount of histories, theories, critical tools and discussions of individual films. Due to the overwhelming amount of information available, I have decided to be very selective in the topics I write about. One of the questions I asked myself when selecting topics is the following: 'What works in film studies?' A great many of the issues and problems that film scholars decide to write about are badly chosen and ill-formed. Because they do not always work in particular instances (they are not general enough), the theories and critical tools that some film scholars use are irrelevant and misguided.

Furthermore, I have divided up the topics in this book into those that develop an internal perspective on film and those that develop an external perspective. An internal perspective develops an intrinsic approach to film and studies a film's inner workings. That is, an internal perspective studies the film itself, in isolation from any historical, moral or social context. This approach is often referred to as 'poetic'. Chapters 1, 2 and 3 outline those approaches that develop a poetic perspective on film. Chapter 1 scrutinizes the work of the formalist film scholars (such as Rudolf Arnheim and Sergei Eisenstein) and the realist film scholars (such as André Bazin) and looks at the particular filmic techniques they promote in their cause to define film as an art. The formalists

promoted editing, montage, low and high camera angles and so on, while the realists promoted the long take and deep focus photography. This chapter also offers a brief survey of colour, the techniques of continuity editing and film sound. Films discussed include: The Magnificent Ambersons (Orson Welles), Citizen Kane (Welles), Secrets and Lies (Mike Leigh), Notorious (Alfred Hitchcock) and Jurassic Park (Spielberg). Chapter 2 investigates the structures of narrative and narration at work in the cinema, including narrative structures such as cause-effect logic, character motivation, transformation, linear and non-linear chronology, together with restricted and omniscient narration. Films discussed include: Psycho (Hitchcock), North by Northwest (Hitchcock), Taxi Driver (Martin Scorsese), Magnificent Obsession (Douglas Sirk), Pulp Fiction (Quentin Tarantino) and Mulholland Dr. (David Lynch). Chapter 3 explores the concept of the director as auteur (author), charting the history of this approach to films from the 1950s to the present day. The chapter looks at the stylistic and thematic approaches to auteurism and investigates the careers of three directors: Alfred Hitchcock, Wim Wenders and Kathryn Bigelow. It can be argued that auteurism is an external approach to the cinema. However, I have emphasized that auteurism looks for stylistic and thematic patterns in a group of films, which therefore defines it as an internal approach.

Chapters 4, 5 and 6 outline those approaches that develop an external perspective on film. An external perspective studies the relation between the film and particular aspects of reality outside it. This type of criticism places a film within its historical and social context. For this reason, external approaches are often called 'contextual criticism'. Chapter 4 examines the problematic area of film genres. Genre study is both internal and external: it is internal to the extent that it attempts to identify the common intrinsic attributes of a group of films, and external to the extent that it attempts to relate a film to its historical and social context, arguing that genre films manifest the basic anxieties and values of a society. This

chapter examines the following genres: the melodrama (and analyses films such as Josef von Sternberg's Blonde Venus and John Stahl's Only Yesterday), the film noir (in particular the neo-films noirs of John Dahl), and the 1950s science fiction film (such as Gordon Douglas's Them! and Don Siegel's Invasion of the Body Snatchers). Chapter 5 looks at the way documentary film-makers organize and structure reality. Prominence is given to the five types of documentary format: expository (in films such as Alberto Cavalcanti's Coalface), observational (Frederick Wiseman's High School), interactive (Michael Moore's Roger and Me and Bowling for Columbine), reflexive (Dziga Vertov's Man With a Movie Camera) and performative (Errol Morris's The Thin Blue Line). Finally, in Chapter 6, the activity of film reviewing comes under scrutiny. Here I expose the conventions film reviewers adopt in writing about and evaluating films. As examples, reviews of Anthony Minghella's The English Patient and Christopher Nolan's Interstellar (2014) are closely examined.

Following each chapter you will find a list of books that have been quoted in the chapter and recommendations for further reading (Dig deeper). This book is intended to function only as the first step on the long and enjoyable path called film studies.

Dig deeper

Corrigan, Timothy, A Short Guide to Writing About Film, Fourth Edition (New York: HarperCollins, 2000).

A concise and practical guide for students on how to write about films, from taking notes during screenings, to the style and structure of essay writing.

Hayward, Susan, *Cinema Studies: The Key Concepts*, Third Edition (London and New York: Routledge, 2006).

More than a glossary, this invaluable reference book includes both shorter entries and mini essays on the industrial, technical and theoretical concepts that currently dominate film studies. Sharff, Stefan, The Elements of Cinema: Toward a Theory of Cinesthetic Impact (New York: Columbia University Press, 1982).

A concise and informative study of cinematic structure through the close analysis of several significant film scenes.

Wollen, Peter, Signs and Meaning in the Cinema, Second Edition, (London: Secker and Warburg, 1972).

This is a key book in the history of film studies. Wollen was the first author to present a sophisticated, theoretical exposition in English of Sergei Eisenstein, film semiology and a structuralist version of *auteur* criticism.

Film aesthetics: formalism and realism

In this chapter you will learn about:

- ten different approaches to studying film
- an examination of one of those approaches namely, a study of film techniques, divided into:
 - elements of mise-en-scène (including set design)
 - elements of mise-en-shot (including the long take, deep focus and colour)
 - rules of continuity editing
 - > film sound
- a theoretical study of film aesthetics, divided into:
 - the realists (e.g. André Bazin, Siegfried Kracauer)
 - the formalists (e.g. Rudolf Arnheim, Sergei Eisenstein), including the theory of montage.

... film had to legitimize its place in our culture. And the way that it initially set about getting itself taken seriously was to prove that it was an art – an art on a par with its seven predecessors.

Noël Carroll, Philosophical Problems of Classical Film Theory, p. 4

Once we have accepted the notion that studying the cinema isn't an absurd idea, the question arises: How do we study the cinema? The cinema has been studied from a multitude of approaches. Following, and modifying, a list put together by Charles Altman, we can identify ten approaches to the cinema (the list is not exhaustive):

- 1 A technological history which may emphasize pioneers, such as the Lumière brothers or Edison, and/or technological innovations such as the coming of sound, the development of colour, etc.
- 2 A study of techniques: either historically, which asks questions such as: When was the first close-up used? or as in this book critically and analytically: What technical choices are available to film-makers?
- 3 A study of personalities (studio moguls, stars, etc.).
- 4 A study of the relation between film and other arts, usually theatre or the novel; this type of approach was one way in which university departments of English justified their study of film in the 1960s and early 1970s.
- 5 A chronological history of classical or important films. Such histories canonized a small group of films (the most unusual, such as *Citizen Kane*, Orson Welles, 1941) and marginalized the majority of films from study (usually the typical or ordinary film).
- 6 Film in relation to society. Film can be studied in relation to important social events such as the Second World War.
- 7 A history of Hollywood studios (including economic histories).
- 8 A study of directors (see Chapter 3).

- 9 A study of genres either formally or as a social ritual (see Chapter 4).
- 10 Regulation of the film industry by means of censorship and anti-trust (or monopoly) laws; censorship is briefly discussed in Chapter 4.

This chapter focuses on point 2, a critical and analytical discussion of the technical choices available to film-makers. In the first part of this chapter, I shall examine three technical choices film-makers have to make. The first concerns set design, or *mise-en-scène*. The second concerns *mise-en-shot* – the way the *mise-en-scène* is filmed. Here we shall look at the long take, which is sometimes combined with deep focus photography. Finally, we shall look at editing and montage. In the second half of this chapter, we shall see how realist and formalist film scholars concentrated on these, and other, filmic techniques in their attempts to defend film as an art.

As I pointed out in the introduction, my aim here is to enable you to go beyond the informal practice of merely verbalizing your personal impressions of a film. The starting point for rejecting this impressionistic talk about films is to study the basic components of the medium of film and the way these components are organized in a particular film. In Chapters 1, 2 and 3 we shall explore the stylistic and narrative dimensions of various cinemas – Hollywood studio films, independently produced American films and European cinema.

The critical and analytical study of films therefore begins with the way a film is constructed. This emphasis on a film's construction combines film practice and film aesthetics because it analyses the choices that are made when a film is constructed, and the effects these choices have on film spectators. The aim of the first section of this book is therefore to enable you to study in an exact and orderly fashion the basic choices available to film-makers, and the effect making a choice has on a film's meaning and effect.

Mise-en-scène

One of the most frequently used terms in film analysis is *mise-en-scène*, which literally translates as 'putting on stage', or 'staging'. The term originates from the theatre, where it designates everything that appears on stage – set design, lighting and character movement. In film studies, *mise-en-scène* often has a vague meaning: it is either used in a very broad way to mean the filmed events together with the way those events are filmed, or it is used in a narrower sense (closer to its original theatrical meaning), to designate the filmed events. In this book the term *mise-en-scène* will be used in its narrower sense to mean what appears in front of the camera – set design, lighting and character movement. Another term will be used to name the way the filmed events, *mise-en-scène*, are filmed – namely, *mise-en-shot*, which literally means 'putting into shots', or simply 'shooting (a film)'.

Set design

If you read film credits, you may notice the category 'Art Director'. Art directors are people who design or select the sets and decor of a film. Initially, their job was simply to create a background in which the action of the film was to unfold. In the heyday of the Hollywood studios (from the 1920s to the end of the 1950s), art directors built entire worlds inside movie studios. More recently, some art directors have become production designers, whose job is to co-ordinate the look of an entire film. They develop a visual concept around which sets, props, lighting and costumes are designed to work together. This is particularly important in contemporary science fiction films, in which the production designer creates a total concept and image of the future. The director Ridley Scott takes set design so seriously that he almost takes over the job of art director on some of his films (he trained as an art director). On his film Blade Runner (1982), for instance, he worked closely with the art department in conceiving and designing sets. Michael Deeley, the film's producer, goes so far as to argue that the futuristic ambience and look of the film was essentially designed by Scott.

The production designer begins by making sketches and by building miniature sets in order to determine the best way to construct and film the actual sets. This is particularly important from a financial point of view because a film may need several – even dozens of – sets, all of which require an army of carpenters, prop buyers and so on, to construct and take down again. This is in opposition to the theatre, where only a few sets are constructed. Because of the expense, many film sets are only partly constructed. In other words, only those parts of the set that appear in the film need to be constructed.

We shall now consider the stylistic options available to art directors/set designers and the choices that two Hollywood studios made in the 1930s. These choices strongly determined the look of the films; in fact, they determined the identity of the studio.

Spotlight

1939 is usually considered to be the most significant year in the Hollywood studio era. In that year, Hollywood produced a whole raft of films that have stood the test of time: Gone With the Wind, The Wizard of Oz, Mr Smith Goes to Washington, Ninotchka, Only Angels Have Wings, Stagecoach, and many others.

SET DESIGN IN 1930S WARNER BROS. FILMS

In the 1930s, Warner Bros. produced low-budget films, many of which had a contemporary theme since their stories were in large part inspired by newspaper stories. One of the themes that dominated American society in the 1930s was gangsterism, so it was little wonder that Warner Bros. made a number of gangster films, the most notable being *Little Caesar* (Mervyn Le Roy, 1932) and *The Public Enemy* (William Wellman, 1931). Due to Warner Bros.' policy of low-budget films, little was spent on set design. Many Warner Bros. films of the 1930s have simple, bare sets – shabby, dank rooms and bare streets. This economic factor largely determined the visual style of Warner Bros. films in the 1930s. But like all artists, Warner Bros. film-makers made the most of this limitation and even used it to their own

advantage. Directors were frequently forced to use medium shots (shots of the actors from waist to the top of the head) or close-ups (a shot of an actor's head and shoulders) so that the actors would take up most of the frame. Low-key lighting (in which only part of the set is lit) was also used in order to partly conceal the cheapness of the set and its small size. Much of the set was shrouded in darkness. Further, Warner Bros. was one of the first studios to use fog generating machines, which also served to hide the set.

Yet, these sets are consistent with the stories and the circumstances that the characters find themselves in. Many of the gangster films are about the impoverished backgrounds of the gangsters. The sets and lighting therefore add to the story's meaning – they complement the story. Although the stylistic options available to Warner Bros. film-makers at this time were severely limited, they used this economic limitation to their own advantage.

MGM SET DESIGN

In complete contrast to Warner Bros., MGM spent a great deal of money on sets and lighting. In fact, MGM had the biggest costume, property and art departments in Hollywood. MGM art directors created large elaborate sets, which were lit using full, high-key lighting, creating a very bright image with little or no shadows. In MGM colour films, the colours are usually saturated. MGM's philosophy was to create clear, clean images. One problem was that the set occasionally dominated the action and the stars - think of the sets of two very famous MGM films, The Wizard of Oz (Victor Fleming, 1939) and Gone With the Wind (Fleming, 1939). The director Vincente Minnelli made musicals for MGM, including Meet Me in St Louis, which opens with a long, elaborate shot of the set of St Louis built on the MGM backlot. It seems imperative that, if the studio was to spend a great deal of money on the sets, then they should be lit properly and should be 'shown off' on screen, which frequently meant that the director used long shots (showing the whole actor in his or her surroundings) or very long shots (in which the actor appears small within the frame).

Mise-en-shot

Above I made the distinction between *mise-en-scène* (staging) and *mise-en-shot* (shooting, or filming). *Mise-en-scène* (in the narrow definition adopted in this book) designates the filmed events – set design, lighting and the movement of the actors. In this sense, *mise-en-scène* refers to a stage of film production that exists prior to filming. In this narrow definition, we can clearly distinguish the filmed events from the way they are filmed. The process of filming, of translating *mise-en-scène* into film, is called *mise-en-shot*, a term invented by the Soviet film-maker Sergei Eisenstein.

A major part of the art of film-making involves the interaction between the filmed events (*mise-en-scène*) and the way they are filmed (*mise-en-shot*). To make a successful film, film-makers need to establish a productive relation between *mise-en-scène* and *mise-en-shot*.

The main parameters of mise-en-shot include:

- camera position
- camera movement
- ▶ shot scale
- the duration of the single shot
- the pace of editing.

In the following pages we shall look at three options directors have in rendering a scene on film. The three options are:

- using a long take
- using deep focus photography
- using continuity editing.

THE LONG TAKE

A long take is the name given to a shot of long duration. In itself, this definition is not very informative, because we have no background information with which to define 'long duration'. Fortunately, the work of the film analyst Barry Salt can help us

establish this background information. Salt has calculated the average length of shots in Hollywood films across the decades. The work he carried out is extensive and detailed, and the results reveal the most common shot lengths for each decade. For example, Salt has calculated that the most common shot length in 1940s Hollywood films is 9 seconds. This means that, in a Hollywood film of the 1940s there is, on average, a change in shot every 9 seconds. What this average can define are the deviations from the norm, such as the long take. A long take refers to a shot that is significantly longer than the norm. Any shot in a Hollywood film of the 1940s that lasts significantly longer than 9 seconds (anything over 30 seconds) is therefore a long take.

DEEP FOCUS PHOTOGRAPHY

Deep focus photography keeps several planes of the shot in focus at the same time (foreground, middle-ground, background), allowing several actions to be filmed at the same time. This decreases the need for editing to present these actions in separate shots.

The long take and deep focus photography are usually combined. Orson Welles was one of the most celebrated directors in 1940s Hollywood who consistently used the long take with deep focus photography. Several scenes in Welles's films Citizen Kane (1941) and The Magnificent Ambersons (1942) were filmed using the long take with deep focus. The long take plus deep focus is therefore one of the stylistic choices made by Welles.

Why did Welles make this stylistic choice? We can approach this question by considering the most celebrated long takes in *Citizen Kane* and *The Magnificent Ambersons*. Eighteen minutes into *Citizen Kane*, we get the famous Colorado sequence, a flashback to 1871 when Kane was a young child. His parents come into a huge fortune, so they decide to have their son brought up by Mr Thatcher. Welles films the moment Mrs Kane signs the adoption papers in a 90-second long take combined with deep focus – as well as other technical choices, including camera movement and a low camera angle (we can tell that the camera is low because it reveals the ceiling). The camera begins

outside with Kane playing in the snow. The camera soon begins to track backwards through a window into the Kane family home. As it continues to move backwards, Mrs Kane is revealed on the left side of the screen (she comes into view at the precise moment she begins to talk). The camera continues to track back, revealing Mr Thatcher on the right of the screen (he too enters the frame at the same time he begins to talk). The camera reveals Mr Kane screen left as it continues to track backwards. He also appears as soon as he begins to talk - it seems that Welles chose to co-ordinate a character's entrance on screen with their speech. Mr Kane then walks towards the camera, which tracks back and stops when it reaches a table, where Mrs Kane and Mr Thatcher sit in the foreground. Mr Kane continues to stand in the middle-ground, looking helpless, and the carefree young Kane can clearly be seen and heard through the window in the far background. He does not realize his fate is being sealed in the room. The characters are arranged in the scene in such a way that they are all clearly visible, and are all in focus; there's no need for any editing therefore or any extensive camera movement. Once the papers are signed, the scene begins to repeat itself in reverse - the characters and camera move forward to the window. The shot ends on a sharp sound when Mrs Kane opens the window and calls out to her son. Welles defines space in this shot via character movement, camera movement and precise staging of characters in the foreground, middle-ground and background.

Twenty-six minutes into the film, Welles uses another flashback to 1929 when Kane goes broke. This time it is he who has to sign a piece of paper, giving control of his assets to Mr Thatcher. Welles films the signing ceremony in a two-minute long take without any camera movement at all. Yet he uses other ingenious methods to divide up the action. The scene begins with Mr Bernstein just a few centimetres from the camera, screen right; he is holding up and reading a document, which takes up most of the left hand of the screen. When he puts the document down on the table, Mr Thatcher is revealed to be in the room (the piece of paper, huge in the foreground, blocked his presence). Moments later, Kane starts to speak and enters screen right (he enters as soon as he speaks). He then

continues talking while walking to the back of the room, before walking back up to the camera to sign the document. The space of the scene is clearly defined by the staging of Mr Bernstein in the extreme foreground, Mr Thatcher in the middle-ground, while Kane moves from middle-ground to background and back to middle-ground. His movement helps to define the background space.

In his next film, *The Magnificent Ambersons*, Welles uses a long take with deep focus to film the parlour scene. George is seated in the left foreground of the shot while his aunt Fanny (Agnes Moorehead) feeds him huge quantities of strawberry shortcake. The tension of the scene is created by the fact that they are talking about Eugene, with whom aunt Fanny is in love. George's uncle Jack enters into the scene and, indirectly, makes fun of aunt Fanny's love for Eugene. Aunt Fanny runs out of the scene, crying hysterically. While all of these events are taking place, the camera remains in its same location throughout the whole scene, with only slight camera movement for reframing.

The way Welles shot this scene suggests that he was unwilling or refused to interrupt the events as they unfolded and developed. In other words, the translation of *mise-en-scène* into *mise-en-shot* is kept to a minimum. The film critic André Bazin wrote the following about this shot:

The refusal to move the camera throughout the scene's duration, particularly when Agnes Moorehead has her emotional crisis and rushes away (the camera keeping its nose obstinately glued to the strawberry shortcake), is tantamount to making us witness the event in the position of a man helplessly strapped to

Orson Welles, p. 74

What Bazin suggests is that the static nature of the camera for a long period of time limits the spectator's involvement with the events and characters. In summary, the long take distances the spectator from the events and characters. It is as if the scene never gets beyond its establishing shot. The long take eliminates editing that would place the spectator within the action. Below we shall see how editing involves the spectator in the action.

So far, I have described the deep focus shot in predominantly negative terms. Yet there are many positive aspects to Welles's stylistic choice. The space and time of the scene remain whole and continuous. The scene is not fragmented into several shots (that is, into several fragments of space and time). In other words, the long take observes the dramatic unities of space and time.

One of the consequences of observing the dramatic unities of space and time is that it emphasizes the actor's performance. Rather than cutting a performance up into many shots, it is realized on screen uninterrupted. If the actor's performance is particularly important in a scene, the director may decide to use the long take in order not to interrupt the actor's performance as it develops.

This principle does not only hold for Hollywood films of the 1940s. Contemporary directors occasionally use the long take when they want to maintain the dramatic unities of space and time or to emphasize the actor's performance. Steven Spielberg uses several long takes in Jaws (1975). In one dramatic scene on the harbour of Amity Island, Mrs Kintner, wearing mourning clothes, confronts Chief Brody about the death of her son, Alex. After a series of reverse angle shots in which she slaps Brody, a static deep focus shot frames Brody in the foreground right with his back to the camera (and probably standing less than 30 cm from the lens), Mrs Kintner in the foreground, and her father in the middle-ground to the left. As with many of the deep focus long takes in this film, the image's composition is distinct. It is composed along a strong diagonal line. The shot is briefly interrupted by a reaction shot of Brody, before returning to the same set-up (one continuous take has been cut in two by a reaction shot). The first half of this diagonal shot lasts 15 seconds, and the second half 43 seconds. By cutting to a reaction shot of Brody, the scene ends up becoming about him. It is the moment in the film when he confronts the moral consequences of his inaction and tendency to be swaved by others. The scene ends with him accepting the blame for Alex's death.

Spielberg combines the long take with deep focus in The Lost World (1997) when Ian Malcolm visits Hammond at his home. While waiting in the hallway talking to Tim and Lex, Hammond's nephew, Peter Ludlow, enters. As he signs documents in the foreground, Malcolm, Tim and Lex are shown in the background (and there is also considerable space behind them). Malcolm then walks into the middle-ground to talk to Ludlow, and in the background the children prepare to leave. This shot consists of deep focus and long take (of 73 seconds). It appears to be strongly influenced by the long take in the Colorado sequence from Citizen Kane that I analysed above. In addition to the use of the long take with deep focus (and low camera angle), the staging is similar: documents being signed in the foreground, Ian Malcolm in the middle-ground (he's as powerless as the father in the middle-ground of the Colorado sequence), and the children in the background (just as Kane was in the background).

Many other directors also prefer to use long takes. Secrets and Lies (Mike Leigh, 1996) focuses on two characters: Hortense (Marianne Jean-Baptiste), as she searches for the mother she has never met, and Cynthia (Brenda Blethyn), an unhappy, working mother preoccupied and distracted with the mundane problems of everyday life. In one scene, Cynthia talks to her brother Maurice during one of his infrequent visits to her. After talking about mundane matters, Cynthia is suddenly overcome by emotion and hugs her brother. They hug each other for over two minutes, which Leigh films in one take, with little camera movement (except a very slow zoom in). Leigh does not interrupt or distract from this sudden expression of repressed emotion with any marked camerawork or editing. He allows the emotion to express itself uninterrupted.

Leigh's use of the long take is more pronounced later in the film when Hortense has telephoned Cynthia, informing her that she is Cynthia's daughter and they meet in a café; Leigh films the scene in one take lasting 7 minutes 40 seconds (and, this time, with no camera movement). The drama of this scene is created by Cynthia's gradual realization that Hortense, who is black, is her daughter (Cynthia is white). The long take then shows the desperate attempts of the two women to communicate

with one another. Leigh allows these dramatic and emotional events to unfold uninterrupted; indeed, the shot is relentless and unyielding in its depiction of the two women trying to communicate with each other.

Richard Linklater employs a long take in *Before Sunrise* (1994). An American student, Jesse, meets a French student, Celine, on a train going from Budapest to Vienna. Jesse persuades Celine to tour Vienna with him. The film charts their growing relationship during their 14 hours in Vienna. In an early scene, Linklater decides to film the two of them on a tram as they begin to get to know one another. Linklater films the scene using a long take lasting six minutes. The long take shows the characters' interaction as it unfolds and blossoms into friendship.

Colour is another important element of *mise-en-shot*. We shall examine a growing trend among contemporary cinematographers – the trend towards silver retention, or non-bleaching processes, in the film development process. Normally, after colour films are developed, they go through a bleaching process, which dissolves all the unexposed silver. The film is then fixed, washed and dried. As its name suggests, the silver retention or non-bleaching process reduces or eliminates altogether the bleaching of the film. In its place the colour film is developed again, this time in a black and white developer, before it is fixed, washed and dried. What this means is that some additional silver is developed in the black and white developer.

This may sound overtly technical, but this process has strongly influenced the look of films such as Reds (1981), Saving Private Ryan (1998) (especially the first half hour), Minority Report (2002), Delicatessen (1991), City of Lost Children (1995), Alien Resurrection (1997), Evita (1996), Seven (1995) and The Panic Room (2002). The last six films on this list were all shot by the same cinematographer, Darius Khondji. In interviews he says he wants to make colour films in black and white. The non-bleaching process allows him to achieve very deep, dense blacks in the films he shoots, which also enhances contrast and 'desaturates' (that is, it reduces the colour intensity of) the image. The first crime scene in Seven demonstrates what results can be achieved: an atmosphere of an old, shiny, greasy

dark space is created through set design, lighting and especially through the non-bleaching process.

CONTINUITY EDITING

In this section we shall briefly look at the techniques of continuity editing. Continuity editing refers to a series of techniques that attempts to imitate, in the cinema, the space of Renaissance painting and the proscenium space of nineteenth-century theatre. These techniques are necessary because, unlike the long take and deep focus photography, editing breaks down a scene into a multitude of shots (fragments of space and time). The techniques of continuity editing function to create a synthetic unity of space and time from these fragments. We shall address the reason why a film-maker may want to use editing rather than the long take. But first, we shall seek an answer to the question: What are the major techniques of continuity editing and how do they work?

Continuity editing is all about coherence and orientation. If a film-maker randomly stuck together a series of shots, the spectator would soon become disoriented. The separate spaces in each shot would not add up because the spectator would not be able to relate them to one another. The way shots are edited together must therefore be controlled and regulated by a series of techniques that permits the spectator to fit them together like the pieces of a puzzle. Once all the pieces of the puzzle have been fitted together, the whole picture becomes clear. When we watch a film that is made up of numerous shots, we piece the shots together in our mind to create a coherent picture. The techniques of continuity editing enable the spectator to create a coherent picture from the shots presented on screen.

I noted that continuity editing attempts to imitate the space of Renaissance painting and the proscenium space of nineteenth-century theatre. Both of these arts attempt to create coherence and orientation, and achieve this by adopting a strategy that may sound rather obvious, but is fundamental and should not be taken for granted. That is, in Renaissance painting and nineteenth-century theatre, the spectator is positioned on the same side of the scene or action. In the theatre, for example, the action takes place within a scenic space consisting of

three walls, and the audience always occupies the space of the invisible fourth wall. The techniques of continuity editing create a coherent scenic space and orient the spectator so that he or she occupies the position of the invisible fourth wall.

In more technical terms, each film creates coherence and orients the spectator by means of the 180-degree axis of action line. David Bordwell writes:

The assumption is that shots will be filmed and cut together so as to position the spectator always on the same side of the story action. Bazin suggests that the 'objective' reality of the action independent of the act of filming is analogous to that stable space of proscenium theatrical representation, in which the spectator is always positioned beyond the fourth wall. The axis of action (or center) line becomes the imaginary vector of movements, character positions, and glances in the scene, and ideally the camera should not stray over the axis.

The Classical Hollywood Cinema, p. 56

A change in shot always involves a shift in vantage point but if the axis of action line is obeyed, then screen direction will be maintained when there is a cut from one shot to another.

Other techniques that create coherence and orient the spectator include:

- the eyeline match
- point-of-view cutting
- the match on action cut
- directional continuity.

In the eyeline match, a character in one shot glances at something off-screen (out of the frame) and a cut reveals the object the character is looking at. The line of the character's glance has therefore matched the two shots together, creating coherence and spatial orientation.

Point-of-view cutting is a variant of the eyeline match. The structure is the same: a character looks off-screen – cut to – the

object the character is looking at. However, what distinguishes point-of-view cutting is that the object is shown from the character's optical vantage point. In other words, the object is seen through the character's eyes.

Point-of-view shots are usually marked to indicate that they represent the character's optical vantage point. In a scene in *The Maltese Falcon* (John Huston, 1941), Marlowe is drugged. As he becomes dizzy, the camera takes his exact optical vantage point. The camera moves from side to side, goes out of focus and eventually fades to black. All of these filmic devices are used to represent Marlowe's (loss of) vision and consciousness.

Similarly, in *The Birds* (Alfred Hitchcock, 1963), Mitch Brenner spies Melanie Daniels in a small boat on the water of Bodega bay. He runs into his house, gets a pair of binoculars, and directs them at Melanie. As he does so, the camera cuts to a close-up of Melanie in the boat. The edge of the image is blacked out by a mask, a cinematic convention signifying a point-of-view shot of a character looking through binoculars.

In the match on action cut, the cut from one shot to another occurs when an action is being performed, in which the action is continued from one shot to the next. It is the continuity of the same action across the cut that creates coherence and orientation.

A related technique is that of directional continuity. If a character exits the shot from the right of the screen, he should enter the next shot from the left of the screen. In addition to creating continuity across the cut, directional continuity maintains screen direction.

All of these techniques create an impression of a coherent scenic space, and they position the spectator on the same side of the action, creating orientation. But these techniques are popular for financial as well as aesthetic reasons. The cameras, crew and technicians remain relatively fixed on the side of the invisible fourth wall and only three walls of the set need to be built.

Editing versus the long take

In contrast to the long take and deep focus photography, editing breaks down a scene into a multitude of shots. But why would a director go to all the trouble of shifting vantage point on the event and actors and risk disorienting the spectator? One answer is that editing gives the director almost complete control over the events and actors, since the scene comes together only when the shots are edited together. One director who is particularly notable for insisting on complete control over events and actors is Alfred Hitchcock. In 1938 Hitchcock wrote:

... if I have to shoot a long scene continuously I always feel I am losing grip on it, from a cinematic point of view. The camera, I feel, is simply standing there, hoping to catch something with a visual point to it... The screen ought to speak its own language, freshly coined, and it can't do that unless it treats an acted scene as a piece of raw material which must be broken up, taken to bits, before it can be woven into an expressive visual pattern.

Hitchcock on Hitchcock (ed. Gottlieb), pp. 255–6

The advantage of editing over the long take and deep focus is that, through the changes in viewpoint implied by the change of shot, the director can fully involve the spectator in the action. We can see this happen in the last scene of Hitchcock's 1946 film *Notorious*. Devlin (Cary Grant) rescues the undercover spy Alicia (Ingrid Bergman) from the house of the Nazi, Alex Sebastian (Claude Rains). Alex has finally discovered that Alicia, his fiancée, is really a spy. Alicia is upstairs in her bedroom, suffering from poisoning. Devlin rescues her while Alex is in a meeting with other Nazis. Alex leaves the meeting and discovers Devlin and Alicia walking down the stairs, but he avoids intervening because otherwise Devlin will inform the other Nazis that Alicia is a spy, and that would get Alex into trouble. So Alex has to allow Devlin to take Alicia out of the house.

The action in this scene is therefore very simple: Devlin guides Alicia down the stairs and out through the front door, under the gaze of the other Nazis and Alex's mother. So why does Hitchcock decide to use 51 shots in only 2 minutes 5 seconds in filming this action (from Devlin and Alicia exiting the bedroom door to them exiting the front door)? Throughout the action, Hitchcock cuts rapidly between five set-ups: Devlin and Alicia occupying the frame alone (15 shots), Alex occupying the frame alone (17 shots), Alex's mother (5 shots), Devlin, Alicia, Alex and his mother together (5 shots) and the Nazis downstairs (9 shots).

The rapid cutting swiftly moves between the five points of action, giving the spectator optimal access to the events, as well as the reaction of each character to those events as they unfold second by second.

Surprisingly, the rapid cutting does not speed up the action; instead, it emphasizes the slowness of Devlin and Alicia as they descend the stairs. The rapid cutting helps to prolong the suspense (will Devlin and Alicia escape or not?). Furthermore, Devlin and Alicia are in love with one another, but they have been kept apart because of Alicia's undercover job. If they escape from Alex's house, they will be free to express their love. A lot is at stake in this scene and Hitchcock expertly uses rapid editing to emphasize the gravity of the situation.

As a footnote, it is worth mentioning that, although Hitchcock is famous for his skilful deployment of editing, he experimented with the long take in the late 1940s in his films *Rope* (1948) and *Under Capricorn* (1949). However, during the 1950s he returned to editing as his preferred way of filming a scene. In Chapter 3 we shall discuss Hitchcock's work in much more detail.

Spotlight

Barry Salt has observed that, in contemporary American cinema, film style has changed significantly: editing in recent films is much faster than in old Hollywood films, and directors prefer to shoot more scenes in close up.

Editing in Jurassic Park

As a contemporary example of editing, we shall briefly look at the opening scene of Spielberg's *Jurassic Park* (1993). The main action consists of a number of park wardens releasing a dinosaur into the park. But the dinosaur manages to drag one of the wardens into its crate and kill him. This scene lasts 2 minutes 30 seconds and contains 43 shots, making an average shot length of 3 seconds (or, on average, a change in shot every 3 seconds). The function of this rapid change in shots is to involve the spectator in the two main points of action – the wardens attempting to release the dinosaur into the park and the dinosaur in the crate. In the second half of the scene, in particular, Spielberg cuts rapidly between the two points of action – that is, from both inside and outside the crate.

The first thing that the opening of *Jurassic Park* tells us is that Spielberg, like Hitchcock, relies on editing in his film-making process. This is because Spielberg's first concern is to involve the film spectator in the action, rather than focus on character psychology and the actor's performance (which is what he focuses on when he uses long takes and deep focus shots, as we just discussed). Spielberg stresses the importance of action and spectator involvement with that action by storyboarding his films – that is, by breaking the final shooting script down into detailed pictures representing the frames of a particular scene. These storyboards usually contain information about camera angles, camera movement, the placement of characters in the frame and so on.

Spielberg storyboards most of his films, particularly the action sequences, although he did not use storyboards for Schindler's List (1993), for the film is (unusually for Spielberg) based on character psychology, not action sequences. Some critics argue that storyboarding stifles creativity and spontaneity, for the film's look and structure is determined in advance of the shooting. The process of making the film (mise-en-shot) is, according to these critics, simply a technical and mechanical exercise for Spielberg, because he has worked out everything in advance.

Film sound

Before we leave this technical discussion of film aesthetics and move on to a more theoretical discussion, we can briefly review another important set of stylistic options and choices made by film-makers – those concerning film sound.

The options available to film-makers in the construction of sound are as rich as the options available in the construction of the image track. Here we shall look at only one – but nonetheless essential – question concerning the soundtrack: What is the source or origin of the sound? The following section will simply offer a classification of sound in the cinema; the basis for this classification is determined by the origin of the sound.

A crucial term that needs to be introduced in the discussion of sound is 'diegesis', which in film studies simply means the story (or narrative) world of the film.

The first term of classification is the most obvious: 'diegetic sound', which refers to sound whose origin is to be located in the story world. Diegetic sound includes the voices of the characters and the sounds of objects that exist in the story world. This includes music made by instruments that form part of the story world (for convenience, we can refer to this type of music as 'screen music').

We need to distinguish external diegetic sound from internal diegetic sound. External diegetic sound has a physical origin in the story world. The examples I gave are examples of external diegetic sound. By contrast, internal diegetic sound has its origin inside a character's mind. In other words, internal diegetic sound refers to subjective sounds – either the rendition of a character's thoughts or imagined sounds. These sounds are still diegetic because they derive from the story world, but they are internal because they cannot be heard by other characters.

The ending of *Psycho* (Hitchcock, 1960) is very instructive from this perspective. (*Psycho* will be analysed in some detail in Chapter 2.) Norman Bates has been arrested for killing his mother, her lover, Marion, and the detective Arbogast. Bates has now become totally psychotic, as he has taken on his mother's
identity. In the police cell, we see him looking passive and hear him thinking to himself – but he is thinking to himself in his mother's voice, and talking as if he were his mother. Although spectators comprehend the technique of rendering thoughts (internal diegetic sound) as a voice-over, nonetheless, in the case of *Psycho*, the spectator needs to have listened to the psychiatrist's speech in the previous scene in order to comprehend this unusual relation between image and sound, in which Norman is thinking to himself in his mother's voice.

A comical play with internal diegetic sound is to be found in the film Dead Men Don't Wear Plaid (Carl Reiner, 1982). The film is a spoof on films noirs of the 1940s (films noirs will be discussed in Chapter 4). The first time we see the hero, private detective Rigby Reardon (Steve Martin), he is sitting in his office. Juliet Forrest (Rachel Ward) visits and hires him to find the killer of her father. As the film progresses, Rigby falls in love with Juliet. In one scene in his office, he begins to express his love for her in voice-over (internal diegetic sound representing his thoughts). His voice-over ends: '... but how can I explain that a man in my business can't take on a wife, have a bunch of kids?', to which Rachel responds, 'We wouldn't have to have kids.' Clearly, the film is challenging - for comic effect - the convention of internal diegetic sound by suggesting that it could be external. Only the spectator should be able to share the internal thoughts of the character.

The final category of sound I shall introduce is that of non-diegetic sound, in which the origin of the sound derives from outside the story world. The music soundtrack of films is, of course, non-diegetic. In documentary films, the voice-of-God commentary (to be discussed in Chapter 5) is also non-diegetic, since the narrator does not appear in the film's story world.

Theoretical analysis of film aesthetics

In the first half of this century, film theorists attempted to justify the serious study of the cinema by arguing that it is a legitimate form of art. They set about achieving this aim by trying to identify the specific property that defines film as film – that is, that distinguishes film from the other arts.

The first school of thought to defend film as art were the formalists, such as Rudolf Arnheim and the film-maker Sergei Eisenstein. For the formalists, film's specific property is its inability to perfectly imitate normal visual experience of reality. It may at first sound odd that the formalists concentrated on the limitations of film to define it as an art. But they argued that these limitations define the expressive potential of film. The limitations of film offer the film-maker the opportunity to manipulate and distort our everyday experience of reality for artistic ends.

Filmic techniques, such as editing, montage, fast and slow motion, the use of low and high camera angles, together with film's transformation of a three-dimensional world onto a two-dimensional surface and so on, prevent film from imitating our normal visual experience. By exploiting these limitations, film-makers can present a unique – a specifically filmic – vision of the world. It is this unique vision of the world, made possible by film's specific properties (editing, etc.), that distinguishes film from the other arts and defines film as an art. For the formalists, film is an art because its specific properties, which prevent it from imitating reality, can be exploited by directors to express their vision. In Chapter 3 we shall see that directors who exploit the specific limitations of film for expressive purposes are conferred the prestigious title of *auteurs*.

In opposition to the formalists, the realists, such as Bazin, Siegfried Kracauer and, more recently, Stanley Cavell, reject montage and expression in favour of film's recording capacity. They begin by arguing that, by means of its automatic mechanical recording of events, film does perfectly imitate our normal visual experience of reality. Furthermore, they argue that film's ability to imitate reality is what defines film as an art. The realists therefore identified film's specific property in its photographic representation of reality. Moreover, they identified the long take and deep focus shots as the elements of film style that realize film's specific property. Deep focus allows for a number of actions to be composed in the same shot. By contrast, editing would present these actions one after another in separate shots. Deep focus therefore supports the use of long takes by reducing the need for editing, thereby maintaining the spatial and temporal unity of the scene.

Bazin emphasizes the unrealistic nature of editing in a long footnote to his essay, 'The Virtues and Limitations of Montage' (What is Cinema?, vol. 1, pp. 41-52). He refers to a scene from the film Where No Vultures Fly. The film is about a young family who set up a game reserve in South Africa. In the scene that Bazin discusses, the young son of the family picks up a lion cub in the bush and takes it home. The lioness detects the child's scent and begins to follow him. The lioness and the child with the cub are filmed separately and the shots are simply edited together. But as the child reaches home, 'the director', writes Bazin, 'abandons his montage of separate shots that has kept the protagonists apart and gives us instead parents, child and lioness all in the same full shot. The single frame in which trickery is out of the question gives immediate and retroactive authenticity to the very banal montage that preceded it.' In this particular example, the realism of the shot for Bazin is a matter of spatial unity - the fact that the child appears in the same shot as the lioness. Indeed, Bazin concludes his footnote by writing that: 'Realism here resides in the homogeneity of space.'

Film's capacity to record reality in all its movement was severely criticized by the formalists, who regarded mechanical recording as a hindrance to film's attempt to be defined as an art. This is because, for the formalists, mechanical recording limits film to the (imperfect) imitation of reality, not to the expression of a new and unique vision of reality.

In realist aesthetics, Bazin understood that the filmed event (whether staged or not) dominates, as is evident in the use of the long take to allow the event to unfold uninterrupted. Eisenstein instead emphasized the film-making process rather than the filmed event and developed – in both theory and in his film-making practice – a tendency towards editing, or more accurately, montage. Whereas editing simply refers to the joining together of shots, montage refers to the expressive use of editing to confer symbolic and metaphorical meanings on to the filmed events. For Eisenstein, shots simply constitute the raw material of film-making. From the raw material of the shots, meanings are created that do not exist in the raw material.

MONTAGE

Earlier in the chapter we discussed continuity editing, which attempts to create a coherent scenic space by means of a number of techniques: axis of action line, the eyeline match, the point-of-view shot, the match on action cut and directional continuity. In relation to montage, continuity editing is simply sequential cutting. This is because montage does not attempt to construct a coherent scenic space, but attempts to create symbolic meanings. It achieves this primarily by juxtaposing shots together, with little regard for coherent scenic space.

Eisenstein called the symbolic meanings created by montage 'associations'. Montage creates associations (symbolic meanings) that are greater than the sum of their parts. In other words, from the montage of two shots is created a chain of associations that does not exist in any of the shots.

Eisenstein explained how montage works by referring to Egyptian hieroglyphs:

The point is that the combination of two hieroglyphs of the simplest series is regarded not as the sum total but as their product, i.e. as a value of another dimension, another degree: each taken separately corresponds to an object but their combination corresponds to a concept. The combination of two representable objects achieves the representation of something that cannot be graphically represented.

For example: the representation of water and of an eye signifies 'to weep'. But – this is montage!!

Writings 1922-1934, p. 139

The crucial passage here is: 'each taken separately corresponds to an object but their combination corresponds to a concept. The combination of two representable objects achieves the representation of something that cannot be graphically represented.' Hieroglyphs and montage create abstract and symbolic meanings by juxtaposing concrete objects.

As an example, we shall look at a celebrated scene in Eisenstein's film *Battleship Potemkin* (1925). After the Cossacks

have massacred the people, the famous Odessa steps sequence, the Potemkin battleship fires on the headquarters of the military. This is followed by three shots of stone lions at the Alupka Palace in the Crimea. The first shot depicts a lion lying down, the second depicts a lion seated, and the third a lion standing up. (The lion is therefore used by both the realists and the formalists to put their arguments across!)

The three shots of the lions create a montage unit. In terms of the content of each separate image, we simply have: a stone lion sleeping, a stone lion sitting and a stone lion standing up. Three concrete objects juxtaposed together. But what does it mean, and what effect does it create?

Due to the framing of the three separate lions, Eisenstein creates the impression that *the same* stone lion has moved from its sleeping position and has stood up. In terms of these three shots by themselves, Eisenstein has already created an abstract meaning that does not exist in each individual shot. The shots of the stone lions (the raw material), when taken in isolation, merely offer a representation of each lion. No shot shows a stone lion going through the motions of standing up. Such an action is impossible anyway. But the editing of the shots together creates the impression or the illusion of a stone lion being woken up. Eisenstein creates this impression purely and exclusively through the juxtaposition of the shots – montage.

But we can go further and consider the abstract and symbolic meanings these shots have in relation to the scene that these shots interrupt. Why would Eisenstein insert three shots in this sequence to give the impression that a stone lion is rising up? There are at least three possible answers:

- ▶ The shots may be suggesting that even a stone lion would be shocked by the massacre on the Odessa steps.
- ► The lion could represent the Russian people who have finally risen against their oppressors.
- ▶ A clever film critic may say that the shots are modernist they draw attention to the cinema's creation of movement from the rapid projection of still images.

This is another point about montage: the montage sequences do not contribute to the creation of a unified story world. They interrupt the story world created by continuity editing.

We can also see the principle of montage at work in the shower scene murder in Hitchcock's film *Psycho*. The scene continually cuts from Marion Crane in the shower to Norman's 'mother' wielding a knife. The shots (the raw material) do not contain images of Marion being cut or stabbed by the knife. Nonetheless, the rhythm of the cutting creates a meaning that goes beyond the literal content of the images – Marion's murder. This scene therefore illustrates Eisenstein's argument that the arrangement of shots into a rhythmic pattern is more important than the single shot just as, in music, the arrangement of notes is more important than the single note.

But the realists stressed the importance of the single shot because it maintains film's recording capacity, which is interrupted by the cut, or the transition to another shot. The realists argued that the formalists are denying film's unique capacity of mechanical recording. For the realists, the exploitation of the recording capacity of film by means of the techniques of the long take and deep focus fulfils, for the first time in the history of art, the aim of art – a life-like representation of reality.

In general terms, the formalists developed their arguments within a modernist framework (a concern with the internal structure of a medium). For the realists, the function of art is to imitate nature.

Filmic examples of these two theoretical positions have already been discussed in the first part of this chapter. But now, hopefully, the significance of the filmic techniques championed by each side – deep focus and the long take in the case of the realists; editing, montage, etc. in the case of the formalists – are more apparent. Furthermore, I have no intention of favouring either the formalists or the realists. Both have put forward strong and cogent arguments and the reader may wish to read the original books that present each side of the argument, to get a more informed view. However, it may be

worthwhile mentioning that both sides have decided to argue that film has only one function and both have emphasized that this function can be achieved only through a limited number of filmic techniques. By considering both arguments, we can see that film performs both functions. A film can be made using the unified, unedited space of the long take, or with the synthetic, constructed space of montage. Film records as well as distorts

Dig deeper

Altman, Charles [Rick], 'Towards a Historiography of American Film', Cinema Journal, 16, 2 (1977), pp. 1–25.

An invaluable outline of various approaches that have been adopted in film studies (I have modified Altman's list in the opening of this chapter).

Andrew, J Dudley, *The Major Film Theories* (New York: Oxford University Press, 1976).

This book is still the most accessible introduction to the work of the formalists (Hugo Münsterberg, Rudolf Arnheim, Sergei Eisenstein, Bela Balazs), the realists (Siegfried Kracauer, André Bazin) as well as the film theories of Jean Mitry, Christian Metz, Amédée Ayfre and Henri Agel.

Arnheim, Rudolf, *Film as Art* (London: Faber and Faber, 1958). Arnheim's formalist statement on film art.

Bazin, André, Orson Welles: A Critical View (California: Acrobat Books, 1991).

A concise and lucid analysis of Welles's early films. For me, this book contains Bazin's clearest defence of the techniques of the long take and deep focus.

Bazin, André, *What is Cinema?*, 2 volumes (Berkeley: University of California Press, 1967, 1971).

Bazin's seminal collection of essays that defends a realist film aesthetic.

Bordwell, David, Staiger, Janet and Thompson, Kristin, *The Classical Hollywood Cinema: Film Style and Mode of Production to 1960* (London: Routledge, 1985).

The undisputed, authoritative heavyweight study of classical Hollywood cinema, covering the history of film style, technology and mode of production.

Buckland, Warren, Directed by Steven Spielberg: Poetics of the Contemporary Hollywood Blockbuster (New York and London: Continuum, 2006).

In this book I examine Spielberg's film-making practices – the choices he makes in placing or moving his camera, framing a shot, blocking the action, editing a scene, designing the sound, and controlling the flow of story information via a multitude of narrational techniques.

Carroll, Noël, *Philosophical Problems of Classical Film Theory* (Princeton: Pinceton University Press, 1988).

Eisenstein, Sergei, Writings, Volume 1: 1922–1934 (ed. and trans. Richard Taylor) (London: British Film Institute, 1988).

The first of three authoritative volumes of Eisenstein's collected essays.

Elsaesser, Thomas and Buckland, Warren, Studying Contemporary American Film: A Guide to Movie Analysis (London: Arnold; New York: Oxford University Press, 2002).

Chapter 3 discusses *mise-en-scène*, and Chapter 7 discusses André Bazin's work.

Gottlieb, Sidney (ed.), *Hitchcock on Hitchcock* (Berkeley: University of California Press; London: Faber and Faber, 1995).

A comprehensive collection of Alfred Hitchcock's writings on the cinema.

Salt, Barry, Film Style and Technology: History and Analysis, Second Edition (London: Starword, 1992).

The research carried out for this book is phenomenal and simply overwhelming. Salt has analysed literally thousands of films shot by shot from each decade of the cinema, noting the stylistic parameters of each shot and scene and representing this information statistically (including bar charts of shot scales of individual films). The book is also packed with information on the history of film technology.

Focus points

Mise-en-scène designates what appears in front of the camera – set design, lighting and character movement.

Mise-en-shot means 'putting into shots' or simply 'shooting (a film)'.

- * The long take and deep focus emphasize the drama as it unfolds within the shot. These techniques create a fusion between actors and settings, allow the actor's performance to shine through and have the potential to sustain a mood or emotion over a long period of time; however, they distance the spectator from the unfolding action.
- Colour can be manipulated to create an atmosphere, as in the non-bleaching process used by cinematographers such as Darius Khondji.
- * Editing, which consists of breaking down a scene into a multitude of shots, allows the director to fully involve the spectator in the action at the expense of breaking the film's actual spatial and temporal unity; however, a synthetic unity is restored by means of the technique of continuity editing (which includes the axis of action line, the eyeline match, point-of-view cutting, the match on action cut and directional continuity).
- The formalists, such as Rudolf Arnheim and the film-maker Sergei Eisenstein, defend film as art; they argue that the limitations of the filmic medium enabled film-makers to manipulate and distort everyday experience of reality for artistic ends.
- ☼ By contrast, the realists, such as André Bazin, Siegfried Kracauer and Stanley Cavell, promote film's recording capacity; they argue that, by means of its automatic mechanical recording of events, film does perfectly imitate our normal visual experience of reality and it is this unique quality of film that makes it an art.
- The formalists favour filmic techniques such as editing, montage, fast and slow motion, and the use of low and high camera angles.
- The realists favour filmic techniques such as the long take and deep focus photography.

amion kules

with a translation of the state of the state

And the month of state of additional political which is not a separate of the state of the state

Transference of the **relation** of the experiment of the second of the se

and the control problem of the control of the contr

and the rest of the second sec

e trop to est entre e para A de Rein e lefte de la companya del companya de la companya de la companya del companya de la companya del companya

The Copyright Court of the state of the spirit as editing to a control of the spirit his spirit has a control of the spirit his spirit his control of the spirit his control o

อันเกมเกลสารควายการบุคคุณ เยาะเลย การเป็นสมัย เคาระ การการแกรที่ เกมเกม

2

Film structure: narrative and narration

In this chapter you will learn about:

- the main elements of a film's narrative structure
- ▶ the different types of narration in a film.

... narrative is a way of organizing spatial and temporal data into a cause–effect chain of events with a beginning, middle, and end that embodies a judgement about the nature of the events.

Edward Branigan, Narrative Comprehension and Film, p. 3

The filmic techniques studied in Chapter 1 make up the micro (or small scale) properties of a film's structure. In this chapter we shall examine the macro (or large scale) properties of a film's structure. These macro structures fall into two main categories – narrative and narration. These structures will be defined and illustrated in relation to both classical and contemporary Hollywood films. Finally, the chapter will end with an analysis of the unusual narrative structure of *Pulp Fiction* (Quentin Tarantino, 1994) and *Mulholland Dr.* (David Lynch, 2001).

The concept of 'narrative' refers to what happens or what is depicted in films (as well as novels), and 'narration' refers to how that narrative is presented to the film spectator (or reader of a novel). So 'narrative' refers to actions, events and characters, whereas 'narration' describes a mechanism that controls how the spectator gains information about those actions, events and characters. Below we shall look at narration. But first, a description of what is meant by narrative.

Spotlight

Steven Spielberg said the following about the importance of narrative: 'I think people will leave their television sets [and go to the movies] for a good story. Before fire and skyscrapers and floods, plane crashes, laser fire and spaceships, they want good stories.'

Narrative structure

A narrative does not consist of a random series of events, but a series of events related to one another in terms of cause and effect. If a film is based on narrative logic, an event on screen will be caused by a previous event: event B happens *because* of event A.

For example, a man in shot A points a gun in an off-screen direction and fires. In shot B another man is shown collapsing to the ground. Because of the way the shots are edited together (shot B immediately following shot A), the spectator reads the event in shot A as the cause of the event in shot B.

The causal link between the two shots can be illustrated by reversing their order: shot B, of the man collapsing, followed by shot A, of another man firing a gun. The logic of the two shots is incomprehensible to the extent that the spectator cannot understand the event of the man collapsing as being caused by the event of the man shooting the gun.

Scenes as well as shots are also linked together by a cause-effect narrative logic. We can see this by looking at the first three scenes of Alfred Hitchcock's film *Psycho* (1960). First, a partial synopsis of the film. *Psycho* begins by narrating the story of Marion Crane (Janet Leigh). She is first shown in a seedy hotel room with her lover, Sam. They talk about getting married, but Sam has no money. Sam goes to the airport and Marion returns to her workplace (a real estate office), where she works as a secretary. Her boss asks her to deposit \$40,000 into the bank. She leaves the office and then goes home, where she packs and drives out of town. One night she stops to rest at the Bates's motel...

Scene 1. The first scene, Marion and Sam in a seedy hotel room during lunch break, establishes a problem: Marion and Sam cannot be married because he has no money (he is not financially independent and so cannot support a wife).

Scene 2. The second scene, of Marion returning to work, develops the theme of marriage further. The spectator learns that Marion's boss, George Lowery (who deals in real estate) is lunching with a wealthy man, Tom Cassidy. Cassidy's daughter is to be married the following day, so he visits the office to buy a property as a wedding gift for his daughter. Cassidy hands over \$40,000 in cash and Lowery asks Marion to take it to the bank. She asks Lowery if she can go home afterwards, since she has a headache and wants to sleep it off.

Scene 3. The third scene opens with Marion in her apartment. When she turns her back to the camera, the camera dollies in to an envelope on the bed and the spectator sees that it contains the \$40,000. The camera then pans right to show a suitcase, which Marion is in the process of packing. In a matter of seconds, this scene (within the context of scenes 1 and 2) establishes Marion's motives: she is going to steal the money and leave town.

The cause–effect logic in these three scenes is very tightly constructed. One of the most fruitful ways to analyse cause-effect logic in narrative film is to imagine the scenes in a different order. For example, if *Psycho* began with scene 3, a sense of mystery would be created, because we would not have sufficient information to understand Marion's motives. Beginning the film with scene 3 is certainly plausible, but would it be logical? It would certainly raise many questions in the spectator's mind: for example, whose money is this and what is this woman going to do with it? However, in the actual film, scene 3 is an *effect* of the previous two scenes (just as shot B in the hypothetical example above is an effect of shot A).

A lack is established in scene 1 – Sam's and Marion's lack of money; a surplus is established in scene 2 – Cassidy hands over \$40,000 in cash. Its surplus status is emphasized throughout the scene: Cassidy stresses that he carries only as much money as he can afford to lose, and that he is rich because he does not pay taxes. Scene 3 then neatly ties up the lack and surplus – Marion steals the money.

The film presents only information relevant to its cause–effect logic. After all, is it a coincidence that the \$40,000 is presented in the scene immediately after Sam and Marion talk about their inability to get married because of their lack of money? Is it a coincidence that Cassidy pays cash? And is it a coincidence that the money just happens to be for a wedding present? We can also ask other questions, such as: Is it a coincidence that the first three scenes directly follow on from one another? Why don't we see Sam leaving the hotel room and going to the airport? And why don't we see Lowery and Cassidy eating lunch?

By asking these questions, we begin to make explicit the film's cause-effect logic. The last two events just mentioned are left out because they are not relevant to the film's cause-effect logic, since they would not cause any effects in subsequent parts of the film. At the end of scene 1 we see Marion closing the door of the hotel room. Scene 2 begins with her entering the office. All extraneous information is simply eliminated (although we see the director, Hitchcock, standing on the sidewalk just outside the office – how relevant is this to the film's cause-effect logic?!).

As with the transition from scene 1 to scene 2, Marion's journey from the office to her apartment (via the bank?) is eliminated between scenes 2 and 3. In scene 2 Marion claims that she will go to the bank and then go home. Because, in scene 3, we see her at home, we initially assume that she has already gone to the bank. However, we soon have to revise our assumption, since the camera then shows the money on Marion's bed. Here the ellipsis between scenes 2 and 3 is significant to the cause-effect logic of the film, whereas the ellipsis between scenes 1 and 2 is insignificant.

Not all shots and scenes in narrative films are linked by causal logic. We can imagine a shot of a man walking a dog followed by a close-up shot of the dog. If the shots are reversed, the meaning is still the same, since there is no causal logic linking these two shots. Such shots can be characterized as being descriptive, rather than narrative. It is common for most narrative films to contain moments of description. Indeed, the opening of *Psycho* contains several shots of the skyline of Phoenix, Arizona, which are descriptive because they simply aim to describe the space in which the narrative events are to unfold. However, the dominant structure that holds a narrative film together (including *Psycho*) is still causal logic.

Spotlight

For a film to appear coherent and meaningful, the relations between its actions and events need to be motivated. In narrative films, this motivation is supplied by the cause-effect logic. But we need to go further than discussing narrative films in terms of cause and effect. Narrative development is dependent on the way in which the cause–effect logic is worked out in relation to the film's character (or characters), who motivates that cause–effect logic. This point can be made by referring to Hitchcock's 1959 film *North by Northwest* (which will also be discussed in my analysis of narration). First, I shall simply outline the rather complicated series of events contained in the film.

After a hard day's work, Roger Thornhill (Cary Grant), a Madison Avenue advertising man, goes to the bar of the Plaza Hotel to meet a couple of friends. He decides to send a telegram to his mother to cancel their night out at the theatre. But, as he calls the bellboy, he is mistaken by spies for the CIA agent George Kaplan. The spies kidnap Thornhill and take him to the head of the spy ring, Vandamm (James Mason). Thornhill manages to escape from Vandamm and begins searching the Plaza Hotel for George Kaplan. But Thornhill, pursued by the spies, is implicated in the murder of a UN delegate (who was in fact murdered by the spy ring). Wanted by both spies and police, Thornhill catches a train to Chicago. On the train he is assisted in his escape by a stranger on the train, Eve Kendall (Eva Marie Saint), who hides Thornhill in her bathroom when the porter arrives, and in the top bunk of her sleeping compartment when the police search the train. But the film spectator discovers that Eve is Vandamm's mistress and, once the train arrives at Chicago, she sends Thornhill into a trap - the famous 'cropduster' sequence. Eve has supposedly contacted Kaplan and has sent Thornhill to meet him in desolate farm country. But, once Thornhill has reached the arranged location, he is pursued by a crop-dusting plane which almost kills him. He manages to escape and tracks down Eve at the Ambassador Hotel. After confronting Eve, Thornhill follows her to an auction room, where he finds her with Vandamm. Vandamm's men attempt to seize Thornhill, but he saves himself by creating a disturbance at the auction and getting himself arrested by the police. It is at this point in the film that the CIA 'Professor' who created the decoy agent intervenes. At Chicago airport he informs Thornhill that Eve is the real CIA agent and that Kaplan is a non-existent

decoy. Because Eve is in danger, Thornhill continues playing Kaplan in order to divert suspicion from Eve. The film then shifts to Mount Rushmore, where the cafeteria becomes the stage of a mock killing, in which Eve 'shoots' Thornhill in order to regain Vandamm's trust. Eve then flees from the police and Thornhill is driven away in an ambulance. In a nearby wood, Eve and Thornhill meet up briefly and declare their love for one another. (It is only at this point in the film that Thornhill meets the 'real' Eve.) Eve then returns to Vandamm, who later discovers her real identity. She is rescued by Thornhill and they escape across the stone faces of the presidents on Mount Rushmore. They are finally reconciled as a married couple after Vandamm is defeated.

Thornhill motivates the film's cause—effect logic, since he must prove his innocence by finding George Kaplan. The forward momentum of the film is therefore driven by the needs and wishes of Thornhill. The resolution of these needs and wishes give the film a strong sense of closure, for Thornhill not only proves that he is the wrong man, but he also manages to expose Vandamm's spy ring and find a wife at the same time!

As this description of *North by Northwest* implies, narrative does not simply consist of a series of events linked together in a causal chain motivated by characters. Narratives are also structured into three stages: a beginning (Thornhill meeting his friends in the bar of the Plaza Hotel), a middle (being mistaken for Kaplan leads to Thornhill's kidnapping and to his subsequent adventures) and an end (Thornhill's successful attempt to prove his innocence, expose Vandamm and marry Eve).

The narrative theorist Tzvetan Todorov also describes narratives in terms of three stages:

- a state of equilibrium
- the disruption of this equilibrium by an event
- the successful attempt to restore the equilibrium.

The transition from one stage to the next is called the narrative's 'turning point', in which crucial events change the direction of the narrative action. (See Kristin Thompson, *Storytelling*

in the New Hollywood, pp. 29-36 for a detailed discussion of 'turning points'.) The crucial issue in examining narratives in terms of Todorov's three-part structure divided by turning points is that the narrative is not defined as a linear structure, but as a circular one. An initial state of affairs is introduced and is then disrupted. The narrative is then driven by attempts to restore the equilibrium, which is finally achieved at the end. However, the equilibrium achieved at the end is not identical to the initial equilibrium. As Todorov argues, narrative involves a transformation. In North by Northwest, it is primarily Thornhill who goes through a transformation. At the beginning of the film, he is an unmarried advertising man planning to go to the theatre with his mother. By the end of the film he is a married advertising man. This transformation is brought about by his temporary loss of identity (he is mistaken for a CIA agent and taken out of his everyday lifestyle by kidnappers). The middle part of the narrative has therefore caused Thornhill's transformation.

We can characterize the middle part of the narrative as the narrative's liminal (or transitional) period, which means that it takes place outside established (or 'normal') social events. The liminal period of a narrative therefore depicts transgressive events, events that exist outside normal social events, whereas the initial and final equilibrium stages of the narrative represent social normality.

The concept of liminality can clearly be applied to *North by Northwest*. The film begins with the everyday routines of Thornhill. He is then literally taken out of his everyday routines by the kidnappers, whereby he loses his identity (the kidnapping therefore signals the beginning of the film's liminal period). It is only when Vandamm is arrested that Thornhill can regain his true identity and return to his original routines – but with a new wife.

David Lynch's independently produced American film *Blue Velvet* (1986) parodies this three-fold narrative structure. It begins with an excessively picturesque series of shots of small town America: a simplistic, naive and innocent environment. However, underneath this chocolate box image, there is a terrifying world of horror, violence and evil. The film depicts the journey of Jeffrey Beaumont (Kyle MacLachlan) from this

picturesque environment to the underworld, and back again. In the liminal space of the film's underworld, Jeffrey confronts Frank Booth (Dennis Hopper), the incarnation of evil, whom Jeffrey has to confront and defeat in order to return to the light of day. With the help of Sandy (Laura Dern), Jeffrey manages to defeat Frank, which then enables Jeffrey to return to the world of innocence. As with the opening scene, this world is presented in an excessively idealistic way, a parodic image of normality (or established social events). As with Roger Thornhill in North by Northwest, Jeffrey has been transformed, for he has found himself a partner, Sandy, as a 'reward' for his journey into, and successful emergence from, the underworld.

Additional elements of narrative structure include exposition, dangling causes, obstacles, deadlines and dialogue hooks.

Exposition fills in the back story of the characters and their situation. The first scene of *Psycho* functions primarily as exposition. In the hotel, the dialogue between Sam and Marion is geared to spelling out the back story of their lives – primarily their lack of money, which prevents them from getting married.

The prologue to Steven Spielberg's A.I.: Artificial Intelligence (2001) offers concentrated exposition, first in the form of a voice-over (which, we discover by the end of the film, is narrated by an alien) and then a lecture by Professor Hobby (William Hurt). The voice-over informs the audience that Earth's resources are scarce and that androids (or mechas) are commonplace because they use few resources. Then, Professor Hobby's lecture informs his audience in the film – and us – that he wishes to manufacture child mechas for childless couples. (We later discover that the child mecha he develops – David – is modelled on his own lost son.) Professor Hobby wants to develop a child mecha that can love, thereby introducing one of the film's main themes.

The first scene of *Psycho* also reveals another standard narrative device: the obstacle, which stands in the way of the characters reaching their goal. Marion's main goal is to get married, but lack of money is an obstacle. She overcomes this obstacle by stealing Cassidy's money. But this act of stealing does not solve Marion's problems, for it throws the film into disequilibrium

and Marion becomes a fugitive. Additional temporary obstacles plague Marion, including the policeman who wakes her up and follows her, the car salesman who does not want to sell her a car too quickly, and, of course, the rain, which prevents her from reaching Sam, and instead diverts her to the Bates Motel. Norman is the final - and permanent - obstacle to Marion achieving her goal. His murder of Marion in the famous shower scene creates a further, more radical disequilibrium than Marion stealing Cassidy's money. In the end, the disequilibrium created by Norman murdering Marion replaces the disequilibrium created by Marion stealing Cassidy's money. Psycho returns to equilibrium when Norman is caught for murdering Marion, his mother and the detective Arbogast. Cassidy's money is only mentioned in passing, indicating its lack of importance in the film's return to equilibrium. Cassidy's money is simply an element of the film that has little importance in itself. Instead, its function is simply to get the narrative underway - what Hitchcock called a 'MacGuffin'.

Kristin Thompson defines the dangling cause as 'information or action that leads to no effect or resolution until much later in the film' (Storytelling in the New Hollywood, p. 12). In fact, we feel that a film is coming to an end precisely because its dangling causes are gradually being tied up. A film such as Mulholland Dr., to be analysed in detail at the end of this chapter, is structured according to many dangling causes. However, they are not conventionally resolved at the end of the film, even though we can argue they are resolved indirectly.

The deadline is simply a time limit placed on a protagonist to accomplish a goal. Thompson gives two examples:

The deadline may last across the film. In His Girl Friday (1940), for example, the opening scene reveals that Walter Burns is under intense pressure to obtain a reprieve for Earl Williams before the execution, scheduled for the next morning. Or a deadline may last only a brief while, as in the situation near the end of Alien when Ripley sets the spaceship's self-destruct mechanism and has only ten minutes to escape.

Storytelling in the New Hollywood, p. 16

The aim of the dialogue hook is to create a link between two consecutive scenes. Thompson notes that:

Frequently at the end of a scene a character will mention what he or she is going to do and will then immediately be seen doing it early in the next scene. Such a line is a 'dialogue hook'.

Storytelling in the New Hollywood, p. 20

Finally, a few words about the actual arrangement of the narrative events. Most narratives are linear and chronological because they present events in the order in which they happen. This applies equally to the two Hitchcock films discussed above, Psycho and North by Northwest. However, a film that, for instance, contains a flashback does not have a chronological narrative, because the narrative events are not presented in a linear order. By rearranging the narrative events in a non-linear order, flashbacks upset a film's cause-effect logic. Flashbacks are evident in films noirs (such as Mildred Pierce and Double Indemnity) and are one of the main devices that create the complex and convoluted narratives that are typical of film noir. (Film noir will be discussed in Chapter 4.) If we return to the discussion of Psycho, where I talked about beginning the film with scene 3, it is possible to imagine that, when Marion drives out of town with the money, scenes 1 and 2 could appear on screen in the form of flashbacks. These two scenes would then supply the cause of Marion's actions. At the end of this chapter we shall look at the complex and convoluted narrative structures of Pulp Fiction and Mulholland Dr.

We shall now discuss how narratives are conveyed to the spectator.

Restricted and omniscient narration

Spectators do not have direct access to a film's narrative events. Instead, narrative is filtered through a process called narration. The term 'narration' refers to a mechanism that determines how narrative information is conveyed to the film spectator. Here I shall discuss how narrative information is conveyed

to the spectator by means of two modes of filmic narration – omniscient narration and restricted narration.

Restricted narration ties the representation of film narrative to one particular character only. The spectator experiences only those parts of the narrative that this one particular character experiences. We can therefore think of restricted narration as a 'filter' or barrier that allows the spectator only limited access to the narrative events. This type of narration is typical in detective films such as The Big Sleep (discussed below), in which the camera is tied to the detective throughout the whole film. In omniscient narration, on the other hand, the camera is free to jump from one character to another so that the spectator can gain more information than any one character. Omniscient narration is therefore more like the view from a large window. which allows the spectator a panoramic view of the narrative events. Omniscient narration is typical in melodramas. However, many films (such as North by Northwest) combine restricted and omniscient narration.

Sometimes in omniscient narration, the camera will disengage itself completely from all characters. In this case, narration is directly controlled by someone outside the narrative - the director. Psycho mixes restricted and omniscient narration. In the first two scenes the camera is tied to Marion, making it restricted narration. But in scene 3, the narration becomes omniscient, as the camera disengages itself from Marion and begins to represent the director's vision directly. In the first few seconds of the scene, Hitchcock keeps the money off-screen, giving the spectator the fleeting impression that Marion may have gone to the bank and deposited the money. But when Marion turns her back to the camera. Hitchcock moves the camera to reveal the money on the bed. The camera then pans to the half-packed suitcase. These seemingly simple camera movements speak volumes. In these moments the camera is representing the director's vision, in which the director is subtly signifying the film's shift towards disequilibrium. In every scene and every shot of a film, ask yourself, Whose vision is being represented? Who is conveying this narrative information to me? These are the questions to ask yourself when analysing a film's narration.

Furthermore, these types of narration produce a particular response in the spectator. In restricted narration, the spectator knows only as much as one character, resulting in mystery. In omniscient narration, the spectator knows more than the characters, resulting in suspense.

A good illustration of these different spectator responses can be found in an example given by Hitchcock in his famous interview with François Truffaut (*Hitchcock*, p. 52). In this interview Hitchcock gave the example of a bomb placed in a briefcase under a table. If the spectator knows about the bomb and the characters around the table do not, then the spectator, placed in an omniscient position in relation to those characters, will feel suspense as he or she anxiously waits for the bomb to explode or to be discovered. But if the spectator is not privileged over the characters' knowledge, then the spectator, like the characters, is in for a shock. In this second example, the scene is governed by restricted narration.

In omniscient narration, the spectator is implicated in a fantasy of 'all-seeingness', where he or she can imagine seeing everything of importance in the narrative. At certain moments in the film, the camera disengages itself from one character and begins to follow another character, which means that the spectator gains more information about the narrative than any of the characters. This results in suspense because it manipulates the spectator's expectations as to how a character will react to a particular piece of information that the spectator already knows about, but which the character does not yet know about.

Restricted narration involves the spectator in the narrative in a different way. Because the camera is usually linked to a single character, then we know only as much as that character. This results in mystery because the spectator, like the character we are following, does not know what will happen next. In detective films, in which the camera follows the detective around the narrative world attempting to uncover the motives of a crime, these motives are hidden equally from the spectator and character by the restricted narration.

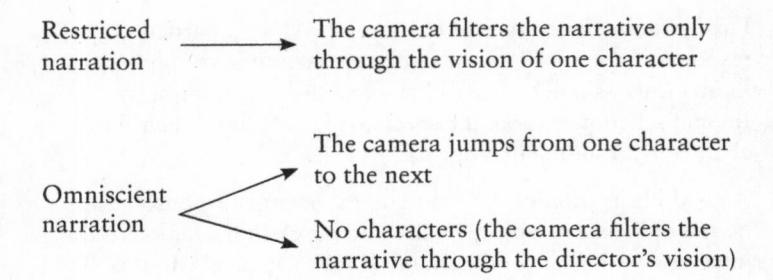

We shall now see how restricted narration structures Howard Hawks's 1946 film *The Big Sleep*, Martin Scorsese's 1976 film *Taxi Driver*, how *North by Northwest* mixes restricted and omniscient narration and, finally, how omniscient narration predominates in Douglas Sirk's melodrama *Magnificent Obsession* (1954).

RESTRICTED NARRATION IN THE BIG SLEEP

In *The Big Sleep*, Marlowe (Humphrey Bogart) is hired by General Sternwood to follow a man called Geiger because he is blackmailing Sternwood's younger daughter, Carmen. Marlowe follows Geiger to his home but remains outside in his car. As he waits, another car pulls up and the driver goes into Geiger's house. Marlowe looks in the car and finds out that it belongs to Carmen. Nothing much happens afterwards, so Marlowe rests. Then he hears a scream and sees a flash of light coming from Geiger's house. As he approaches Geiger's house, Marlowe hears gunshots, footsteps as someone exits the house via the back door, and sees two cars pull away. Marlowe enters Geiger's house and finds Geiger dead on the floor and Carmen drunk. He also finds an empty camera and a book written in code. Marlowe takes Carmen home...

What is significant about *The Big Sleep* in terms of narration is that it strictly adheres to restricted narration; that is, the camera is always tied to Marlowe, so the spectator finds out what happens in the narrative only when Marlowe does. For example, while waiting outside Geiger's house, Marlowe sees a car pull up outside. He hides in his car so as not to be seen. Interestingly, the camera remains outside the car and shows

a figure getting out of the other car and entering Geiger's house. Yet, the figure remains in shadow. So, even though the camera does not directly imitate Marlowe's point of view as he hides in the car, it does not privilege the spectator either. The spectator does not know who got out of the car and neither does Marlowe. It is only when Marlowe goes to inspect the car that he and the spectator find out, at the same time, that the car belongs to Carmen.

The spectator hears the scream and sees the flash of light at the same time as Marlowe does. We are not privileged into knowing who screamed (although both we and Marlowe can guess that it was Carmen) and we do not know what the flash of light represents. As Marlowe approaches Geiger's house, he hears someone leaving via the back door. He does not see who it is, so neither do we. However, we do see a shot of the feet of the person leaving. This is an aural point-of-view shot. It would have been easy for the director to have shown the whole figure (we later find out that it was Sternwood's chauffeur, Owen Taylor; he was followed by the blackmailer Joe Brody in the second car). But if the film had revealed the identity of Owen Taylor (and Joe Brody), this would have violated the film's adherence to restricted narration.

Inside Geiger's house Marlowe attempts to find out what happened. Again, the spectator closely shadows him and discovers what happens only when Marlowe does. This analysis of a segment from *The Big Sleep* therefore illustrates the film's strict adherence to restricted narration.

RESTRICTED NARRATION IN TAXI DRIVER

Taxi Driver narrates the story of Travis Bickle (Robert de Niro). An ex-marine, he is unable to sleep at nights, so he gets a job as a night-time taxi driver. He begins to date Betsy (Cybill Shepherd), who works in the presidential campaign office of Charles Palantine. But after Travis takes Betsy to a porn film, they split up. Travis's increasing paranoia (brought on by a multitude of causes) leads him to buy an arsenal of weapons. He meets a young prostitute, Iris (Jodie Foster), and decides that his mission in life is to save her. At first, Travis decides to assassinate Charles Palantine, but his attempt is thwarted.

The climax of the film consists of Travis shooting and killing Iris's pimp, Matthew (Harvey Keitel), and several other men associated with him. Travis is himself wounded in this massacre, and attempts to shoot himself but runs out of bullets. The end of the film shows that the media has treated Travis as a hero, because he saved Iris and returned her to her parents. In the last scene, Travis picks up Betsy in his cab but they fail to communicate with one another. Travis drops off Betsy at her destination and drives off alone.

A few words about the narrative structure of *Taxi Driver* before proceeding to analyse its narration. The narrative is motivated by Travis's attempts to find meaning in his life. This attempt leads him briefly to Betsy, but when their relationship breaks up, Travis quickly descends into paranoia and the underworld of New York city (the transition from initial equilibrium to disequilibrium is not clearly marked, but takes place very gradually). The shoot-out marks the violent end to the disequilibrium period of the narrative, leading to a new equilibrium, marked by the transformation of Iris. However, Travis is not transformed by his journey into paranoia and into New York's underworld. He remains the same insomniac unable to communicate with people.

Taxi Driver is based almost exclusively on restricted narration. This means that the flow of narrative information is filtered through a single character. Travis Bickle acts as the film's dominant character, the narrative agent who determines the flow of narrative information to the spectator.

The almost obsessive attachment of the camera to Travis means that spectators gain a very limited perspective on the narrative world. This attachment of the camera to Travis is clearly signified in the film's credit sequence, in which three shots of New York city, as seen through a car windscreen, are framed by two close-up shots of two eyes (presumably Travis's) looking off-screen.

Additionally, this positioning of Travis as dominant character is strengthened in the first three scenes of the film. Scene 1 opens with a shot of a glass office door with the words DEPENDABLE

TAXI SERVICE printed on it, through which we see a man sitting behind a desk. Within a second of this shot appearing on screen, a man enters screen right and physically dominates the frame, even though he has his back to the camera. On his back is written the name 'Bickle T'. As he walks through the door, the camera moves with him. In other words, the camera has attached itself to Travis's movement. The camera then moves round to focus on Travis's face, thus linking name and face in the same shot. This opening shot also links together the words 'Bickle' and 'dependable', an ironic commentary when we realize how highly unstable and unbalanced Travis is.

In this opening shot, it is as if the camera is 'waiting' for someone (anyone) to approach and enter this door; whoever does so becomes the film's dominant character. This process of looking for a dominant character is common to the opening of most narrative films, but the seeming randomness of this process was turned into an art form by Hitchcock. In the opening of *North by Northwest*, for example, the camera wanders through a busy rush-hour crowd before finally attaching itself to Roger Thornhill. And, in the opening of *Psycho*, the camera pans across the skyline of Phoenix and gradually moves towards a hotel; it seems to randomly pick one hotel room window, penetrate it and find its dominant character in the form of Marion Crane.

But back to *Taxi Driver*. The first three scenes are based on concentrated exposition, providing in condensed form background information about the film's dominant character. The man behind the desk interviews Travis for the job of a taxi driver. From his questions the spectator comes to understand Travis's motivation for wanting to work nights as a cab driver, about his honourable discharge from the marines, his age, lack of education and so on.

The final three shots of this scene consist of Travis walking out of the office, through the cab station and into the street. None of these shots provides additional narrative information about Travis; instead, their aim is indirect, to provide atmosphere, and to set the scene in which the film is to unfold. Moreover, this gives Scorsese the opportunity to play with film style. As

Travis walks out of the office, he looks towards the taxis and then walks off-screen right. The camera then pans left across the garage and stops at the entrance, by which time Travis has re-entered screen space, this time from the left. In other words, he has walked behind the camera.

This use of the space behind the camera is an unusual practice because, as we saw in Chapter 1, narrative film attempts to imitate the space of Renaissance painting and the proscenium space of nineteenth-century theatre. The rules of continuity editing aim to position the spectator in the cinema in a similar way in which the spectator is positioned in theatre – on the side of the invisible fourth wall.

However, in the shot under discussion, Scorsese breaks this rule by allowing Travis to briefly occupy the imaginary space occupied by spectators. This stylistic trick (which is also evident in the films of Ernst Lubitsch and Carl Dreyer) is repeated again, when Travis returns his taxi to the garage after his first night. The taxi is driven behind the camera, rather than in front, as would be usual in order to maintain the proscenium space of theatre and Renaissance painting.

The second scene of *Taxi Driver*, depicting Travis in his apartment, consists of one shot, a slow panning shot which functions to describe his domestic space (hence the shot is expositional). Furthermore, this shot is accompanied by Travis's voice-over, which serves to strengthen his role as dominant character. As we shall see in more detail below, this shot is repeated in the film's penultimate scene. This time it pans across the wall of Travis's apartment, upon which is pinned a series of newspaper articles defining him as a hero and a letter from Iris's parents, thanking him for returning their daughter. Travis's voice-over in scene 2 is now replaced by the voice of Iris's father. Like Rupert Pupkin in Scorsese's *The King of Comedy*, Travis has attained recognition through controversial means.

The third scene then re-establishes one of the film's internal norms – point-of-view shots of New York at night from the perspective of Travis in his taxi. These shots, as with the last three shots of scene 1, serve to set the scene in which the narrative is to be played out and are immediately given meaning

by the continuation of Travis's voice-over offering a negative evaluation of what is shown on screen. This serves further to define Travis's contradictory character – contradictory because he is at once fascinated and reviled by the low life on New York's streets.

The windscreen of Travis's taxi, the use of camera movement and placement, together with Travis's voice-over, mark the narration as restricted. It could be argued that some scenes are not focused on Travis (in other words, the film does rely on moments of omniscient narration after all). The first scene that may conform to this reading occurs in Charles Palantine's campaign office, which consists of Betsy talking to a fellow worker, Tom. However, as the scene begins to draw to a close, Betsy notices Travis sitting in his cab staring at her. We then retrospectively read this scene as being focused on Travis. Travis may not be able to hear what Tom and Betsy are talking about, but the scene is nonetheless based on his visual experience.

Another scene in *Taxi Driver* that could more legitimately be defined as beyond Travis's awareness is the scene in Matthew's apartment, where he attempts to convince Iris that he loves her. However, this scene begins with Travis outside the apartment sitting in his cab, looking off-screen. The implication here is that Travis is well aware of the events going on in the apartment.

Another shot we need to consider in terms of restricted narration is the penultimate scene of the film, already mentioned above. Here, the camera pans across the wall of Travis's apartment, showing the newspaper clippings and a letter from Iris's parents. Travis is not present in the apartment, so the camera movement is not determined by his awareness at this moment in time. The shot is therefore not focused on Travis, although it does not offer the spectator any information Travis is not already aware of. Instead, it functions as a new expositional scene, informing the spectator (with some surprise) of what happened to Travis after the shoot-out. The film reached its climax with the shoot-out so we have now reached a new equilibrium.

However, in the shoot-out, there are a few seconds of omniscient narration, as a man is seen coming out of Iris's room. The spectator sees him come out of the room and shoot

Travis in the shoulder. Moreover, once the massacre is over, the camera pans over the scene of the carnage. With the exception of these few shots, it is possible to argue that the rest of *Taxi* Driver is structured on restricted narration.

As this analysis of *Taxi Driver* shows, it is very difficult for any film to rigidly adhere to restricted narration, that is, tie itself exclusively to the experiences of the dominant character. Nonetheless, in *Lady in the Lake* (Robert Montgomery, 1947), virtually the whole film's narrative is constructed around the point of view (POV) of the detective:

Edward Branigan has described the effects this has on the film:

For most of the 103 minutes, [Lady in the Lake] appears to be an elaborate POV shot from the private eye of detective Phillip Marlowe (played by Robert Montgomery). Characters look directly into the camera when speaking to Marlowe. At various times we see Marlowe's arms and feet at the edges of the frame; we see his shadow, smoke from his cigarette, his image in mirrors; we see extreme close-ups of a telephone receiver as he talks, lips approaching for a kiss, an on-rushing fist approaching for a knock-out blow. The camera sways as Marlowe walks, shakes when he is slapped, loses focus when liquor is splashed in his eyes, and blacks out when his eyes close for a kiss and when he's knocked out.

Narrative Comprehension and Film, p. 142

These shots are interrupted only by shots of Marlowe sitting at a desk and speaking directly to the camera about the events being shown. The overall effect is one of artificiality and claustrophobia.

RESTRICTED AND OMNISCIENT NARRATION IN NORTH BY NORTHWEST

We shall now see how *North by Northwest* uses omniscient narration at strategic points in order to manipulate the spectator's engagement with the narrative. At specific moments in the film, the camera disengages itself from its dominant

character, Roger Thornhill, in order to give the spectator some additional information about the narrative that Thornhill does not possess.

Narration does not become omniscient in haphazard fashion; rather, it does so only at specific moments in the narrative. There are several significant moments when the narration becomes omniscient in *North by Northwest*. (Remember that omniscient moments are those which lie outside Thornhill's span of awareness; sometimes it may be a single shot, sometimes an entire scene.)

- The first omniscient moment is in the bar of the Plaza Hotel, when Thornhill attracts the attention of the pageboy who is paging George Kaplan. The camera quite suddenly and dramatically disengages itself from Thornhill and the group of men he is drinking with to show the two kidnappers. The spectator then sees, from the kidnapper's point of view, the pageboy walk up to Thornhill. The kidnappers then wrongly infer that Thornhill is Kaplan.
- ▶ The second moment is when Thornhill, his mother and the police go to the house where Thornhill said he was taken, to check up on his story about the kidnapping. As this group drives away from the house, the camera remains behind and pans left to reveal a gardener, who is in fact one of the kidnappers.
- The third moment is in the public lounge in the UN building, when the camera cuts from Thornhill to the same kidnapper.
- So far, these examples refer to single shots which are inserted into scenes constructed around restricted narration. But the fourth example of omniscient narration refers to an entire scene, in which the CIA professor explains to his colleagues that Kaplan is a non-existent decoy agent (although he is in fact indirectly explaining to the spectator who Kaplan is). This scene comes between the shot of Thornhill escaping from the UN and his arrival at Grand Central Station. In other words, the scene 'interrupts' Thornhill's escape, for we can easily imagine the scene at the train station directly following his escape from the UN.

- ▶ The fifth major moment of omniscient narration is when a cashier at the train station looks at a news photo of Thornhill and then telephones the police. But in this instance, Thornhill has guessed the additional information that the spectator is privileged to see, for Thornhill turns away from the window before the cashier returns.
- ▶ The next moment occurs on the train, when Thornhill meets Eve. In Eve's compartment, Thornhill hides in the washroom while the porter makes up the bed. The camera remains with Thornhill in the washroom. But afterwards, we see the porter carrying a message to Vandamm. Here, the narration has become omniscient, for the camera has disengaged from Thornhill in order to provide the spectator with additional information, namely, that Eve is working with Vandamm. Yet the narration is not being completely omniscient at this stage in the film, it does not reveal the true identity of Eve (a CIA agent).

There are a few other moments of omniscient narration: when Eve telephones Leonard (Vandamm's right-hand man) at Chicago train station when Thornhill is, again, in the washroom having a shave; there are two shots of the professor at the auction; and, finally, the shots of Eve and Vandamm walking towards the plane near the end of the film while Thornhill is still in the house.

These are the major moments in the film when omniscient narration dominates. Their primary aim is to create suspense; they create suspense because the spectator knows more than Thornhill, and is anticipating how Thornhill will react to this situation.

OMNISCIENT NARRATION IN MAGNIFICENT OBSESSION

In opposition to restricted narration, a film based predominantly on omniscient narration presents the spectator with a wide breadth of narrative information. This is achieved by the narration shifting from one character to another, so that narrative information is conveyed to the spectator from many sources. This type of narration is commonly used in melodramas and television soap operas, in order to create a discrepancy in knowledge between the spectator and characters.

Like the moments of omniscient narration in *North by Northwest*, the spectator of melodrama is presented with more narrative information than any one character can possibly know. However, unlike melodrama, *North by Northwest* is not based on the systematic use of omniscient narration. The purpose of systematically employing omniscient narration in melodrama and television soap operas is to create a plethora of dramatic scenes where characters find out what the spectator already knows.

To illustrate how omniscient narration is systematically used in melodramas, I shall analyse Douglas Sirk's film Magnificent Obsession. As with most melodramas, Magnificent Obsession narrates the story of more than one character. The film begins with Bob Merrick (Rock Hudson), a rich playboy testing his speedboat on a lake. The boat crashes and he has to be revived with the help of a neighbour's resuscitator. However, while the resuscitator is being used on Merrick, its owner Dr Wayne Phillips, has a heart attack and dies. Merrick is admitted to the hospital run by the late Dr Phillips. Merrick discharges himself. from the hospital and tries to walk home. He is given a lift by Helen (Jane Wyman), the widow of Dr Phillips. At first, the two do not recognize one another. But Merrick soon discovers who Helen is. He collapses and Helen takes him back to the hospital. It is only then that she finds out who he is. The rest of the film narrates the interrelation between Merrick and Helen Phillips and the transformations they undergo. Helen, at first, hates Merrick because he indirectly killed her husband but Merrick has fallen in love with Helen. In a scene where he attempts to express his love to her, she is run down by a car and blinded (remember this is a melodrama!). Doctors proclaim that she will never see again. On a trip to Europe, Helen decides to disappear (aided by her best friend, Joyce). Meanwhile Merrick, a former medical student, gives up his playboy lifestyle and returns to medical school, eventually setting up his own hospital. Finally, Joyce telephones Merrick to tell him that Helen is living in New Mexico and is extremely ill. Merrick visits her and performs an operation on her eyes. When she awakes, she regains her sight. They are then united as a couple.

We shall look at how omniscient narration structures the first 15 minutes of the film. Once Merrick is revived after his accident, the police take the resuscitator back to Dr Phillips. The film then follows the trauma of the Phillips family as they discover that Dr Phillips has died while his resuscitator was being used by Merrick. The film is therefore shifted from one story (that of Merrick) to another (that of the Phillips family).

The following scene takes place in the hospital, where Merrick is recovering. A discrepancy of knowledge exists in this scene because, unlike the spectator and the other characters, Merrick does not know that Dr Phillips has died, nor does he know he was the cause of his death. In the middle of the scene he is eventually told about Dr Phillips's death, thus reducing some of the discrepancy in knowledge. But crucially, he does not know how Dr Phillips died.

Merrick leaves the hospital and begins to walk home. He is picked up by Helen as she drives from the hospital. The discrepancy in knowledge at work in this scene is more pronounced than in the scene in the hospital. At first, Helen and Merrick do not know one another, whereas the spectator knows both of them. As soon as she tells him who she is and how her husband died, we see Merrick in a close-up shot, as he reacts to what the spectator already knows. The discrepancy of knowledge between Merrick and the spectator is overcome as he now shares the same amount of narrative information as the spectator.

However, Helen still does not know the identity of the man she has picked up. After he collapses, she takes him back to the hospital, where she is told that he is Merrick. The discrepancy in knowledge between Helen and the spectator is finally overcome.

The scenes in the hospital and in the car (as well as many subsequent scenes in the film) are based on omniscient narration. The scene in the car creates dramatic suspense as the spectator waits to see how the characters will react to one another once they discover each other's identity. Merrick collapses when he finds out Helen's identity and, later, Helen is shocked when she finally discovers that she drove Merrick to the hospital. Later in the film, after Helen is blinded, this

discrepancy in knowledge is revived when Merrick visits Helen but pretends to be someone else. The spectator, of course, knows his real identity, whereas Helen does not initially know who he is, thus leading to additional scenes of dramatic suspense.

NARRATIVE CHRONOLOGY IN PULP FICTION

One of the dominant characteristics of *Pulp Fiction* in terms of narrative is the non-linear ordering of its events. In this respect it is similar to Stanley Kubrick's *The Killing* (1956) and, more recently, David Lynch's *Lost Highway* (1997) and Christopher Nolan's *Memento* (2000) in the way it radically alters the sequence in which the events are presented.

Spotlight

Christopher Nolan's film *Memento* (2000) is a very good example of what we can call a 'puzzle film'. It is a puzzle because its narration tells its story in a complex way – backwards! 'Because the film moves backward', writes Stefano Ghislotti, 'the viewer is progressively obliged to put the scenes into the right order: but it is really difficult to follow the flow of events while simultaneously recalling the events already seen, and putting everything into a coherent sequence. These difficulties involve a more general question: is it possible to understand a narration in which time and causality are reversed?' (Stefano Ghislotti, in Buckland (ed.), 2009, p. 88).

In the following analysis I shall attempt to discern the exact chronology of the events in *Pulp Fiction*.

Firstly, the events rendered chronologically (not how they appear in the film) are:

- 1 Captain Koons (Christopher Walken) presents a gold watch to the young Butch Coolidge; the watch is a gift from Butch's father, who died in a prisoner-of-war camp. This sequence, coded as Butch's memory, occurs about 20 years prior to all the other events that take place in the film.
- 2 (a) Vincent Vega (John Travolta) and Jules Winnfield (Samuel L. Jackson), two hit men, carry out a job for mobster

- Marsellus Wallace (Ving Rhames). They retrieve a valuable case from four 'business partners' who tried to double-cross Marsellus. Two of the partners are shot.
- (b) After shooting the two partners, Vincent and Jules escape injury when another one of the partners rushes into the room and shoots at them. Vincent and Jules shoot him and take the fourth partner (Marvin) with them.
- 3 In the car, Vincent accidentally shoots Marvin and both Vincent and Jules have to clean up both the car and themselves.
- 4 (a) In a restaurant, Honey Bunny (Amanda Plummer) and Pumpkin (Tim Roth) talk about their previous heist jobs. They decide to hold up the restaurant they are occupying.
 - (b) Vincent and Jules enter the restaurant, before it is held up, and Jules talks about quitting his job. As Honey Bunny and Pumpkin rob the restaurant, there is a standoff between them and Vincent and Jules. Vincent and Jules convince Honey Bunny and Pumpkin to leave the restaurant. Vincent and Jules then leave the restaurant with the case.
- 5 The boxer Butch Coolidge (Bruce Willis) is seen talking to Marsellus in Marsellus's bar. Marsellus pays Butch to throw a boxing match. Vincent and Jules enter the bar with the case. Vincent buys some drugs, then takes out Marsellus's wife Mia (Uma Thurman) for the evening (at Marsellus's request). She takes Vincent's drugs and becomes ill. Vincent is able to revive her.
- 6 Butch is in his dressing room, thinking about his father's watch (scene 1). He decides not to throw the fight and, after winning, escapes from the city. However, he has to return to his apartment the next day to retrieve his watch. Vincent is waiting inside but Butch kills him. Butch then, literally, runs into Marsellus. After a chase, both are trapped in a basement by two deviant homosexuals. Butch manages to escape, sets Marsellus free and therefore cancels their debt.

Secondly, these events are presented in *Pulp Fiction* in the following order:
- 4 a) The pre-credit sequence where Honey Bunny and Pumpkin talk about their previous heist jobs; the scene ends with both of them pulling out their guns in preparation to rob the restaurant; credit sequence
- 2 a) Vincent and Jules go to retrieve the case for Marsellus
- 5 Butch and Marsellus; Vincent and Jules enter
- 1 Butch receiving his father's watch
- 6 Butch winning the fight, killing Vincent, gets even with Marsellus
- 2 b) The end of segment 2, of Vincent and Jules retrieving the case
- 3 Vincent kills Marvin
- 4 b) Vincent and Jules in the restaurant held up by Honey Bunny and Pumpkin.

The causal relation between the pre-credit sequence and 2a) remains unexplained until the end of the film. Furthermore, the spectator does not realize that the film has moved backwards in time from the pre-credit sequence to 2a) because, in the pre-credit sequence, Vincent and Jules are also in the restaurant after retrieving the case, although we do not see them in the restaurant until the end of the film.

There does not seem to be a major ellipsis between 2a) and 5. The only sign that suggests that Vincent and Jules have not come directly from the apartment is their change of clothes. This remains unexplained but does not appear to be significant. Segment 5 begins with Butch (talking to Marsellus) and so do segments 1 and 6. Segment 1 is retrospectively coded as Butch's memory, as he prepares (beginning of segment 6) for the fight that Marsellus has paid him to throw. After Butch has escaped from the basement, it is not evident that this is the last action that takes place in the film's chronology.

When the film returns to the apartment where Vincent and Jules retrieve the case, the transition is quite marked, not least because we saw Butch kill Vincent in the previous segment, and we thought that the events in the apartment had been resolved. But instead, we come to realize that the path from Vincent

and Jules retrieving the case to them returning it to Marsellus was far from straight. The intervening events explain both the change in clothes and link up the Honey Bunny and Pumpkin story with the Vincent and Jules story, therefore finally placing the pre-credit sequence within the film's cause—effect logic. We also come to realize that the pre-credit sequence and the sequence with Vincent and Jules in the restaurant talking to one another take place at the same time, even though they are shown at different times in the film.

Moreover, there is a systematic structure to the film's non-linearity. The film begins with events in segment 4; it jumps back to segment 2; jumps forward again to 5; it then jumps right back to 1 before jumping to the end events in 6. Finally, it jumps back to events in segment 2, picks up where it left off and then progresses chronologically to segment 4, where it began.

The film's chronology therefore begins and ends with events that take place in the middle (segment 4). It then jumps backwards and forwards, in wider and wider arcs until it returns to 2 and moves along to the events it began with. That the film jumps backwards and forwards in wider and wider arcs can be illustrated with a series of diagrams:

As you can see from these two diagrams, the movement between one segment and another is equal, but the movement in the second diagram is more encompassing. From 2 to 5, the film

then moves back to the events before 2 and then moves forward to the events after 5 (1 and 6). From 6, the film then returns to 2 and ends where it began, at 4.

Although the chronology of *Pulp Fiction* is an extreme example, its complexity evidently did not detract from the film's huge popularity. However, whatever we make of *Pulp Fiction*, I hope to have shown that it is not structured randomly, but according to a definite pattern. By concentrating on the chronology and cause-and-effect logic of *Pulp Fiction*, we can begin to understand that films do not need to represent the cause-and-effect logic of a film in chronological order. Returning to *Psycho*, it would after all have been perfectly logical for Marion to steal the \$40,000 first before any exposition or causes were given.

THE NARRATIVE AND NARRATION OF MULHOLLAND DR.

We shall end by applying what we have learnt about narrative and narration in this chapter to David Lynch's Mulholland Dr. (2001), a complex and mysterious film that pushes narrative and narration to – and beyond – their limits. This film gained immediate critical success on its release. Lynch won the Best Director category at the Cannes Film Festival, and he received an Oscar nomination for Best Director. He was also voted Best Director by four Film Critics Associations: Boston, Chicago, Los Angeles and Toronto. The film itself received the Best Film award from the Chicago and New York Film Critics, and in France it also won a César for best foreign picture. The following analysis assumes you have already viewed the film, and mixes a description of the plot (which is often difficult to untangle) with narrative analysis.

Mulholland Dr. is divided into two main sections: the first, which can plausibly be coded as a dream (1 hour 56 minutes), and the final 25 minutes. These two sections are separated by a perplexing set of incidents. Important events in the first (the dream) section are repeated in the final section. However, these are repetitions with differences: different characters repeat the same actions, and these different characters are played by the same actors. Furthermore, the important events in the dream sequence seem to be mysterious, but there is a

more mundane repetition of them in the second section. So, if something appears significant but mysterious in the first section of the film, one way to make sense of it is to look for a more ordinary representation of it in the second section. As well as summarizing the film's plot and analysing its narrative, we shall examine the repetition of events. We shall see that repetition replaces the logic of cause and effect as a way of creating textual coherence across the film. For although *Mulholland Dr.* may seem mysterious, it is structured according to an internally consistent logic.

The most noticeable repetitions focus on the two lead actresses. Actress Naomi Watts plays Betty in the first section of the film, Diane in the second section. Actress Laura Harring plays the 'dark-haired woman' (later named 'Rita') in the first section, Camilla Rhodes in the second. Other repetitions involve the recurrence of the same action, event or piece of dialogue, but in a different context. The spectator needs to link up these repetitions to make sense of them, to work out their meaning. It is only when an event is repeated much later in the film that its first appearance makes sense. When watching Mulholland Dr., events that appear meaningless at the beginning gradually make sense as we continue watching. We therefore revise our initial experiences according to what happens later in the film.

The film begins with a jitterbug dance contest. This dancing is not filmed in a straightforward manner. Instead, it consists of a series of superimposed images of dancers. Over these images are superimposed a further set of images, of Betty accompanied by what we can assume are her parents. Additionally, these images of Betty and her parents are overexposed and out of focus, and have been filmed with a jittery camera. The film therefore begins with heavily stylized images.

Only later do we discover the significance of this opening scene. Similar images of Betty and her parents are repeated later in the film, when Betty arrives at Los Angeles Airport. And much later, in the second section of the film, we discover that Diane won a jitterbug contest, which led to acting in Hollywood. The spectator therefore eventually receives the back story behind and motivation for these opening shots.

The first section of the film, Diane's dream, begins with a point-of-view shot of Diane going to sleep, and ends when 'the Cowboy' tells her to wake up. She dreams of herself in exaggerated terms, as the young, naive, blonde star-struck Betty, and she dreams of her lover, Camilla Rhodes, as a dark mysterious woman called Rita.

The point-of-view shot is a privileged example of restricted narration, since the narrative is literally filtered through the vision of one character. We share Diane's vision as she heads towards her bed with red sheets, and we hear her breathing off-screen. Everything except the bed is out of focus. Additional out-of-focus images of Betty and her parents are superimposed over this point-of-view shot, combined with flashes of light and jittery camera movement. These devices (out-of-focus shots, flashing lights, jittery camera, restricted view) can be read as representing a character's consciousness. What we have seen up to now can therefore be motivated by character psychology. We can guess that the opening jitterbug dance scene is somehow linked to this person whose point of view we share.

As the camera approaches the pillow, the screen goes black, representing this unseen character's loss of consciousness. As the film fades up from black, we see a road sign for Mulholland Dr. The sign shimmers as light flashes on and off it, creating occasional overexposure. This shot of the sign is followed by a Cadillac driving along Mulholland Dr. at night with its headlamps on. The headlamps are the cause of the sign's shimmering; the shimmering is the effect (the effect is therefore motivated). The credits themselves shimmer, as if light is being shone on them. The film's proper beginning, its credit sequence, is 'born from' the blackness, from the character's loss of consciousness, or her entry into sleep and dream state. Lynch is equating his film with the dream state of a character in the film.

The Cadillac seems to float along Mulholland Dr. The dark-haired woman is in the back of the Cadillac, and we occasionally share her point-of-view shots of the road ahead. This scene is repeated in the film's second section, but with Diane sitting in the back. The shots are literally filmed in exactly the same way, creating an uncanny echo.

The Cadillac driver stops the car. The dark-haired woman says: 'What are you doing? We don't stop here.' He then orders her out of the car. There is a sudden moment of omniscient narration, as the director gives us more information than any of the characters knows: two cars are drag racing along Mulholland Dr. The drag racers do not know that the Cadillac is ahead, and the people in the Cadillac do not know that the drag racers are heading towards them. Only the spectator knows about both events.

The driver turns around and points a gun at the dark-haired woman. This gesture (and the dark-haired woman's line) are repeated in the film's second section, except that Diane is in the back of the car, and the driver has no gun. As the dark-haired woman is ordered out of the car, the drag racers' headlamps shine onto her face, overexposing the image. One of the drag racing cars collides with the Cadillac. After the cars have crashed, smoke gradually fills the space. The image of smoke filling the screen is repeated in the Silencio club and at the film's end, after Diane shoots herself.

Both the threat to the dark-haired woman's life and the car crash constitute a turning point that shifts the film's narrative into disequilibrium, an imbalance that needs to be addressed, and which can be formulated into a series of questions: Who is this woman? Why is her life being threatened? Who is threatening her life? How has the crash affected her? These questions signify dangling causes that are partially addressed as the film progresses. We later discover the dark-haired woman has lost her memory, which creates obstacles to the simple answering of these questions. The lack of answers and the partially unresolved dangling causes are therefore motivated by the dark-haired woman's amnesia.

This also leads to another important point, concerning the absence of the narrative elements outlined earlier in this chapter. The most notable absence, at least from the film's opening, is exposition. The spectator has to wait over two hours before most of the exposition is presented (in the scene where Diane goes to dinner with Camilla and the director, Adam Kesher, and immediately afterwards, when Diane meets the hit man Joe in Winkies restaurant).

But back to the film's beginning. The dark-haired woman survives the car crash and stumbles towards Los Angeles. On Franklin Street, the motifs of the headlamps and overexposed image are repeated. The dark-haired woman then falls asleep under some bushes (outside Ruth's apartment). This image of her sleeping is repeated on several occasions in the first section of the film. Note what is happening here: in Diane's dream, the dark-haired woman falls asleep.

The next scene takes place in Winkies. When this scene ends, we return to the dark-haired woman, still asleep. This gives the impression that the scene in Winkies is the dark-haired woman's dream. The content of the scene is also about dreaming. Dan and Herb sit at a table in Winkies talking about dreams. Dan recounts a dream about a frightening man behind the restaurant. The recounted dream seems to come real, because the man is shown to be behind the wall. His appearance literally frightens Dan to death. It is difficult to connect this scene to others, since neither Dan nor Herb play prominent roles in the film (Dan only makes a second fleeting appearance towards the end). There is no exposition, nor any cause–effect links between this and other scenes.

However, we do return to this restaurant on two occasions — when Rita and Betty enter, and when Diane hires the hit man. Towards the end of the film, we also return to the man behind the restaurant. The significance of this scene seems to lie in the fact that it is about dreams coming true. The scene is a fragment of Diane's dream. Diane is dreaming of her lover (Rita in the dream, Camilla outside it), and she dreams that her lover is falling asleep, dreaming of two men, Dan and Herb, in a restaurant who are talking about dreams! Dan's dream comes true and, as we shall see later, Diane's dream also comes true.

The next scene consists of fragments of a series of phone calls between the midget, Mr Roque; a Mexican man; a man in rundown lodgings (in the credits he is the 'hairy arm man'); and Diane's phone – but only in the second section, when this image is repeated, do we realize it is her phone. Diane's phone rings three times, but she does not answer.

The next scene depicts Betty arriving at Los Angeles Airport. Notice the sound bridge from the previous scene: the ringing phone continues over the cut, but it is distorted, and can be heard over the image of Betty. Remember, this is Diane's phone that is ringing; it is attempting to summon Diane. Instead, it summons Betty (who is Diane's exaggerated alter ego in the dream). Betty indirectly 'responds' to the telephone ringing, that is, she appears when Diane's telephone rings. However, this is a very tenuous link between scenes. This is also the first time we see Betty since the jitterbug scene. She appears with her parents (although she does not address them as her parents).

Betty meets Mrs Lanois, the concierge, at her aunt Ruth's apartment. Mrs Lanois says, 'Just call me Coco, everybody else does.' Coco repeats this line to Diane in the film's second section, when we discover that Coco is in fact Adam Kesher's mother.

Betty enters Ruth's apartment, and meets the dark-haired woman. We already know that the dark-haired woman is in the apartment, whereas Betty does not. This is a moment of omniscient narration. Betty meets the dark-haired woman while she is in the shower, naked and vulnerable. The darkhaired woman cannot remember her name, so she takes the name from a film poster in the bathroom - Rita Hayworth's name, from a poster for the famous film noir Gilda. Notice how the appropriation takes place: we have the dark-haired woman's point-of-view shot, not of the poster as such, but of the poster as reflected in the mirror. The camera then moves into the mirror image. Like Alice in Wonderland, the dark-haired woman seems to enter the looking glass and emerge as a new character, Rita. She is a mysterious woman who is vulnerable, naked, an amnesiac and injured. She has no past or identity. If we believe this section of the film to be Diane's dream, then Diane is constructing an idealized image of her lover, Camilla.

Why Rita Hayworth in *Gilda*? This is not an arbitrary choice, but is motivated on several levels. Both Rita Hayworth and Laura Harring are Latino women who also look Anglo. Indeed, Rita Hayworth went through a dramatic transformation when she entered Hollywood. Most of her Latino appearance was disguised. But, beyond comparisons between the two actresses,

there are also similarities between the two characters they play. In *Gilda*, the character of Gilda hastily marries a man, and tells him that she was born the moment she met him, that she has no past. In *Mulholland Dr.*, Rita is also constructed as a woman with no past, who seems to be born the moment Betty meets her.

After Rita exits the shower, she talks to Betty, and we get some exposition, or back story, about Betty's past. Betty assumes that Rita is a friend of aunt Ruth. Rita then falls asleep again. In Diane's dream, her lover is passive, and is always falling asleep.

In the next scene, set in a boardroom, the character of Adam Kesher, the film director, is introduced. There is some narrative development – the lead actress of Adam's film needs to be recast, for his lead actress has disappeared.

In the boardroom, the meeting is chaired by Ray Hott, president of production. The Castigliane brothers, who seem to 'own' Adam's film, enter the boardroom and insist that a newcomer, called Camilla Rhodes (but who looks like Betty – identities are becoming mixed!), should play the part. Luigi Castigliane's comment and the action taking place at the same time are significant: Luigi comments 'This is the girl', while Camilla's résumé photo is passed around. This is a significant action, which is repeated in the film's second section: in Winkies, Diane gives Joe (the hit man) a résumé photo of Camilla Rhodes and says 'This is the girl' (to be killed). However, the résumé photo is of Camilla Rhodes as played by Laura Harring. At this point in the dream, Diane is dreaming of the moment she hired Joe to kill her lover.

During the boardroom meeting, Adam rejects the imposition of this new actress in his film, thereby creating an obstacle. We also cut to Mr Roque in his sparse, air-purified room. We saw him once before in the telephone sequence. He can hear the boardroom conversation, and we assume most of the people there do not know that he can hear. This shot is therefore omniscient, although later we discover that Ray knew that Mr Roque was listening. After the board meeting, Adam damages the Castigliane brothers' car and then drives off.

After one shot of Betty checking Rita, who is still asleep, we cut to Ray talking to Mr Roque. They decide to shut down the

movie. This, of course, is another obstacle in the way of this new character (Adam) achieving his goal.

The next scene introduces yet more characters and a new location: Joe (the hit man) and Ed, a businessman. They seem to be talking about Rita's car accident, although it is unclear. Unexpectedly, Joe kills Ed and steals his black book of phone numbers (in an attempt to find Rita?). But there is insufficient exposition or character motivation to explain what is happening in this scene, and the dangling causes are not sufficiently addressed or resolved later in the film.

The next scene returns us to Betty and Rita. Betty finds out that her aunt Ruth does not know anyone called Rita. Rita wakes up, and in an attempt to find out who she is, opens her bag, to find it contains \$125,000, plus a blue key. These are mysterious and significant dangling causes, which are repeated in the second section of the film – in Winkies, when Diane is hiring Joe to kill Camilla. She opens her bag to reveal the payoff. He then shows her a blue key, and says he will leave it in a certain place to indicate when he has killed Camilla. These repetitions are therefore of events that are significant in Diane's life, particularly her plan to hire a killer to murder Camilla. The second occurrence of these events provides indirect resolution, as we belatedly realize that the money in Rita's purse is Joe's pay-off to kill her.

In subsequent scenes, Adam finds out his film set has been closed down, goes home and discovers his wife is having an affair with the pool man, while Betty and Rita hide the \$125,000 and go to Winkies (the film's second visit to this location). The waitress is called Diane, and looks like Betty on a bad day. Rita begins to remember something, and thinks that her real name might be Diane Selwyn. This is the first lead the two women can follow concerning Rita's real identity. Rita and Betty go back to Ruth's apartment, look in the phone book, and call Diane Selwyn, thinking that it might be Rita's real name. Betty says, 'It's strange to be calling yourself' to which Rita replies, 'Maybe it's not me.' They only get the answer phone message, 'It's me. Leave a message.' Betty's comment ('It's strange to be calling yourself') is, of course, significant, since it is Betty who is calling herself.

The Castigliane brothers (in a new Cadillac) turn up at Adam's house and send in a heavyweight bodyguard. But Adam has already left. This scene is causally linked with the scene where Adam damages the Castigliane brothers' car, since the brothers have sent in a bodyguard to sort him out.

Adam, who is hiding in a run-down hotel, speaks to his secretary, Cynthia, on the phone, who asks him to meet with 'the Cowboy'. When they meet, the Cowboy asks Adam to select (the blonde) Camilla Rhodes for the lead in his film. Note the 'flickering light' motif that begins and ends the conversation, and the Cowboy's sudden disappearance, giving the impression that he does not exist. The identity of this real or imaginary Cowboy becomes another unresolved dangling cause. He knows a great deal about Adam's predicament, but we do not find out where he gets his information from, or who he is in league with. He simply appears from and disappears into the darkness.

Betty prepares for her audition the following day (one of the film's few deadlines), and she and Rita rehearse Betty's lines. At first it seems as if the two of them are having a conversation about their own situation, but it soon transpires that they are rehearsing. However, the lines do indirectly refer to their situation:

Betty: You're still here?

Rita: I came back. I thought that's what you wanted.

Betty: No one wants you here!

Only after this line is uttered does the spectator realize that Rita and Betty are rehearsing. This is a very significant moment in the film, on several levels. Firstly, the lines suggest that Betty has tired of Rita, and wants her out of the apartment. Secondly, and more importantly, the lines also refer to Diane and Camilla's relationship in the film's second section (but we can only retrospectively read this into the scene). However, in their relationship it is Camilla who tires of Diane. What has happened is that, in her dream, Diane has reversed the power dynamics between her and Camilla. A later part of the rehearsal involves Betty threatening Rita's life, a threat Diane carries out against Camilla.

At her audition, Betty does well and is liked by everyone except the director, Bob Brooker. Betty is then taken to Adam's film set, where he is recasting his lead actress. There is an intense exchange of gazes between Adam and Betty. The blonde Camilla Rhodes auditions and Adam utters, 'This is the girl.' Betty leaves the set to return to Rita, and both go to Diane Selwyn's apartment.

Rita and Betty break into the apartment and find Diane dead in bed (the same bed with red sheets that appears in the shot immediately before the credit sequence). This scene represents the part of Diane's dream where she fantasizes that she has killed herself. Those who fantasize about suicide think about what they would look like when found dead, who would find them, how close friends and lovers would react. When Rita and Betty find Diane, Betty (representing Diane) is witnessing her own suicide. She finds out what she would look like, how she would be found, and how her former lover Rita/Camilla would react. The aim of the fantasy is to represent her lover in a guilty way, and as expressing remorse. Diane's neighbour, De Rosa, knocks on the door, but Rita and Betty do not respond. Several images from this scene are repeated later (when the film segues into its second section): the image of Diane dead in bed, the knocking, and Betty's point of view as she slowly walks along the dark corridor leading up to Diane's bedroom.

Back in Ruth's apartment. Rita believes that Diane's death is in some way related to her past and that she will be next. So she puts on a blonde wig for disguise, creating a superficial likeness between her and Betty. Diane's death is the cause of Rita's change of appearance. Betty and Rita then express their mutual love in a lesbian love scene.

Betty and Rita wake up at 2 a.m. The image of them in bed resembles an image from Ingmar Bergman's film *Persona*, another film about the strong relationship between two women. Rita starts to speak Spanish, and has an urgent need to leave. Both of them go to the Silencio club.

As they hail a cab, the image goes out of focus, and in the Silencio club, the motif of flashing lights is repeated, together with smoke. Betty reacts violently to the flashing lights. The

performances at the club indicate the illusionistic relation between sound and image. Roy Orbison's song *Crying* is sung in Spanish, and serves as exposition to the break-up of the relationship outside the dream between Camilla and Diane. Finally, Diane finds a mysterious blue box in her purse.

Back at the apartment, Betty inexplicably disappears from Ruth's bedroom. Rita opens the blue box with the blue key and also disappears. Ruth then enters the bedroom, but finds nothing unusual, and leaves.

This (and the next scene) is the most perplexing in the whole film. It constitutes another turning point in the film, as the film radically changes protagonists and direction, although it gradually begins to repeat what happened previously. This scene resembles the moment in Lynch's *Lost Highway* when Fred Madison, in solitary confinement in prison, inexplicably transforms into Pete Dayton. At this point *Lost Highway* also radically changes protagonists and direction, and also gradually begins to repeat what happened previously.

The blue key is explained in the second section of the film. It is a sign that Joe has killed Camilla. The shot of Rita opening the blue box with the key therefore signifies Camilla's death. The blue key is a sign to Diane that Camilla has been killed, and the empty darkness inside the blue box represents Camilla's death. This moment in the film is a major turning point, since we suddenly lose the two characters who have propelled the film forward. Both have gone through a radical transformation (they have disappeared). The camera no longer filters the narrative through the vision of the characters. Instead, the director's vision becomes prominent. The camera begins to wander around in an attempt to attach itself to another character, in much the same way as Hitchcock's camera in Psycho is disengaged from Marion, after she has been murdered in the shower, and wanders around her room, until Norman enters. The camera then attaches itself to him.

The scene dissolves from the hallway in Ruth's apartment to the hallway in Diane's apartment. But it then dissolves back again. This is a very 'self-conscious' moment in the film, as if the director cannot decide which location to film. The dissolve takes place once more from Ruth's hallway to Diane's. The shot of Diane's hallway is in fact a repetition of Betty's point-of-view shot as she approached Diane's bedroom. Betty may have disappeared, but her point-of-view shot remains and is repeated.

This transitional scene contains three shots of Diane: she adopts the same pose in all three, but in two of the shots she is sleeping, and in the second (middle) shot she is dead (a repetition of Betty's point-of-view shot discovering the dead Diane). The Cowboy appears and tells Diane to wake up. When he leaves, we hear the sound of knocking, and Diane wakes up. The camera attaches itself to this 'new' character.

This first section of the film, although shown first, is a dream representation of events that take place in the second section. The first section, the dream, begins to make sense once we see what events it is representing. The chronology of the film has been reversed (unless we believe that the dream is a premonition of events that are going to happen).

When we see Diane for the third time, she finally wakes up (to the sound of the knocking), and lets in her neighbour, De Rosa, who takes her belongings, including an ashtray. As she does so, we get a close-up of a blue key. One implication here is that Diane and De Rosa shared the apartment, had a casual lesbian relationship, but are now living in separate apartments. The blue key is shown outside the dream, but is still not explained. Later we discover that Joe placed it there after supposedly killing Camilla. In this instance, the image of the blue key has to be shown three times in total, before it makes sense.

As De Rosa leaves, she tells Diane that two detectives are looking for her. Diane makes coffee and has hallucinations about Camilla being present in the room. In one hallucination, Diane's coffee suddenly transforms into a glass of whisky, and De Rosa's ashtray is shown to be back on the table, indicating that the hallucination is also a memory of past events. Diane's hallucinations therefore break the film's chronology, but this break is motivated psychologically, as we share Diane's hallucinations. Diane begins to make love to Camilla, but Camilla asks her to stop, and tries to break off the relationship. This conflict takes the spectator back to two moments in the

film: 1) The Silencio club, in which Roy Orbison's lyrics to *Crying*, and why they are sung in Spanish in the film, take on meaning: the Latino Camilla is trying to break off her relationship with Diane. 2) The conflict takes us further back, to the moment Betty and Rita rehearsed Betty's lines. Those scripted lines indirectly refer to this moment. The scene ends with Diane saying, 'It's him, isn't it?'

Cut to a film set, with Adam directing Camilla in a scene, and then kissing Camilla as Diane watches. The temporal relation between this scene and the previous scene is unclear. Is this a memory image? The two scenes are primarily linked by Diane's dialogue hook: she says, 'It's him' at the end of one scene, and 'him' (Adam) is shown in the next scene.

Diane finds herself alone in her apartment, and masturbates. Her point-of-view image goes out of focus, and she is interrupted by the telephone ringing. We then cut to the ringing telephone, a repetition of the final shot in the sequence of telephone shots near the film's beginning. The answerphone message is the same as the one Betty and Rita hear when they phone up Diane Selwyn: 'It's me. Leave a message.' Diane then appears, but is dressed differently from the way she was dressed previously. The phone ringing in this scene is not a continuation of the phone ringing in the previous scene, even though the editing and ringing sound give the impression that there is continuity. Diane picks up the phone and speaks to Camilla. Diane is to be driven in a Cadillac to Camilla's dinner party. The destination is Mulholland Dr.

The image of the phone ringing is just one of many repetitions that begin to inundate the film from this point onwards. The Cadillac that drives Diane to the dinner party lights up the sign for Mulholland Dr. and glides along the road in the same way it did in the credit sequence. Diane is shown in the back of the Cadillac. She is filmed in exactly the same way that the darkhaired woman was filmed in the credit sequence. As with the car in that sequence, this one suddenly stops, and Diane repeats the words the darkhaired woman uttered: 'What are you doing?' We don't stop here.' The driver turns around, just like the driver in the credit sequence. However, he does not have a gun.

He simply informs Diane of 'a surprise'. Camilla then appears suddenly from a concealed entrance to a pathway, and takes Diane up to the house.

They meet Adam Kesher, and then Coco, who utters the same line she did when she first appeared in Diane's dream: 'Just call me Coco. Everybody else does.' However, she is now Adam's mother, not the concierge of an apartment complex.

The dinner scene begins out of focus. Its coming into focus is coordinated with a drum roll on the soundtrack. This scene offers exposition and numerous links to previous scenes, as Diane speaks about her past: she won a jitterbug contest; she inherited some money from her aunt Ruth, so she came to Hollywood to try to make a career as a movie star; she auditioned for the lead in a film called The Sylvia North Story, but Camilla got the part because the director Bob Brooker did not like Diane's performance; she then made friends with Camilla. Other links: the blonde Camilla Rhodes who appeared in the photo in the boardroom scene and in Adam's recasting of his lead later in the film turns up and kisses Camilla in front of Diane. Diane drinks some coffee, looks up, and sees Luigi Castigliane. The Cowboy then walks past in the background. Diane becomes agitated as Camilla kisses Adam (soon after kissing the blonde Camilla). In these few minutes, Diane becomes paranoid, and believes that everyone she sees at the dinner is conspiring against her. This is why they all reappear in her dream (section one of the film) and this is the moment Diane decides to kill Camilla. Diane hears a loud sound and turns around.

We suddenly find ourselves in Winkies (the third visit to this location). Diane hears a sound and turns around. The transition from the previous scene to this one takes place on a match on action cut: at the end of the previous scene, and the beginning of this scene, Diane performs the same action, of suddenly turning around to locate the source of a loud noise, but the location has suddenly changed. Diane is now in Winkies with Joe, the hired killer.

This is a key scene, with concentrated exposition and another turning point. Diane changes direction, for she is hiring a killer to eliminate Camilla. The waitress 'Betty' in Winkies serves Diane coffee. This is a repetition of the action in the second visit to Winkies, in which the same waitress – but who was called Diane – serves coffee to Betty while she is sitting in the same place with Rita.

Diane then passes a résumé photo to Joe and says at the same time, 'This is the girl.' This is a repetition of events in the boardroom, when the Castigliane brothers pass out a photo of the blonde Camilla Rhodes and say, 'This is the girl.' The blonde Camilla is an amalgam of Diane (her appearance) and Camilla (her name), and the boardroom scene is Diane's dream distortion of this moment in Winkies.

Diane then opens her bag to show Joe that she has the money to pay him. (This is probably the money Diane inherited from aunt Ruth.) Joe then shows Diane a blue key, and says he will leave it with her once the job is done. In other words, the money and the blue key exist in a symbiotic relationship: they exchange for one another. The money and blue key are linked in the scene in Diane's dream when Rita opens her bag to find that it contains \$125,000, plus a blue key. The dangling cause presented in the film's first section is now given significance (if not clarity of meaning). Diane looks up and sees Dan, from the first scene in Winkies. Joe also has in front of him Ed's black book that he killed for earlier in the film.

Finally, the scene ends with the camera going behind Winkies to show the homeless man holding the blue box that Betty found in her purse. The homeless man cannot open it, so he puts it in a paper bag and drops it on the ground. Miniature versions of Betty's 'parents' emerge from the bag, moving quickly. The reason why the homeless man, the blue box and Betty's parents are linked remains unclear. One can only guess that all three signify death – we have already surmised that the blue box represents Camilla's death; the homeless man's appearance literally kills Dan; and, in the film's next and final scene, the parents literally drive Diane to suicide.

In Diane's apartment. Diane stares at the blue key on the table. This scene seems to be a continuation of the scene much earlier, when De Rosa left and Diane made coffee and began having hallucinations about Camilla. We now know that the blue key

signifies Camilla's death. Diane hears knocking at the door. Her miniaturized 'parents' crawl under the door, grow to their normal size and then confront her. The room fills with blue flashing lights, and Diane goes insane. She runs into the bedroom and shoots herself. The room fills with smoke. The film ends on a montage sequence: a shot of the man behind Winkies; an overexposed shot of Betty happy; and a shot of the Silencio club, where a woman in a blue wig simply utters 'Silencio'.

Dig deeper

Bordwell, David, Narration in the Fiction Film (London: Routledge, 1985).

A long and wide-ranging book that discusses both how spectators comprehend narrative films, and various historical modes of narration (Hollywood cinema, Art cinema, Soviet cinema, the films of Jean-Luc Godard).

Branigan, Edward, *Narrative Comprehension and Film* (London: Routledge, 1992).

This book is similar in some respects to Bordwell's Narration in the Fiction Film, in that it discusses how narrative is comprehended by film spectators. However, Branigan's book focuses on more specific issues (such as 'levels of narration' and 'focalization') and discusses them in great detail; it is a very erudite, sophisticated and complex book.

Buckland, Warren (ed.), *Puzzle Films: Complex Storytelling in Contemporary Cinema* (Oxford: Wiley-Blackwell, 2009).

This volume identifies and analyses contemporary 'Puzzle Films' – a popular cycle of films from the 1990s that rejects classical storytelling techniques and replaces them with complex storytelling. Films include Lost Highway, Memento, Charlie Kaufman's screenplays, Run Lola Run, Infernal Affairs, 2046, Suzhou River, The Day a Pig Fell into a Well and Oldbóy.

Buckland, Warren (ed.), *Hollywood Puzzle Films* (New York: Routledge, 2014).

A sequel to *Puzzle Films* (2009), focusing on contemporary Hollywood films that use techniques of complex storytelling,

including Inception (2010), Source Code (2011), The Butterfly Effect (2004), The Hours (2002) and films based on the science fiction of Philip K. Dick, including Minority Report (2002) and A Scanner Darkly (2006).

Thompson, Kristin, Storytelling in the New Hollywood: Understanding Classical Narrative Technique (Cambridge, Mass: Harvard University Press, 1999).

A detailed investigation into the narrative techniques used in contemporary Hollywood films. Thompson argues that contemporary Hollywood films use similar narrative techniques found in the classical period of Hollywood (1920s to the 1950s) – techniques that continue to create clear, unified narratives. She then presents detailed analyses of ten contemporary Hollywood films, ranging between Alien, Back to the Future and The Hunt for Red October.

Truffaut, François, *Hitchcock* (New York: Simon and Schuster, 1967). The most famous book on Alfred Hitchcock, based on more than 50 hours of interviews between Truffaut and Hitchcock.

Luton Sixth Form College Learning Resources Centre

Focus points

- * A narrative is a series of events related to one another in terms of a cause-effect logic.
- The cause-effect narrative logic is motivated by the needs and wishes of characters.
- * Narratives are structured in terms of a beginning (the initial state of equilibrium), a middle (disruption of the equilibrium) and an end (restoration of equilibrium).
- * The progression from initial equilibrium to the restoration of equilibrium always involves a transformation (usually of the film's main character).
- * The middle period of a narrative can be called liminal because it depicts actions that transgress everyday habits and routines.
- * In addition, film narratives are frequently structured using exposition, dangling causes, obstacles, deadlines and dialogue hooks.
- Narrative events are not necessarily presented in a linear, chronological order.
- * Narration refers to a mechanism that determines how narrative information is conveyed to the film spectator.
- There are two dominant modes of filmic narration: restricted narration and omniscient narration.
- * Restricted narration conveys the narrative to the spectator via one particular character (thus aligning the spectator to that character), leading to a sense of mystery.
- Omniscient narration shifts from one character to another, conveying narrative information to the spectator from many sources. This creates a discrepancy in knowledge between the spectator and characters, for the spectator knows more narrative information than any one character, creating scenes of dramatic suspense.
- Sometimes in omniscient narration, the camera will disengage itself completely from all characters. In this case, narration is directly controlled by someone outside the narrative – the director.

3

Film authorship: the director as auteur

In this chapter you will learn about:

- an historical account of how and why some film directors are raised to the level of artists or 'authors' (auteurs)
- the criteria critics use to raise a director to the status of an auteur, such as the stylistic and thematic consistency across their films
- how Jean-Luc Godard developed the concept of film director as auteur in his film criticism and early film-making, and then later rejected it when he became a committed political filmmaker
- an examination of the stylistic and thematic consistencies in the films of three well-known auteurs: Alfred Hitchcock, Wim Wenders and Kathryn Bigelow.

The director is both the least necessary and most important component of film-making. He is the most modern and most decadent of all artists in his relative passivity toward everything that passes before him. He would not be worth bothering with if he were not capable now and then of sublimity of expression almost miraculously extracted from his money-oriented environment.

Andrew Sarris, The American Cinema, p. 37

One aim of Chapter 1 was to introduce the ideas of *mise-en-scène* and *mise-en-shot*. These ideas are important for this chapter, so I shall briefly summarize them here:

- Mise-en-scène as it is used in this book refers to filmed events, what appears in front of the camera set design, lighting and character movement.
- Mise-en-shot designates the way the filmed events, the mise-en-scène, are translated into film images.

Spotlight

Most critics do not distinguish *mise-en-scène* from *mise-en-shot*, but are content to absorb *mise-en-shot* into *mise-en-scène*. However, this distinction is crucial when discussing the director as *auteur*, as this chapter will attempt to show.

Chapter 2 outlined the key structures of narrative and narration. It concentrated on the narrative's cause—effect logic and the difference between restricted narration (narration tied to one character only) and omniscient narration (narration that jumps from character to character, or which shows the spectator information that no character knows about).

In this chapter we shall see how individual directors use *mise-enscène*, *mise-en-shot*, and strategies of narrative and narration. In particular, we shall look at the rise of the critical approach to film known as the *auteur* policy (or *la politique des auteurs*, to use its original French name). The aim of the *auteur* policy is to assign to certain directors the title of artists, rather than thinking of them

as mere technicians. *Auteur* critics study the style and themes (or subject matter) of a director's films and assign to them the title of artist if they show a consistency of style and theme.

Directors whose films show a consistency of style and theme are called *auteurs*. By contrast, directors who show no consistency of style and theme in their work are called *metteurs-en-scène*, and are relegated to the status of technicians rather than artists. According to *auteur* critics, the difference between an *auteur* and a *metteur-en-scène* is that an *auteur* can transform a mediocre script into a great film, but a *metteur-en-scène* can make only a mediocre film out of a mediocre script. *Auteur* critics made the evaluative distinction between an *auteur* and a *metteur-en-scène* because an *auteur* is able to maintain a consistency of style and theme by working against the constraints of the Hollywood mode of production. Andrew Sarris writes:

'The auteur theory values the personality of a director precisely because of the barriers to its expression. It is as if a few brave spirits had managed to overcome the gravitational pull of the mass of movies'

The American Cinema, p. 31.

In other words, an *auteur* is able to transcend the restrictions imposed upon him or her by the Hollywood studio system.

But more central than the distinction between an *auteur* and a *metteur-en-scène* is the question: Is it legitimate to concentrate on the director as the primary creator of a film? *Auteur* critics acknowledge that the cinema is, of course, a collective activity involving many people at various stages of pre-production, production and post-production. Nevertheless, the *auteur* critics argue, it is the director who makes the choices concerning framing, camera position, the duration of the shot, and so on – those aspects of *mise-en-shot* that determine the way everything is visualized on screen. And it is precisely *mise-en-shot* that *auteur* critics focus on, because this is what makes film unique, what distinguishes film from other arts.

The origin of the auteur policy

The first half of this chapter will look at the origin of the *auteur* policy, which initially concentrated exclusively on the stylistic consistencies of a director's work. Other *auteur* critics expanded the scope of the *auteur* policy by looking at an equally important consistency: the thematic consistency in a director's work, the uniformity and coherence of subject matter across a director's films. The *auteurist*'s emphasis on the consistency of style and theme is expressed in the statement that *auteurs* are always attempting to make the same film. The second half of this chapter will consider the dominant styles and themes in the films of Alfred Hitchcock, Wim Wenders and Kathryn Bigelow.

FRANÇOIS TRUFFAUT AND CAHIERS DU CINÉMA

The *auteur* policy emerged from the film criticism of the French journal *Cahiers du Cinéma* in the 1950s. This policy was put into practice by a number of critics who became well-known film-makers of the French New Wave of the 1960s, including Jean-Luc Godard, François Truffaut, Jacques Rivette, Eric Rohmer and Claude Chabrol. The manifesto of the *Cahiers du Cinéma* critics is Truffaut's 1954 essay 'A Certain Tendency of the French Cinema', whereas the manifesto of the New Wave film-makers is Jean-Luc Godard's 1960 film *A Bout de Souffle (Breathless)*. I shall look at each in turn.

In 'A Certain Tendency of the French Cinema', Truffaut criticizes the dominant tendency in French cinema during the 1940s and 1950s, which he calls the tradition of quality. This cinema is a contrived and wooden cinema that projects a bourgeois image of good taste and high culture. In Ginette Vincendeau's definition, the tradition of quality:

... refers to a loose industry category, actively promoted (by financial aid and prizes) to project a 'quality' image of French film: expertly crafted pictures with high production values and often derived from literary sources. Psychological and/or costume dramas such as Jean Delannoy's La Symphonie Pastorale (1946), Claude Autant-Lara's Douce (1943), Rene Clement's Jeux Interdits/Forbidden Games (1952), Max Ophuls'

La Ronde (1950), Jacques Audry's Minne, L'ingénue Libertine/ Minne (1950), Jean Renoir's French Cancan (1955), Rene Clair's Les Grandes Manoeuvres (1955), all projected an image of Frenchness tied to good taste and high culture.

Encyclopedia of European Cinema, pp. 426-7

These values were achieved by the following means:

- ▶ high production values
- reliance on stars
- genre conventions
- privileging the script.

For Truffaut, the tradition of quality offers little more than the practice of filming scripts, of mechanically transferring scripts to the screen. As Truffaut emphasizes, the success or failure of these films depends entirely on the quality of their scripts. Truffaut's attack is focused primarily on two scriptwriters, Jean Aurenche and Pierre Bost.

Truffaut writes:

Aurenche and Bost are essentially literary men and I reproach them here for being contemptuous of the cinema by under-estimating it.

'A Certain Tendency of the French Cinema', p. 229

These literary men write scriptwriters' films, in which the film is seen to be completed when the script has been written. Incidentally, the French director Bertrand Tavernier returned to the tradition of quality film-making in the 1970s. He opposes himself to the New Wave, which was clearly signified when he asked Aurenche and Bost to script his first film *The Watchmaker of Saint Paul* (1974).

The privileging of the script in the tradition of quality deflected attention away from both the film-making process and the director. The *Cahiers du Cinéma* critics and the New

Wave film-makers defined themselves against literature, against the literary script, and against the tradition of quality, and instead promoted 'the cinema' as such. Whereas the tradition of quality advocated a conservative style of film-making, in which the best technique is one that is not seen, the style of the French New Wave films is similar to the decorative arts, where style draws attention to itself. In the tradition of quality, film style is a means to an end, a means of conveying story content to the spectator. But in the New Wave films, style becomes independent of the story. New Wave films dazzle the spectator with style rather than story content. The *auteur* policy therefore embodies Marshall McLuhan's idea that 'the medium is the message'.

The critics of Cahiers du Cinéma respected the work of Hollywood film-makers, such as Hitchcock, Howard Hawks, Orson Welles, Fritz Lang, John Ford, Douglas Sirk, Sam Fuller and Nicholas Ray, all of whom worked against the scripts imposed upon them by the studios. In the following extract, Jacques Rivette attempts to explain why Lang is an auteur, while Vincente Minnelli is only a metteur-en-scène:

When you talk about Minnelli the first thing you do is talk about the screenplay, because he always subordinates his talent to something else. Whereas when you talk about Fritz Lang, the first thing is to talk about Fritz Lang, then about the screenplay.

Quoted in Hillier, Cahiers du Cinéma: The 1960s, p. 3

An *auteur* in the Hollywood studio system is a director who transcends the script by imposing on it his or her own style and vision. An *auteur* film involves subjective and personalized film-making, rather than the mechanical transposition of a script onto film. The script is the mere pretext for the activity of film-making, and an *auteur* film is about the film-making practices involved in filming a script, rather than being about the script itself. But how does a Hollywood director impose his own vision on a studio film? Primarily through his manipulation of *mise-en-scène*, or, more accurately,

mise-en-shot (as I pointed out in Chapter 1 and at the beginning of this chapter, most critics do not distinguish mise-en-scène from mise-en-shot). In the following quotation, we see John Caughie linking the auteur policy to what he calls mise-en-scène (although it is evident from the quotation that he means mise-en-shot):

It is with the mise-en-scène that the auteur transforms the material which has been given to him; so it is in the mise-en-scène – in the disposition of the scene, in the camera movement, in the camera placement, in the movement from shot to shot – that the auteur writes his individuality into

Theories of Authorship, pp. 12-13

Victor Perkins (a member of the Movie group – see the next section) has also outlined the director's role in detail (*Film as Film*, Chapter 5). He writes that:

The director's most significant area of control is over what happens within the image. His control over the action, in detail, organization and emphasis, enables him to produce a personal treatment of the script situation. On occasion the treatment can be so personal as to constitute a reversal of attitudes contained in the script.

Film as Film, p. 74

Perkins adds that the director does not need to subvert the script to make a personal statement; instead, he or she can intensify part of the script's possibilities to create meaning:

The director has to start from what is known or necessary or likely or, at the very least, possible. From this base he can go on to organize the relationship between action, image and décor, to create meaning through pattern.

Film as Film, p. 94

The creation of 'meaning through pattern' is another way of saying 'significant form' (a term discussed in this book's Introduction).

Finally, Perkins also emphasizes that it is the director's control of the action and the actors' gestures that partly defines personal style: 'the director defines his effects within the action' (Film as Film, p. 95), which can be effective and distinctive as long as the director does not impose meaning on or reach beyond the limits of the action.

Spotlight

Mise-en-shot names those techniques through which everything is expressed on screen. An auteur works out his or her own vision by establishing a consistent style of mise-en-shot, a style that usually works in opposition to the demands of the script.

For the French New Wave film-makers, the script merely served as the pretext to the activity of filming. Indeed, for *auteur* critics, there was no point in talking about the film script at all, for an *auteur* film is one that does not represent a pre-existing story, but is one that represents the often spontaneous events that took place in front of the camera.

The French New Wave can be seen as a film-making practice that rejects classical Hollywood cinema's dominance by producers (in which the producer acts as the central manager controlling the work of the technicians) in favour of a more 'archaic' mode of production that favours the director. Consequently, the New Wave directors strongly supported the idea of filming unimportant stories, which then allows the director great freedom to impose his or her own aesthetic vision on the material. This is one reason Truffaut chose to film Henri Pierre Roche's novel *Jules and Jim* in 1961.

Movie magazine

Before moving on to the New Wave film-makers I shall mention, in passing, how the *auteur* policy was taken up in Britain and North America. The *auteur* policy was adopted by the British

film critics Ian Cameron, Mark Shivas, Paul Mayersberg and Victor Perkins in the magazine Movie, first published in May 1962. Like the critics of Cahiers du Cinéma, the Movie critics sought auteurs within the Hollywood studio system. Similarly, Movie critics also defined the auteur in terms of self-expression, as manifest in the stylistic and thematic consistency across a director's work. However, Movie was more flexible than Cahiers du Cinéma. The Cahiers critics were notoriously well known for preferring the worst films of an auteur to the best films of a metteur-en-scène. For example, Cahiers critics regarded Nicholas Ray to be the ultimate auteur. For this reason, in 1961 they hailed Party Girl to be a masterpiece, Ray's best film to date (above his other films such as They Live by Night, 1948 and Rebel Without a Cause, 1955). However, Party Girl (1958) is generally considered a routine and hack piece of work - even Ray himself called it 'a bread-and-butter job'.

In contrast to the judgements of *Cahiers du Cinéma*, *Movie* critics were more moderate. They recognized that even *auteurs* can make bad films and that the *metteur-en-scène* can, occasionally at least, make a good film. The prime example of the latter is Michael Curtiz, who is regarded by *auteur* critics to have directed only one film of lasting value in the history of the cinema – *Casablanca* (1942).

For such an avowedly evaluative mode of criticism as the auteur policy, it is inevitable that the critics of Cahiers du Cinéma and Movie would differ about the directors they identified as auteurs. For example, whereas Cahiers classified Minnelli as a metteur-en-scène (as we saw above in the quotation from Rivette), Movie defined him as an undisputed auteur and discussed him in three issues of Movie, including the first issue which consisted of an interview with Minnelli together with an article called 'Minnelli's Method' by Shivas. In this article, Shivas argues that the consistency of Minnelli's film style is sufficient to define him as an auteur, since Minnelli's style transcends the film script – a defining characteristic of an auteur. Shivas argues for the superiority of style over script in relation to two of Minnelli's films, The Reluctant Debutante and The Four Horsemen of the Apocalypse:

Minnelli's way with William Douglas Home's rather dreary play
[The Reluctant Debutante] is to emphasize the falseness and
untrammeled idiocy of the Season by insisting that the adults
behave like children and the children like adults, reinforcing
the less than witty lines primarily in its visual treatment... As a
result of Minnelli's visual style, a mediocre story becomes as
sophisticated as The Philadelphia Story is verbally witty.

With The Four Horsemen, Minnelli was once more landed with a turkey, an old one, too, of which only a primitive like King Vidor (Duel in the Sun) could have made a meal... The Four Horsemen is not, except from the point of view of decoration, roses all the way, but at its best it transcends its story by the brilliance of its mise-en-scène.

'Minnelli's Method', Movie, 1, 1962, p. 18

For Shivas, Minnelli is an *auteur* because his films go beyond the mediocre scripts handed to him by the studio. A *metteur-enscène*, by contrast, would have simply made two mediocre films from these mediocre scripts.

ANDREW SARRIS

During the early 1960s, Andrew Sarris introduced the auteur policy into North American film criticism via his essay 'Notes on the Auteur Theory in 1962' in the journal Film Culture (No. 27, Winter, 1962-3). Sarris translated the term 'la politique des auteurs' into the term 'auteur theory', giving it the prestige that goes with the word 'theory'. Furthermore, he argued that the auteur theory is primarily a history of American cinema, since it develops a historical awareness of what individual directors have achieved in the past. This is in contrast to Hollywood practice where, according to studio executives, a director is only as good as the last film he or she made. An auteurist history of the cinema needed to be evaluative, according to Sarris, if it was not to become a hobby like stamp collecting or trainspotting. The criteria for evaluation were the same for Sarris as for other auteur critics - consistency in style (how) and theme (what) across a director's films: 'The whole point of meaningful style is that it unifies the what and the how into a personal statement' (The American Cinema, p. 36).

Sarris published an evaluative history of American auteurs in 1968 in the form of his comprehensive book, The American Cinema: Directors and Directions, 1929-1968, which became the bible of auteur critics. To write The American Cinema, Sarris saw over 6.000 films of 200 directors. Without VHS, DVD or many TV channels, that was a hard task. Only after viewing all the films of a particular director can the auteur critic evaluate a director as good or bad, strong or weak. In other words, for Sarris, the distinction between strong and weak directors should not be taken on trust. It must be proved through a systematic viewing and analysis of a director's films. Despite this emphasis on watching a large quantity of films, the auteur critic is still concerned with the particular details of each film, its uniqueness.

Andrew Sarris on one of Nicholas Ray's themes: 'Ray does have a theme, and a very important one, namely that every relationship establishes its own moral code, and that there is no such thing as abstract morality. This much was made clear in Rebel Without a Cause when James Dean and his fellow adolescents leaned back in their seats in the planetarium and passively accepted the proposition the universe itself was drifting without any frame of reference. (The American Cinema, pp. 107-8.)

A BOUT DE SOUFFLE/BREATHLESS

So far we have surveyed the work of the Cahiers du Cinéma critics and New Wave film-makers in an attempt to explain the motivations for their privileging of the director as auteur. We then saw how the idea of the director as auteur entered British and North American film criticism. We shall now turn to Godard's film A Bout de Souffle/Breathless to look at the aesthetics of the French New Wave at work.

The French New Wave is one of the major movements of European Art Cinema. Vincendeau (Encyclopedia of European Cinema, p. xiv) defines European Art Cinema as sharing the following aesthetic features:

- a slower editing and narrative pace than Hollywood cinema
- a strong 'authorial voice'
- an investment in realism and ambiguity

- the desire to provoke thought and sometimes shock
- a taste for unhappy endings.

In A Bout de Souffle (1960), we see Godard creating most of these aesthetic features by using the following production techniques, all of which were innovative when Godard made the film:

- ▶ location shooting (rather than the studio, as in the tradition of quality)
- a hand-held camera (made possible by the invention of lightweight cameras)
- natural lighting (rather than artificial studio lighting)
- casual acting
- subversion of the rules of classical editing.

All these techniques, none of which is to be found in the tradition of quality, turn the films into spontaneous and improvised performances, rather than being the mere representation of the script, which exists before the film-making process begins.

A Bout de Souffle begins with Michel Poiccard (Jean-Paul Belmondo) stealing a car to drive to Paris. However, two policemen on motorcycles chase him. He turns off the road, but is followed by one of the policemen. Michel shoots the policeman and runs off. What makes this part of the film unusual and innovative is the way it is filmed.

I shall describe the shots, beginning with Michel being chased by the police, to the moment when Michel shoots one of the policemen. I shall then discuss the production techniques used in this sequence of shots:

- 1 The camera is inside Michel's car. He overtakes a lorry and is spotted by two policemen.
- 2 The camera, outside the car, shows Michel overtaking the lorry. The car is shown travelling from screen right to screen left.
- 3 The camera, inside the car, quickly pans from the windscreen of the car to the back window, where the police can be seen chasing Michel.

- 4 Cut to a slightly different shot of the police chasing Michel. The camera then pans to inside the car (that is, it reverses the pan of shot 3).
- 5 The camera, outside the car, shows it moving from screen left to screen right.
- 6 Shot of the policemen on their motorcycles. They are shown travelling from screen right to screen left.
- 7 Michel pulls off the road. He looks off-screen left, and sees...
- 8 one of the police motorcycles racing by.
- 9 Michel opens the bonnet of the car to try to get it started again. He looks off-screen left and sees...
- 10 the second police motorcycle racing by.
- 11 Cut back to Michel attempting to repair the jump lead that will start the car again. Michel looks up and sees...
- 12 the second motorcyclist heading towards him.
- 13 Shot of Michel reaching into the car.
- 14 Close-up of Michel's head in profile, facing screen right. He says, 'Stop, or I'll kill you.'
- 15 Close-up of Michel's hand holding a gun.
- 16 Close-up of the gun as Michel gets ready to fire.
- 17 The cut to shot 17 occurs as the sound of the gun going off is heard. Shot 17 consists of the policeman falling down.
- 18 In this shot, Michel is shown running across open fields.

This description cannot capture the frenetic nature of this series of shots. The first 17 shots last just 44 seconds, which makes on average a change of shot every 2.6 seconds. (The final shot lasts 14 seconds.) All the innovative production techniques mentioned above are apparent in this series of shots. The scene is shot on location, on the highway. The rest of the film is also shot on location, particularly on the streets of Paris. The camera is very mobile and shaky. The pans in shots 3 and 4 are very quick, creating blurred images. The lighting is

natural. In shot 7, the sun shines directly into the lens, creating a bloomer. Belmondo is renowned (and often imitated) for his casual acting style in this film. He seems to improvise most of the time. Finally, this series of shots subverts the rules of continuity editing. The cut from shot 3 to shot 4 is less than 30 degrees and, therefore, creates a jump cut. In shot 5, Michel's car is travelling from screen left to screen right. But in shot 6, the police are shown travelling in the opposite direction, from screen right to screen left. The cameraman has crossed the road after filming the car to film the motorcycles. Such a change of direction creates a confusion of screen space. Similarly, when Michel stops the car, he looks screen left at the police passing by. But after he has picked up the gun, he looks screen right at the policeman, rather than screen left, as we would expect. Finally, the cut from 15 to 16, the shot of Michel's hand to the shot of the gun, creates another jump, because there is very little difference between the two shots.

The use of a shaky, hand-held camera, together with the use of location shooting and natural lighting, jump cuts and discontinuous editing, do not aim to show the action clearly; instead, it offers a fragmentary and partial vision of the scene. These 'imperfect' techniques represent the *auteur*'s presence and serve as clear marks of the way he or she writes his or her individual vision into the film.

The effect these production techniques create is one of spontaneity and improvisation. However, what interests me in the use of these techniques is that they give the film a documentary feel. The blurred pans, the shaky camera movements and abrupt editing testify to the difficulty the cameraman has filming in the conditions he found himself in, and to his physical interaction with the event.

It is important to point out that the stylistic choices made by the French New Wave directors were not simply determined by aesthetic considerations, but also by economics. The French New Wave is a low-budget film-making practice. Filming on location with natural lighting decreases production costs, just as the emphasis on spontaneity reduces pre-production costs such as scriptwriting. Nevertheless, far from being despondent by the lack of money, the French New Wave directors identified low production costs with artistic freedom. They saw an inverse relationship between the size of the budget and artistic freedom: the higher the budget, the lower the artistic freedom. They even saw economic failure at the box office as a sign of artistic independence.

These economic considerations also fed into the judgements the New Wave directors made when they were *auteur* critics. When assessing the films of American directors, *auteur* critics defined an *auteur* as a director who transcended the high production values of the Hollywood studios. In other words, an *auteur* managed to stamp his or her personality on a high-budget film, whereas a *metteur-en-scène* was swamped by high production values and became an anonymous technician.

Consequently, a Hollywood *auteur* film is one that contains a tension between the demands of the studio system and the director's self-expressiveness. As John Caughie explains:

... the struggle between the desire for self-expression and the constraints of the industry could produce a tension in the films of the commercial cinema..., encouraging the auteurist critics to valorize Hollywood cinema above all else, finding there a treasure-trove of buried personalities, and, in the process, scandalizing established criticism. Uniqueness of personality, brash individuality, persistence of obsession and originality were given an evaluative power above that of stylistic smoothness or social seriousness.

The business of the critic was to discover the director within the given framework, to find the traces of the submerged personality, to find the ways in which the auteur had transformed the material so that the explicit subject matter was no longer what the film was really about...

Theories of Authorship, pp. 11-12

As a final point, we need to consider the implicit criticism of the *auteur* policy that Caughie refers to in the first quotation above, when he writes that 'Uniqueness of personality, brash individuality, persistence of obsession and originality were given an evaluative power above that of stylistic smoothness or social seriousness' (emphasis added). Both the auteur critics and the New Wave directors have been criticized for their lack of social commitment. However, the auteur policy offers a defence against standardized film-making practices in favour of an alternative – a more expressive and personalized – cinema. The New Wave, while concerned primarily with the personal lives of the young French middle class, put into practice this alternative style of film-making.

From the mid-1960s onwards, Godard's film-making became politicized, both in terms of his innovative and disturbing style, and in terms of theme and content. His style became political by jolting spectators out of their comfortable and leisurely consumption of film, by continually distracting them, making them notice the style, thereby distancing them from the film's content. In other words, the disturbing style makes spectators aware of the film-making process, rather than trying to conceal it. He also changed the content of his films by including political subject matter (the activities of a Marxist group of students in La Chinoise, a strike in Tout Va Bien). In other words, Godard made films about politics and also made films politically. These films include La Chinoise, Le Weekend, Le Gai Savoir, made between 1967 and 1968, and films made under the banner of the Dziga Vertov Group (basically Godard and Jean-Pierre Gorin) between 1969 and 1972, including Pravda, Vent d'Est and Tout Va Bien.

In 1973, the Dziga Vertov Group was dissolved and Godard teamed up with Anne-Marie Miéville and made a series of video projects for television. Godard rethought his political position and this led him to pursue new themes in his work, including family and personal relationships, reflecting the emergence of the women's movement in France.

In the early 1980s Godard returned to making less marginal films, including *Passion* in 1982. However, this commercial period came to an abrupt end in 1987 when he made a film version of *King Lear*, with Norman Mailer and his daughter. Both walked off the set before the film was completed, so Godard started again.
A number of film critics (David Bordwell among them) point out that the spectator cannot read character relations or thematic significance from Godard's political films, and the films do not seem to have any overall coherence. Each scene seems to go off on a tangent. Part of Godard's move towards becoming a political film-maker was to downplay the Romantic idea of the film director as an *auteur*, making films with stylistic and thematic unity. This is why he made his most radical political films under the impersonal banner of the Dziga Vertov Group, rather than his own name.

Style and themes in Alfred Hitchcock's films

Alfred Hitchcock is an undisputed auteur for all the auteur critics mentioned above – Cahiers du Cinéma, the Movie critics and Andrew Sarris. I shall briefly review the ways in which these three schools of auteur criticism discussed Hitchcock before listing the stylistic and thematic elements that unify his films. Cahiers published a special issue on Hitchcock in 1954 (no. 39), which comprises two interviews with Hitchcock, one by André Bazin, the other by Chabrol. In 1957, the Cahiers critics Rohmer and Chabrol published the first book-length study of Hitchcock, simply entitled Hitchcock and translated into English as Hitchcock: The First Forty-Four Films. Rohmer and Chabrol developed a thematic and stylistic analysis of Hitchcock's films. They identified the following themes:

- ▶ the influence of Catholicism
- ▶ the theme of shared guilt
- homophobia and misogyny.

In terms of form and style, they noted at the end of the book that:

Hitchcock is one of the greatest inventors of form in the entire history of cinema. Perhaps only Murnau and Eisenstein can sustain comparison with him when it comes to form. Our effort will not have been in vain if we have been able to demonstrate how an entire moral universe has been elaborated on the basis of this form and by its very rigor. In Hitchcock's work, form does not embellish content, it creates it.

Hitchcock: The First Forty-Four Films, p. 152

Rohmer's and Chabrol's book was followed by a book by another *Cahiers* critic, Jean Douchet, whose *Alfred Hitchcock* was published in 1967. Douchet identifies three worlds operating in Hitchcock's films:

- the world of the mundane (of everyday events)
- the world of subjective desire
- b the intellectual world.

For example, *Psycho* (1960) begins with the mundane. The camera pans across the skyline of Phoenix, Arizona, and we are supplied with mundane information: the name of the city, the date and the time. We see and hear about the mundane lives of Sam and Marion and see the mundane office job that Marion has. The film then moves on to the world of subjective desire, in this instance, Marion's, as she steals the \$40,000 to fulfil her love with Sam. But after Marion is murdered, the film moves into the intellectual world as several characters try to work out what happened to her.

Douchet was one of the first critics to draw the (by now familiar) analogy between Jeff (James Stewart) in *Rear Window* (1954) and the film spectator. Jeff is a photographer who is confined to a wheelchair after breaking a leg. He spends his days spying on his neighbours across the courtyard. For Douchet, Jeff replicates the film spectator – the spectator confined to a chair observing a spectacle at a distance. In *Rear Window*, the windows of the apartments across the courtyard replicate the cinema screen.

The most famous book on Hitchcock was published in 1967 – François Truffaut's *Hitchcock*, which was based on more than 50 hours of interviews in which Truffaut and Hitchcock talk about Hitchcock's films in chronological order, covering such issues as the inception of each film, the preparation of

screenplays, directorial problems and Hitchcock's evaluation of each film.

The Movie critics also interviewed Hitchcock and wrote several essays on mechanisms of suspense in his films. Robin Wood, who wrote regularly for Movie, published a book on Hitchcock, simply called Hitchcock's Films (1965) (which has been revised and updated several times), which is almost as famous as Truffaut's book. Wood argues that we should take Hitchcock seriously because of his thematic and formal unity, and because his films have a thematic depth similar to Shakespeare's plays.

Finally, in *The American Cinema*, Sarris defined Hitchcock as a pantheon director, the highest and most prestigious category in his evaluative history. Pantheon directors, according to Sarris:

are the directors who have transcended their technical problems with a personal vision of the world. To speak any of their names is to evoke a self-contained world with its own laws and landscapes.

The American Cinema, p. 39

STYLISTIC UNITY IN HITCHCOCK'S FILMS

1 Emphasis on editing and montage

Early in his career, Hitchcock was influenced by German Expressionism and Soviet theories of montage. The first two films he completed as director, *The Pleasure Garden* (1925) and *The Mountain Eagle* (1926), were made in German studios. Examples of Hitchcock's reliance upon editing are numerous, but one can do no better than look closely at the end of *Notorious*, already analysed at the end of Chapter 1. Hitchcock's reliance on editing is also illustrated in the famous shower scene murder in *Psycho*, in which 34 shots appear on screen in a matter of 25 seconds. The style and themes of this scene were analysed in detail by the *Movie* critic Perkins in *Film as Film*.

2 High number of point-of-view shots

Hitchcock had a tendency to use shots that represent a character's look. It is common to find that about 25 per cent

of all shots in Hitchcock's films are point-of-view shots, which critics interpret as Hitchcock's fascination with voyeurism. The clearest examples are *Rear Window* (the shots of Jeff looking out of his window at his neighbours) and *Vertigo* (1956), in which the private detective, Scottie (James Stewart), is hired to follow Madeleine (Kim Novak).

Spotlight

Hitchcock's Rear Window (1954) can be seen as a metaphor for the cinema itself. Chair-bound Jeffries (James Stewart) represents the cinema audience, while the apartments opposite his window represent the cinema screen.

3 Shooting in a confined space

In the 1940s and early 1950s, Hitchcock imposed upon himself a technical constraint: he made a number of films in confined spaces. In films such as *Lifeboat* (1944), *Rope* (1948), *Dial M for Murder* (1954) and *Rear Window* (1954), most of the action takes place in the same space (a lifeboat in the film of the same name, the Manhattan penthouse of Brandon Shaw in *Rope*, Tony Wendice's apartment in *Dial M for Murder*, and Jeff's apartment in *Rear Window*). This self-imposed constraint limited the stylistic choices that Hitchcock could make and offered him a challenge on how to construct the film.

Considering Rope would be useful, because it marks a deviation in Hitchcock's film-making. In the late 1940s, Hitchcock temporarily abandoned his emphasis on editing and experimented with the long take (plus camera movement). Rope takes the long take to its logical conclusion, because the film consists of only 11 takes, two of which last 10 minutes, which is the maximum length of the reel of film that fits into the camera. Yet, despite the limitations Hitchcock imposed on himself – limitations of space and a severe limitation on cutting from one shot to another – the camera moves almost continuously around the apartment, in the hallway and in the kitchen, demonstrating Hitchcock's skill in translating mise-enscène into mise-en-shot.

Moreover, the effect of these long takes, as I pointed out in Chapter 1, is to emphasize the actor's performance, which is not cut up into many shots. This is because the long take maintains the dramatic unities of space and time. In *Rope*, the events in Brandon's penthouse take place in one evening; in fact, the skyline outside Brandon's penthouse slowly changes from daylight to twilight as the film progresses. Hitchcock combined editing and long takes in his film *Under Capricorn* (1949) and returned to editing from *Stage Fright* (1950) onwards.

THEMES IN HITCHCOCK'S FILMS

Narrative techniques

We can identify two basic narrative techniques in Hitchcock's films. These two narrative techniques are related in that both involve investigations, usually the investigation of a murder. These narratives are distinguishable by whether the main protagonist is the one who carries out the investigation, or whether the main protagonist is the one who is under investigation.

In the first narrative technique, the film focuses on the protagonist as he carries out an investigation. Furthermore, he is usually set up with a mistaken identity. The solving of the crime occurs simultaneously with the unmasking of the mistaken identity (I shall discuss this point below).

In the second narrative technique, the protagonist comes under investigation – that is, the film focuses on the protagonist who is being investigated. For example, Marnie in the film of the same name, Tony Wendice in *Dial M for Murder*, Manny Balestrero in *The Wrong Man* (1956), Marion and Norman in *Psycho*. *Psycho*, for instance, begins with a crime (Marion stealing \$40,000), which is then investigated by Arbogast, Lila and Sam. But as the investigation continues, it soon becomes evident that it is not only Marion's theft that is being investigated, but also the murders committed by Norman.

This discussion of murder and its investigation leads to the other themes in Hitchcock's films, which are:

Confession and guilt, as Rohmer and Chabrol point out in their book. Marion in Psycho realizes her guilt in stealing the

- \$40,000; Marnie is plagued by guilt concerning a childhood experience she murders a man who attacked her mother; in *I Confess* (1953), Otto Keller confesses a murder to Father Michael Logan (Montgomery Clift), who is then bound to silence.
- ▶ Suspense (Hitchcock as the 'master of suspense'). This applies to most of Hitchcock's films, but is epitomized in *North by Northwest* (1959), analysed in Chapter 2.
- The perfect murder. A single character or group of characters devise complex and unusual methods of committing the perfect murder; however, the investigator always finds a clue overlooked by the murderers. In Rope, there is no motive for Brandon and Phillip to kill David Kentley; they are simply acting out the existential theory of their former teacher Rupert Cadell. After killing Kentley and hiding his body in the apartment, Brandon and Phillip hold a party at the scene of the crime and invite Rupert as one of the guests. However, upon leaving the party, Rupert is mistakenly given Kentley's hat; this is the clue that leads to his solving of the crime. In Rear Window, Thorwald cuts up his wife's body, but Jeff and Lisa find her wedding ring, disconfirming the claim that she has simply left town. One more example: in Strangers on a Train (1951) Bruno Antony meets by chance Guy Haines, a famous tennis player, on a train. Bruno knows that Guy wants to divorce his wife Miriam and marry his girlfriend Anne Morton. As the two of them get talking, Bruno mentions that he wants to kill his own father. He suggests to Guy that they swap murders - Bruno would murder Guy's wife Miriam and Guy could murder Bruno's father, making two perfect (that is, motiveless) crimes. Guy does not take Bruno seriously, but simply humours him. Nevertheless, Bruno carries out the murder of Miriam at a fairground. However, he is spotted by an attendant in charge of one of the rides, who later confirms that it was Bruno, not Guy, who was at the scene of the crime at the time of Miriam's murder.
- ▶ The wrong man. As is apparent from the discussion of narrative techniques, one of the dominant themes of Hitchcock's films is the wrong man. In *The 39 Steps* (1935), Richard Hannay

(Robert Donat) is falsely accused of the murder of the spy Anabella Smith. In *To Catch a Thief* (1955), Cary Grant plays John Robie, a retired cat thief who is accused of carrying out new thefts. In *The Wrong Man* (1956), Manny Balestrero (Henry Fonda) is falsely accused of robbing an insurance office. In *North by Northwest*, Thornhill is mistaken for the non-existent decoy agent George Kaplan. Finally, in *I Confess*, Father Michael Logan, who hears Otto Keller confess to murdering Mr Villette, is mistakenly suspected of committing the murder.

The cinema of Wim Wenders

Wim Wenders is one of the dominant figures in the New German Cinema which, like the French New Wave, is a dominant school of European Art Cinema. In the *Encyclopedia of European Cinema* (pp. 304–5), Thomas Elsaesser and Joseph Garncarz identify the following characteristics of New German Cinema:

- It is a German art movement that was dominant from 1965 to 1982.
- ▶ It rejected the work of post-Second World War German commercial directors, who had begun their careers during the Third Reich.
- It rejected established German film genres and stars.
- ▶ It was indirectly influenced by American cinema, rather than by German cinema (with the exception of the films of Fritz Lang and F W Murnau).
- ▶ It dispensed with the producer and scriptwriter, as the directors of the New German Cinema (such as Werner Herzog, Alexander Kluge, Rainer Werner Fassbinder, as well as Wenders) took on these roles.

We shall go through a number of these points in more detail by considering the work of Wenders.

THEMATIC ANALYSIS OF THE FILMS OF WENDERS

▶ The influence of American culture

It is significant to note that Wenders was born in 1945, a few months after the end of the Second World War. He grew up in a Germany dominated by the American occupying forces. Germany after the Second World War was based on a collective amnesia, an unwillingness to speak about the Nazi regime. Those who grew up in the post-war period therefore had little or no access to recent German history or culture. Instead, their sense of culture was dominated by American culture and this domination is reflected in many of the films of Wenders, as well as other directors of what came to be known as New German Cinema.

What characterizes New German Cinema is its representation of 'the German situation', of a nation self-exiled from its own past and its own culture. In its place, the Germans found American culture. It should not be surprising, therefore, that American culture plays a prominent role in New German Cinema (as well as in post-war German literature). Indeed, a number of German writers travelled through America and wrote about their experiences, which were made up of a combination of familiarity and estrangement.

One of the most prominent writers in German to tackle the German situation is Peter Handke. He travelled across America in 1971 and wrote a book called *Short Letter*, *Long Farewell*. In an interview, Handke explains:

America is for the story only a pretext, the attempt to find a distanced world in which I can be direct and personal. For if I imagine writing the same adventure in Europe, I can't think of a place where the objects, the outer world, would constitute a similar challenge, and at the same time, there is no other place except America which provokes in me such depersonalization and estrangement. I tried to represent the inner world of my characters as exactly as possible. But I also tried to depict the outer world as a fiction. So that everything that the protagonist sees becomes a sign for him of what he has experienced, or what he would like to do. America is an environment which is known to me in advance by its signs.

Quoted in Thomas Elsaesser, 'Germany's imaginary America:
Wim Wenders and Peter Handke'. p. 7

America is also known to Wenders in advance by its signs and images, and these signs and images constantly recur in his films. Wenders collaborated with Handke on three films, *The Goalkeeper's Fear of the Penalty* (1972), which is based on a novel by Handke, *Wrong Move* (1975) and *Wings of Desire* (1987).

Road movies

It is this experience of travelling – of travelling through a land that both constitutes one's identity and at the same time alienates oneself – that becomes one of the dominant themes in Wenders's films. Most of his films can be defined as road movies, particularly Alice in the Cities (1974), Kings of the Road (1976), Paris, Texas (1984), culminating in the ultimate road movie, Until the End of the World (1991), in which the characters literally travel around the entire world and then travel into their inner selves (as I shall point out below).

The first ten minutes of *Alice in the Cities* consists of the main protagonist, a German writer called Philip, travelling across America in an attempt to write a story about American culture. But he ends up taking Polaroid photographs of typical signs and images of American culture. The whole film is a record of Philip's journey. Moreover, his journey is presented as a series of returns: the film begins with Philip in California as he prepares to return to New York. From New York, he flies back to Europe (landing in Amsterdam) and then finally on to Germany, where he drives around various cities looking for childhood homes, first the home of a lost ten-year-old girl, Alice, who is travelling with him, but also his own childhood home.

The journey in *Alice in the Cities*, and Wenders's films in general, depict a search for one's identity, which involves a return to origins. The link between journey and identity is made explicit in *Alice in the Cities*, when Philip's former girlfriend tells him that he takes Polaroid photographs of what he sees in order to prove that he exists.

Wenders goes one step further than the Polaroid in *Until the End of the World*. After the main characters have travelled around the world, they employ computer technology to record their own dreams, which are predominately childhood images.

This is simply an advancement of the use of Polaroids in *Alice* in the Cities. In *Until the End of the World*, the journey around the world leads to a journey into the inner self in search of one's origin and identity.

From male bonding to male-female relationships

Probably Wenders's most well-known road movie is *Paris*, *Texas*. This film charts the journey of Travis (Harry Dean Stanton) as he walks out of the desert in search of his wife, Jane (Nastassja Kinski) and son, Hunter. But he is also searching for the place where he thinks he was conceived, a place called Paris, Texas. The link between journey and identity is therefore explicit in this film. Travis is aided in his journey by his brother, Walt (Dean Stockwell), who, along with his wife, is looking after Hunter. Travis and Hunter eventually find Jane working in a seedy peep-show joint. Travis realizes that they cannot return to being a couple, although he does reunite Jane with Hunter.

The introduction of the brother into the journey charted in *Paris, Texas* also introduces another dominant theme in Wenders's films – male bonding. The following Wenders's films involve the bonding between two male characters on the move: *Kings of the Road, The American Friend* (1977), *Paris, Texas* and *Wings of Desire*. By contrast, *Alice in the Cities* involves a journey taken by Philip and a ten-year-old girl.

The themes of these films point towards Wenders's relation to women. In fact, we can chart a progression in his films. In early films such as *Kings of the Road* and *The American Friend*, women are almost non-existent. And when they are introduced in his early films, it is for pure innocence, as with the ten-year-old Alice in *Alice in the Cities*. However, in *Wings of Desire*, we see a strong female character, Marion, dominating the narrative. The male bonding between two angels, Damiel and Cassiel, is gradually broken up by Marion, with whom Damiel falls in love. He even forfeits his eternal angelic existence and becomes human in order to experience that love with her. Moreover, *Until the End of the World* is a road movie featuring a journey taken by a woman in search of her identity. We can therefore discern a progression in Wenders's films when it comes to his

depiction of women, from non-existent (Kings of the Road) to the innocent ten-year-old Alice in Alice in the Cities, to Jane, the fallen woman in Paris, Texas, Marion in Wings of Desire and Claire in Until the End of the World. Lana in Land of Plenty (2004) is also a strong, well-rounded character who goes to Los Angeles in search of her uncle.

Does this gradual introduction and dominance of women in Wenders's films mean that he offers a veritable image of male-female relationships? Far from it! The way in which Travis and Jane are brought together in Paris, Texas shows the unbridgeable gap between the sexes. Travis finds his wife in a seedy peep-show joint, consisting of booths in which the customers can talk to the women through a two-way mirror, where the men can see the women, but not vice versa. When Travis finds Jane in one of these booths, he tells her about the relationship between two people he knows. He tells her how the couple fell in love, how the man gradually became obsessed with and jealous of the woman, and how that eventually led to the breakdown of their relationship. Jane gradually realizes that the story is about her and Travis, and that Travis is narrating it to her. But the couple are not brought together again. Travis tells Iane where to find Hunter and then he drives off.

The scene in the booth consists almost entirely of a monologue delivered by Travis about the disintegration of a relationship. The visual nature of the image, with the couple divided by a two-way mirror, sums up Wenders's philosophy about malefemale relationships (or the impossibility of such relationships). Wings of Desire seems to transcend the problems of malefemale relationships, as Damiel is able to break through the seemingly impossible barrier between angels and humans in order to express his love of Marion. Additionally, the penultimate scene consists of a monologue delivered by Marion about male-female relationships, in which she expresses her belief that she can, for the first time, become seriously involved in a relationship. To some extent, then, Wings of Desire transcends the two-way mirror of Paris, Texas by giving the woman a voice to express her desire. Nonetheless, Marion expresses her desire in hopelessly idealistic terms, which brings

into doubt the idea that her relationship with Damiel can be long term. Even the relationship in the more optimistic *Until the End of the World*, between Claire and Eugene, breaks down by the end of the film.

FORMAL ELEMENTS IN THE FILMS OF WENDERS

In recent debates in film studies, the *auteurists*' opposition between *mise-en-shot/mise-en-scène* versus the script has been redefined as an opposition between image and narrative. This is important to keep in mind because Wenders talks about his own films in these terms.

In the majority of narrative films, the elements of the film image (camera movement, camera angle, cutting, etc.) are completely motivated by the script's narrative logic. What this means is that camera movements, cutting and so on simply serve the function of presenting the actions and events of the narrative to the film spectators. But in European Art Cinema, there is a more ambiguous relation between the film image and the script's narrative. In other words, the image is not completely subordinated to the narrative, but is largely separate from the narrative.

Wenders's films show this ambiguous relationship between the image and narrative. Yet, his films do not simply eliminate narrative logic either. However, their images are not completely subordinated to the narrative logic. Wenders describes his films, in an interview by Jochen Brunow, as consisting of carefully composed and framed images:

Summer in the City [1970] had been done with a two- or threepage exposé. The shorts, too, were done without any script; there were only a few sketches of images. I came to filmmaking through images and as a painter. The concept of story was foreign to me, it was new territory. In those days, it was a process of gradually feeling out the filmmaking process, and for me the script was the strangest part of it.

The Cinema of Wim Wenders, p. 65

Wenders's films avoid action and drama in favour of observation – the camera simply observes and shows events

from a detached viewpoint. In temporal terms, these moments are called dead time.

Only a cinema of the image and dead time can reply to the hectic pace of Hollywood action films, its explosions, car chases and gun battles. Wenders's cinema challenges the supremacy of narrative causality by foregrounding the space and time of the image. This is particularly evident in Alice in the Cities and Wings of Desire. In Alice in the Cities, Alice and Philip search for the home of Alice's grandmother. The grandmother's home could have been found almost immediately. A narrative event would then have been completed, leading to another event. Instead, the grandmother is never found. The process of searching becomes the main focus of the film. What we see is a catalogue of events loosely linked together by the search for Alice's grandmother. Part of the search consists of the following actions:

- Alice and Philip have breakfast (14 shots).
- They drive to Essen (9 shots).
- They stop to ask a couple sitting on a bench if they recognize the grandmother's house from a photo that Alice has (6 shots).
- Alice and Philip drive through an area of town full of empty houses (6 shots).
- One shot of the industrial landscape.
- Alice and Philip stop to ask some children and a cab driver if they recognize the photo of the grandmother's house (14 shots).
- Alice's views of the passing townscapes (5 shots).
- Alice and Philip in a photo booth having their photographs taken (1 shot).
- Alice and Philip in a car park doing warm-up exercises for swimming (1 shot).
- One shot of the industrial landscape.
- Alice and Philip drive around Gelsenkirchen and find the grandmother's house, but Alice's grandmother no longer lives there. They decide to go swimming (25 shots).

Most of the events in this segment are unimportant to the narrative; for example, the shots of the empty houses, the shot of Alice and Philip doing the warm-up exercises and the shot of the two of them in the photo booth. Furthermore, the order of the events is not important. We can change around many of these events without creating confusion. Is it important that the shot of Alice and Philip doing the warm-up exercises comes before or after the shot of the two of them in the photo booth? Unlike the opening three scenes of *Psycho*, analysed in Chapter 2, the events in *Alice in the Cities* are not linked together by a strong cause–effect logic. We can say that *Alice in the Cities* has an episodic structure, because each scene consists of an autonomous episode.

Yet, this is not to suggest that the actions are totally arbitrary. Many scenes described above do have a symbolic meaning.

To give just two examples: the empty houses symbolize the loss of stability that both Philip, the German writer, and Alice, the temporarily abandoned girl, feel as they drive around Germany. And in the shot of the warm-up exercises, Alice closely mimics Philip's actions, symbolizing both the child's innocence and her total dependency on the adult.

Part of Alice in the Cities was set in the German city of Wuppertal. Wenders returned to the city to make Pina (2011), a documentary based on the life and work of the legendary choreographer of modern dance, Pina Bausch. The film is based around several of Bausch's dance-theatre works (including 'Café Müller' and 'The Rite of Spring') which, Wenders felt, could only be filmed in 3D. Yet, Pina is not a film 'driven' by 3D, the way many blockbusters employ 3D as a special effect. Instead, the 3D becomes another technical tool, one that the director can use to capture and enhance the choreography of the dancing body. Wenders hired 3D expert Alain Derobe to assist. Rather than filming the dancers from a distance with a still camera, Wenders and Derobe decided on occasions to place the camera close to the dancers and to follow them. This technique placed the film spectator right next to the action, and captured the volume of the dancers' bodies and the intensity and energy of their movements. Pina is the first European art house film to be made in 3D.

The cinema of Kathryn Bigelow

From the 1970s onwards, the number of women entering the American film industry rose significantly due to changes in the structure of the industry. Previously, the industry acted as a type of 'closed shop' that largely excluded women from above-the-line jobs such as directing or producing. During the early history of the American film industry (1895 to the 1920s), there was only Alice Guy Blaché (see Alison McMahan, Alice Guy Blaché) and Lois Weber working as directors. In Hollywood's classical period there was only Dorothy Arzner, who directed films such as Christopher Strong (1933), Craig's Wife (1936) and Dance, Girl, Dance (1940), and actress Ida Lupino who also directed Outrage (1950), The Hitch-Hiker (1953) and The Bigamist (1953).

In the 1970s, Joan Micklin Silver began as a feature director on independent features such as Hester Street (1975) and Between the Lines (1977) before moving on to mainstream studio films like Crossing Delancey (1988) and Big Girls Don't Cry... They Get Even (1992). Gale Anne Hurd moved from independent production to major studio pictures with The Terminator films (1984, 1991, 2003), Aliens (1986), The Abyss (1989), Dante's Peak (1997) and Hulk (2003). Susan Seidelman set out to work in the low-budget independent sector. Her first film, Smithereens (1982), was made for \$80,000 and became the first independently produced American film to be accepted in the main competition at the Cannes Film Festival. She then moved to bigger-budget studio movies such as Desperately Seeking Susan (1985).

Penelope Spheeris, Stephanie Rothman, Amy Holden Jones and Martha Coolidge began their directing careers by making exploitation movies. Some revised the exploitation from a woman's perspective. In Rothman's *The Velvet Vampire* (1971) a woman played the vampire and men were the victims, reversing the usual genre conventions, while Holden Jones's *Slumber Party Massacre* (1982) is a woman's slasher movie.

Other women directors, including Amy Heckerling, Susan Seidelman and Marisa Silver, graduated from film school, while Penny Marshall, Jodie Foster, Sondra Locke, Barbra Streisand and Sofia Coppola moved from acting to directing.

Kathryn Bigelow entered film-making via art school. In her feature films she takes a European Art Cinema approach to Hollywood's traditional masculine film genres. She partly subverts those genres by combining them into one film, creating hybrid genres. Her 1987 film *Near Dark* is a hybrid between the horror-vampire movie and the Western, for example.

In terms of stylistic traits, Bigelow's films:

- consist of a strong, distinctive visual style based on moody (for example, blue-tinted) lighting and visceral textures
- ▶ consist of an editing pace that goes from one extreme to the other: it is either slow, as in *The Loveless* (1982) and *The Weight of Water* (2000) or hyperkinetic, most especially in *Point Break* (1991), *Strange Days* (1995), *The Hurt Locker* (2008) and *Zero Dark Thirty* (2012)
- contain homages to classical films.

In terms of themes, Bigelow's films consist of:

- rebellious male characters and strong androgynous female characters
- ▶ representation of a counter-cultural lifestyle as an alternative to the dysfunctional family
- paraphic depictions of violence, such as rape and murder.

Some critics also identify a lack of narrative coherence and motivation in Bigelow's films, although this, in part, is due to her transformations of traditional genre codes. We shall now look at her early film *The Loveless* to see where her innovative film-making techniques were first manifest.

THE LOVELESS

In August 1981, Bigelow (and co-director Monty Montgomery) took her debut independent feature film *The Loveless* to the Locarno film festival. Made for less than \$1 million, the film stars Willem Dafoe in his first leading role as a leather-clad biker who stops in a small Southern rural town with his gang

to get a bike fixed. The film explores the extreme contrast and hostility between the locals and outsiders, who represent a counter-cultural lifestyle to the locals. Critics perceived the film as dealing only with style and surface features ('its lovingly assembled props and wardrobe' as one critic put it) with very little story holding it together: the Coca-Cola vending machines, music boxes, cars, old advertisements and pin-up calendars seem to become the film's main focus.

The film had a protracted release, finally opening in Los Angeles in September 1984, three years after its first screening (the original title of *Breakdown* was changed to *The Loveless* in 1982). The difficulties Bigelow encountered with this film (and others) may not be due simply to its focus on surface detail, but on Bigelow's art house re-working of traditional Hollywood male genres.

The Loveless is a homage to and re-definition of the biker teen movie, epitomized in the classical Hollywood film *The Wild One* (1953) and further developed in Kenneth Anger's underground film *Scorpio Rising* (1964). The Loveless therefore combines (and mediates between) the aesthetics of the classical Hollywood film and the underground film.

Bigelow explains the deliberate lack of cause-effect logic in the film:

The Loveless was a psychological bikers' film. We wanted to suspend the conventional kind of plotting where everything spirals into problem solving after problem solving, and create a meditation on an arena, on an iconography, using the bikers as an iconography of power.

Quoted in Christina Lane, 'From *The Loveless* to *Point Break*: Kathryn Bigelow's trajectory in action', *Cinema Journal*, p. 65

Bigelow is not simply using the iconography of traditional genres, but is taking one step back to create a meditation on the iconography of genres, a position that, some critics say, makes *The Loveless* appear to be a cold, emotionless film.

The Loveless foregrounds one of the most common characters in Bigelow's film-making: the androgynous female. Telena

(Marin Kanter) in *The Loveless* is followed by Mae (Jenny Wright) in *Near Dark* (1987), Megan (Jamie Lee Curtis) in *Blue Steel* (1990), Tyler (Lori Petty) in *Point Break* (1991), and Maya in *Zero Dark Thirty* (2012).

There is violence in *The Loveless*, but far less than in other Bigelow films such as *Blue Steel*, *Point Break* and *Strange Days*. No rape is shown on screen (as it is in *Blue Steel* and *Strange Days*), but it is implied (in the form of incest committed against Telena). We need to keep in mind that *The Loveless* is Bigelow's most explicitly independent art house movie. She cowrote and co-directed it, and it has a leisurely pace, like many independent films.

Her next film, *Near Dark*, also represents a counter-cultural lifestyle. A hybrid horror-vampire movie and Western, it has a cult following. Her following films gradually become more studio oriented – *Blue Steel*, *Point Break*, *Strange Days*, *K-19* (2002), *The Hurt Locker* (2008) and *Zero Dark Thirty* (2012) – although they still (to a greater or lesser extent) mix genres and contain an art house sensibility. Only in the *Weight of Water* did Bigelow return to a more overt independent style of film-making.

Bigelow's status as a Hollywood film-maker raises an important question: Should women specialize in making feminist films?

SHOULD WOMEN SPECIALIZE IN MAKING FEMINIST FILMS?

The opportunities are still limited for women in Hollywood – in terms of both directing and producing – and so it seems appropriate for women to exploit their chances by developing women-themed film projects that rarely get made in Hollywood.

Holden Jones said the following about her film Love Letters (1983):

It's feminist in that it's rare to have a film that's entirely about a woman, and an experience that's very female, and which treats her and her female friends as worthy of sustaining an entire movie, focusing on her relationship with her mother as opposed to some guy's relationship with his father or friends for the hundredth time.

Quoted in Hillier, The New Hollywood, pp. 130-1

Seidelman meanwhile says that:

All my films have a strong female protagonist, and I've always tried to show the women from an insider's point of view as opposed to an outsider's point of view.

Quoted in Hillier, The New Hollywood, p. 131

And Coolidge said about her film Rambling Rose (1991):

A man might really have simplified the women in this movie and cast Rose as a bimbo. I felt that I was sympathetic to the male point of view but I was also the guardian of those women.

Quoted in Hillier, The New Hollywood, p. 131

However, Mary Lambert, who directed Pet Sematary (1989) and The In Crowd (2000), and Bigelow argue that the label 'woman director' is sexist, since the job of director is genderless in its classification: directing is not a gender-defined skill. Being labelled a woman director can restrict the kind of material a film-maker has a chance to work with. 'This notion that there's a woman's aesthetic, a woman's eye, is really debilitating. It ghettoizes women' (Bigelow, quoted in Hillier, p. 127). Both Lambert and Bigelow have managed to make horror and actionoriented films, genres usually thought to be masculine. But do directors such as Lambert and Bigelow simply end up imitating male directors? In the end, what counts in Hollywood is the box office, Jim Hillier reminds us. If a women-themed movie makes money at the box office, then more will be made. This places an extra pressure and responsibility on women directors to make commercially successful films.

The contemporary auteur

The *auteur* is no longer just a critical category, but also an industry category. In contemporary Hollywood, this is due to new production practices. Instead of the assembly-line production of the old Hollywood system, where stars, directors and technicians were tied to long-term contracts, in

contemporary Hollywood, talent is hired on a film-by-film basis. Rather than a few directors being defined as *auteurs*, every director has to set him- or herself up as an *auteur* in order to get work. Directors must establish for themselves a distinct visual style so they can be considered for a particular project:

By treating film-makers as independent contractors, the new production system places particular emphasis on the development of an idiosyncratic style which helps to increase the market value of individual directors rather than treating them as interchangeable parts. Directors such as Steven Spielberg, David Lynch, Brian DePalma and David Cronenberg develop distinctive ways of structuring narratives, moving their camera, or cutting scenes which become known to film-goers and studio executives alike. The emergence of the auteur theory in the 1960s provided these directors with a way of articulating and defending these stylistic tendencies as uniquely valuable.

Henry Jenkins, 'Historical Poetics' in *Approaches to Popular Film*, Joanne Hollows and Mark Jancovich, p. 115

Spotlight

One can argue that contemporary Hollywood directors are marketed as *auteurs*, with their own brand image. The director's name is used to achieve pre-production deals (as a director's name can guarantee to the studio executives a certain style of film-making) and particularly in the distribution and marketing of films: *Batman and Robin* (1997) is identified in its trailer as 'A Joel Schumacher Film', *The Lost World: Jurassic Park* (1997) is clearly identified as 'A Steven Spielberg Film', and so on.

Dig deeper

Caughie, John (ed.), *Theories of Authorship* (London: British Film Institute, 1981).

A representative sample of essays on the various schools of *auteurism*, although Caughie has taken the liberty of shortening a number of the papers, in some cases quite drastically.

Cook, Roger and Gemünden, Gerd (eds), *The Cinema of Wim Wenders: Image, Narrative, and the Postmodern Condition* [Michigan: Wayne State University Press, 1997].

A wide-ranging collection of essays that serves both as an introduction to Wenders's cinema and a detailed discussion of specific films (including *Until the End of the World* and *Wings of Desire*).

Douchet, Jean, Alfred Hitchcock (Paris: 1967; Cahiers du Cinema, 1999).

Elsaesser, Thomas, 'Germany's Imaginary America: Wim Wenders and Peter Handke' (1986), available from the author's website: http://www.thomas-elsaesser.com/index.php?option=com_content&view=article&id=78&Itemid=68

Hillier, Jim (ed.), Cahiers du Cinéma, the 1950s: Neo-Realism, Hollywood, New Wave (Cambridge, Mass: Harvard University Press, 1985); The 1960s: New Wave, New Cinema, Reevaluating Hollywood (1986).

The first two volumes in a three-volume series publishing representative essays from *Cahiers du Cinéma*. An indispensable collection.

Hillier, Jim, The New Hollywood (New York: Continuum, 1993).

My account of women film directors working in Hollywood is indebted to Hillier's chapter, 'Unequal Opportunities: Women Filmmakers', pp. 122–42.

Jenkins, Henry, 'Historical Poetics' in Joanne Hollows and Mark Jancovich (eds), *Approaches to Popular Film* (Manchester: Manchester University Press, 1995), pp. 99–122.

Jenkins offers an overview to the internal (or poetic) approach to the cinema. A useful supplement to the first part of this book.

Jermyn, Deborah and Redmond, Sean (eds), *The Cinema of Kathryn Bigelow: Hollywood Transgressor* (London: Wallflower Press, 2003).

A series of academic essays on Kathryn Bigelow, including a detailed case study of *Strange Days*.

Lane, Christina, 'From *The Loveless* to *Point Break*: Kathryn Bigelow's Trajectory in Action', *Cinema Journal*, 37, 4 (1998), pp. 59–81.

A scholarly examination of the first four films of Bigelow's career, focusing on gender issues.

McMahan, Alison, Alice Guy Blaché: Lost Visionary of the Cinema (New York: Continuum, 2002).

A detailed history of the work of the first woman film-maker.

Perkins, Victor, Film as Film: Understanding and Judging Movies (Harmondsworth: Penguin Books, 1972; New York: Da Capo Press, 1993).

An important book on the criticism and evaluation of narrative films. Perkins combines the approaches of both the realists and formalists (see Chapter 1 of this book) by arguing that film is a hybrid medium, consisting of both realist and formalist tendencies. To be evaluated as good, each film needs to create a balance between realism and formalism. A film can achieve this balance, according to Perkins, by firstly producing images that conform to the realist principles of credibility (of being 'true-to-life'), and secondly, by unobtrusively adding symbolic meanings (or significant form) to these realistic images.

Rohmer, Eric and Chabrol, Claude, *Hitchcock: The First Forty-Four Films* (New York: Ungar, 1979).

The first book-length study of Alfred Hitchcock's films, first published in French in 1957 by two prominent writers for *Cahiers du Cinéma*

Sarris, Andrew, *The American Cinema: Directors and Directions:* 1929–1968 (New York: Da Capo Press, 1996).

First published in 1968 and fortunately republished by Da Capo Press, this is the bible of *auteur* studies. The 11 categories in which Sarris places various directors ('Less than meets the eye', 'Make way for the clowns!') may be a little quirky, but the dictionary-length and mini essays on, predominately, American directors are invaluable.

Shivas, Mark, 'Minnelli's Method', Movie, 1 (1962), pp. 17-18.

Shivas examines how Vincente Minnelli's films transcend their scripts via *mise-en-scène*.

Truffaut, François, 'A Certain Tendency of the French Cinema' in Bill Nichol (ed.), *Moves and Methods* (Berkeley: University of California Press, 1976), pp. 224–37.

Truffaut's celebrated and controversial attack on the French 'tradition of quality' and his promotion of the film director as auteur.

Vincendeau, Ginette (ed.), Encyclopedia of European Cinema (London: Cassell, 1995).

A comprehensive and informative reference book with a slight bias towards French cinema. The longer entries are particularly valuable.

Walker, Michael, *Hitchcock's Motifs* (Amsterdam: Amsterdam University Press, 2005).

The author painstakingly enumerates the major themes and motifs that recur in Alfred Hitchcock's films.

Wood, Robin, Hitchcock's Films (London: Zwemmer, 1965).

Wood's celebrated *auteurist* study of Hitchcock, revised and updated several times since its first publication in 1965.

Focus points

- ★ The aim of the auteur policy is to distinguish between directors as artists (auteurs) and directors as mere technicians (metteurs-en-scène).
- * An auteur is a director who manifests a consistency of style and theme across his or her films.
- * The director is privileged by *auteur* critics because he or she is the one who visualizes the script on screen.
- * The auteur policy was formulated by François Truffaut in his essay 'A Certain Tendency of the French Cinema', in which he attacks the French 'tradition of quality' school of filmmaking, particularly for its over-reliance on scripts. Auteur critics privilege the work of Hollywood directors (including Hitchcock, Hawks, Welles, Lang, Ford, Sirk, Fuller and Ray) whose visual style transcends the scripts imposed on them by the studios.
- Many of the auteur critics associated with Cahiers du Cinéma in the 1950s (Truffaut, Godard, Chabrol, Rohmer and Rivette) started to make their own auteur films in the 1960s; they abandoned the script in favour of improvisation and spontaneity.
- * The auteur policy was developed in Britain in the magazine Movie and in North America by Andrew Sarris.
- * Hitchcock is identified by all *auteur* critics as an undisputed *auteur* because of his consistency in style and themes.
- ★ Hitchcock's style consists of: 1) an emphasis on editing and montage; 2) a high number of point-of-view shots; 3) filming in confined spaces, which provided Hitchcock with challenges on how to construct scenes.
- Hitchcock's themes include: 1) a narrative involving an investigation (usually of a murder), in which the film's protagonist is either the investigator or the one who is investigated; 2) confession and guilt; 3) suspense; 4) the perfect murder; 5) the wrong man.
- * Wenders is an auteur of the New German Cinema.

- ★ The main themes in Wenders's films include: 1) the influence of North American culture; 2) road movies; 3) male bonding; 4) the impossibility of male-female relationships.
- * The main stylistic elements in Wenders's films include:
 1) an emphasis on the image, rather than narrative; 2) an emphasis on dead time.
- * Bigelow's style consists of: 1) a strong, distinctive visual style based on moody lighting; 2) visceral textures; and 3) an editing pace that is either slow of hyperkinetic. Bigelow's consistent themes include: 1) rebellious male characters; 2) strong androgynous female characters; 3) a counter-cultural lifestyle; and 4) graphic violence.

(4) A second consistent of the property of

there there is an interest of the exception of the except

A Latin to make the smallest of the species of the control of the

And the second of the second o

4

Film genres: defining the typical film

In this chapter you will learn about:

- the differences between auteur and genre studies of film
- two approaches to the study of genre films: the descriptive approach and the functional approach, plus the strengths and weaknesses of each
- new studies of melodrama films ('the fallen woman film', the 'melodrama of the unknown woman' and the 'paranoid woman's film')
- classical and new (or 'neo') films noirs, including an overview of the career of neo-film noir director John Dahl
- ▶ 1950s science fiction films such as Invasion of the Body Snatchers, and their ambiguous political meanings.

Genre movies have comprised the bulk of film practice, the iceberg of film history beneath the visible tip that in the past has commonly been understood as film art.

Barry Keith Grant, Film Genre Reader, p. xi

What the film critic, who sits blindly through films week after week, could be expected to do is to contribute to an aesthetic of the typical film.

Lawrence Alloway, 'The Iconography of the Movies', p. 4

The genre film is the mass-produced product of the Hollywood film industry. Whereas the *auteur* approach to Hollywood cinema, discussed in the previous chapter, privileges invention and personal creation, the study of genre privileges convention and collective meaning.

Spotlight

Auteurism emphasizes the uniqueness of a film, whereas genre study emphasizes the similarities that exist between a group of films. Genre study privileges a film's conformity to a pre-existing set of conventions.

More accurately, *auteurism* identifies the common attributes that make an individual director's films unique, whereas genre study identifies the common attributes that define a particular group of films. *Auteurism* groups together a small body of films according to their specific stylistic attributes, which are equated with the director's authorial signature. Genre study groups together a large body of films according to the common attributes that make that film a typical example of its type.

The contrast between *auteurism* and genre study can be spelled out in the following terms:

Genre study privileges what is general, standard, ordinary, typical, familiar, conventional, average and accepted in a group of films. Auteurism privileges what is specific, unique, unusual, inventive, exceptional and challenging in a group of films.

The same film, of course, can be analysed from the perspective of genre study or auteurism. Each perspective will simply privilege different aspects of the film. For example, Blonde Venus (1932) has been studied both as a genre film - a melodrama - and as an auteurist film - a film by the well-known auteurist Josef von Sternberg, containing the typical attributes of his mise-en-scène, such as shallow depth, created by lace or netting occupying the foreground and covering the entire image, which obscures the story and characters in favour of reducing story space to an abstraction, emphasizing pattern, texture and rhythm (indeed, Sternberg downplayed story and character to such an extent that he wanted his films to be projected upside down!). Below I shall discuss Blonde Venus as a melodrama.

There are two main approaches to genre: a descriptive approach and a functional approach. A descriptive approach divides up the Hollywood cake into genre slices and defines each genre according to its properties, or common attributes. But it is not sufficient merely to describe the common attributes of each genre. This descriptive approach needs to be supplemented by an approach that defines the function of genre films. Below we shall see how the notion of genre enables us to determine the relation between a film and the society in which it is produced and consumed. This involves defining the genre film as a cultural myth. In the second part of this chapter we shall see how genre critics have attempted to describe and define the function of three film genres: the melodrama, the film noir and the 1950s science fiction film.

Problems in the study of genres

The word 'genre' means 'type' or 'category'. To study a film as a genre involves treating it, not as a unique entity, but as a member of a general category, as a certain type of film. In the descriptive approach, a film is subsumed under a particular genre category if it possesses the necessary properties or attributes of that genre. The aim of the descriptive approach to genre is therefore to classify, or organize, a large number of films into a small number of groups. Yet, in film studies at least, this process of classification does not systematically organize films into genres. This is because the boundaries between film genres are fuzzy, rather than clearly delineated. Moreover, genres are not static, but evolve. Therefore, their common attributes change over time. Many films are hybrid genres, since they possess the common attributes of more than one genre. A typical example is the singing cowboy film, which possesses the attributes of both the musical and the Western.

Spotlight

In an interview, David Lynch (director of *Lost Highway*) says, 'I don't like pictures that are one genre only, so [*Lost Highway*] is a combination of things. It's a kind of horror film, a kind of a thriller, but basically it's a mystery. That's what it is. A mystery' (Lynch, David and Gifford, Barry, *Lost Highway*, 1997, p. xiii).

Further problems arise in the descriptive approach. For example, how do we define genres? Do we rely on categories identified by the film industry, or categories defined by film critics? And how do we identify the common attributes of genres? If we start by grouping films together and then identifying their common attributes, we must ask ourselves, 'Why did we group these particular films together?' If you answer that it is because of their common attributes, then you have pre-empted the descriptive aim of genre study, which is precisely to identify those common attributes.

The descriptive approach to genre is therefore fraught with difficulties. At the end of this chapter we shall see that the functional approach also raises difficulties. But despite these difficulties, I shall still endeavour to see what results both the descriptive and functional approaches to film genre have so far achieved.

Genre film as myth

Genre films create expectations that condition our responses. The familiarity of the genre film enables each spectator to anticipate and predict what will appear in them. The genre film sets up hopes and promises and brings pleasure if these hopes

and promises are fulfilled. In studying genre films, we first need to isolate the patterns and themes that appear repeatedly in them. For genre critics, these recurring patterns are not merely formal patterns; instead, they reflect the basic questions, problems, anxieties, difficulties, worries and, more generally, the values of a society and the ways members of that society attempt to tackle those basic questions and problems. A genre film is satisfying, then, if it addresses those questions and problems that spectators expect it to address. The genre film is a form of collective expression, a mirror held up to society that embodies and reflects the shared problems and values of that society.

The genre film also offers solutions to those problems, and reinforces social values. Of course, a genre film cannot offer real solutions to real questions and problems; its solutions are imaginary and idealistic. But this may explain one of the attractions of the cinema, and the genre film in particular: it offers imaginary answers to real problems, although during the film, these answers seem to be more than mere fantasy. It is only upon leaving the movie theatre, as we try to get home, or after we switch off the television, that the real problems begin to emerge again.

From this discussion of the function of genre films, we can argue that watching them is a form of cultural ritual. To study genre films is one way of studying the culture that produces and consumes them. Barry Keith Grant argues that:

Surely one of our basic ways of understanding film genres, and of explaining their evolution and changing fortunes of popularity and production, is as collective expressions of contemporary life that strike a particularly resonant chord with audiences. It is virtually a given in genre criticism that, for example, the '30s musicals are on one level 'explained' as an escapist Depression fantasy; that film noir in the '40s expressed first the social and sexual dislocations brought about by World War II and then the disillusionment when it ended; and that the innumerable science fiction films of the '50s embodied cold war tensions and nuclear anxiety new to that decade.

Experience and Meaning in Genre Films', Film Genre Reader, pp. 116-17

The genre film offers a lesson in how to act within society and how to deal with current problems and anxieties. But it does not offer neutral ways of dealing with social problems. Instead, it prescribes a preferred set of values, those of capitalist ideology, with its emphasis on the individual: the individual's right of ownership, private enterprise and personal wealth, the nuclear family with the wife staying at home and the husband working, the necessity of conforming to moral and social laws and so on.

New studies of melodrama

In the following pages we shall review the common attributes of film melodrama and then look at recent studies that have divided up the genre of melodrama into thinner slices. The genre of melodrama has been exhaustively studied; see, for example, the books by Barbara Klinger, Christine Gledhill and Jackie Byars (Dig deeper). Rather than attempt to summarize this enormous body of work and repeat its conclusions, it is more beneficial to concentrate on narrowly focused studies. But first, a few general remarks.

Historically, melodrama has replaced religion as a way of thinking through moral issues and conflicts. As with religion, the function of melodrama is to clarify ethical choices that we have to make in our lives. This is why the conflict between good and evil is central to melodrama. But rather than focusing on the sacred, as religion does, melodrama focuses on moral issues and conflicts as experienced by ordinary people on a personal, everyday basis.

The genre of the film melodrama is frequently defined as a woman's genre, because it represents the questions, problems, anxieties, difficulties and worries of women living in a male-dominated, or patriarchal, society. The first and most prevalent property, or common attribute, of melodrama is that it is dominated by an active female character. Below I have attempted to list the melodrama's primary attributes.

- A woman often dominates the narrative of the melodrama.
- Melodrama narrates the perspective of the victim; in conjunction with the above attribute, melodrama can be said to turn its female character into a victim.
- Melodrama makes moral conflict its main theme or subject matter, particularly the moral conflicts experienced by women within a patriarchal society.
- Melodrama is usually based on an omniscient form of narration. Chapter 2 illustrates omniscient narration by means of Douglas Sirk's melodrama Magnificent Obsession.
- The plot of melodrama consists of unexpected twists and sharp reversals in the storyline.
- The plot of melodrama also consists of chance events and encounters.
- Secrets dominate the melodrama plot.
- Finally, the melodrama contains dramatic knots, which complicate the plot and create the moral conflicts.

Almost all melodramas contain some or all of these attributes, although not all are dominated by women. A number of Sirk's films (such as Written on the Wind, 1956, and Tarnished Angels, 1957) are called male melodramas because their narratives are dominated by men, who are set up as victims, and who experience moral conflicts because they cannot live up to the roles carved out for them by a patriarchal society.

We shall now look at the more narrowly focused studies of melodrama. We shall first consider what Lea Jacobs calls the 'fallen woman' film and then analyse Blonde Venus (von Sternberg, 1932) as a fallen woman film. I shall then discuss what Stanley Cavell, the philosopher, calls the 'melodrama of the unknown woman' and then analyse Only Yesterday (John Stahl, 1933) as a melodrama of the unknown woman. Finally, I shall examine what Mary Ann Doane calls the 'paranoid woman's film' and briefly discuss several films that belong to this subgenre.

THE FALLEN WOMAN FILM

Although the term 'fallen woman film' has been used for some time, it has now been immortalized in a book by Jacobs called *The Wages of Sin: Censorship and the Fallen Woman Film*, 1928–1942 (1991). A representative sample of fallen woman films includes *Anna Karenina* (Clarence Brown, 1935), *Ann Vickers* (John Cromwell, 1933), *Baby Face* (Alfred Green, 1933), *Bachelor Mother* (Garson Kanin, 1939), *Back Street* (Robert Stevenson, 1941), *Blonde Venus* (Sternberg, 1932), *Camille* (George Cukor, 1936) and *Marked Woman* (Lloyd Bacon, 1937).

Jacobs defines this group of films in the following way:

These films concern a woman who commits a sexual transgression such as adultery or premarital sex. In traditional versions of the plot, she is expelled from the domestic space of the family and undergoes a protracted decline.

The Wages of Sin, p. x

Because of the transgressive nature of their subject matter, these films were strongly censored. Jacobs attempts to demonstrate how censorship shaped and defined the fallen woman's film, or, more specifically, how censorship imposed certain narrative conventions on studios which made fallen woman films. The influence of censorship can therefore be found in the way it affected a film's cause–effect logic.

As we saw in Chapter 2, classical narrative films are governed by a cause–effect logic, which means that one action or event is perceived by the spectator to be caused by another action or event. These actions and events are normally carried out by a single character, or small group of characters, who thereby initiate, motivate and link together in a cause–effect logic the film's actions and events across the entire film. However, some actions and events were deemed offensive by film censors. In the early 1930s, due to public pressure (notably by the Legion of Decency, which had 11 million members, and which recommended to all its members that they boycott offensive films), the Hollywood film industry established a form of

self-regulated censorship, in which all film scripts had to be sent to the Studio Relations Committee before shooting began. The film studios then attempted to incorporate the censors' suggestions into the script before shooting, so scripts were primarily censored in Hollywood, not final films. The censors' recommendations usually meant that the film's cause–effect logic had to be distorted, for censorship did not so much affect what was to be depicted in films, but how it was to be depicted.

Jacobs points out that, at the level of the whole film, censorship clearly sought to encourage unambiguous forms of representation (that is, films with a unified moral message). But at the level of the shot and the scene, censors recommended that film-makers represent potentially offensive events in an indirect way. Such a strategy resulted in ambiguous forms of representation.

Jacobs analyses in detail how censorship affected Blonde Venus. Before reviewing Jacobs's analysis, I shall sum up the film's plot. The film centres on a former cabaret performer Helen Faraday (Marlene Dietrich), her chemist husband Ned Faraday (Herbert Marshall) and their son Johnny. Ned develops chemical poisoning which can be cured only in Europe. In order to pay for his journey and his treatment, Helen returns to the stage. While Ned is in Europe being cured, Helen develops an affair with a rich politician called Nick Townsend (Cary Grant). On his return, Ned discovers that Helen is having an affair and tries to take custody of Johnny. Helen goes on the run with Johnny. She falls into destitution and becomes a prostitute. She is found by an undercover cop hired by her husband and gives up her son. She eventually picks herself up and becomes a famous cabaret star in Europe. In Europe, Helen meets Nick and they return to America to enable Helen to see her son again. But, during the visit, Helen decides to remain with Ned and Johnny.

Blonde Venus is clearly a melodrama, for the following reasons. It is dominated by a woman, Helen Faraday, who is also a victim. She is confronted with moral conflicts throughout the film: she has to give up her successful career for a domestic life; she sleeps with Nick in order to obtain the money to cure her husband; she leaves home with her child when her husband finds out that she

is having an affair; she gives up her child and eventually returns home again. These are not straightforward choices that Helen makes; each requires a sacrifice and creates a moral dilemma. Moreover, many of these dilemmas are shared by most women living in a patriarchal society. There are several unexpected twists and sharp reversals in the plot: Ned returns early from Europe, which is how he finds out about his wife's affair (the main secret in the film); and Helen very quickly pulls herself out of destitution and becomes a cabaret star in Europe. Ned and Helen first meet each other by chance while Ned is on a walking tour in Germany, and Helen and Nick meet by chance in Europe at the time that she has become a famous cabaret star.

According to the censors, there were three basic problems with *Blonde Venus*: 1) the affair between Helen Faraday and Nick Townsend; 2) scenes of Helen soliciting; 3) the film's ending. The film's director, von Sternberg, incorporated or avoided the censors' criticisms of the script through the manipulation of the film's causal logic.

The script of *Blonde Venus* indicates that, after singing one evening in a club, Helen must sleep with Nick in order to obtain \$300 to pay for her husband's treatment in Europe. The depiction of Nick sleeping with Helen was obviously objectionable to the censors, but Sternberg filmed it in such a way as to make it acceptable (but at the cost of making the scene ambiguous). First, we see Helen and Nick in Helen's dressing room. This scene is followed by an insert of Nick writing a cheque for \$300 to Helen, and finally, we see a shot of Helen being driven home.

We do not see Helen go to Nick's apartment to sleep with him. Yet it is precisely this event which motivates (which is the primary cause of) the action of Nick giving the cheque to Helen. All we see is Nick writing out a cheque. The reasons why he does this are not explicitly stated in the film itself. The spectator has to supply the repressed part of the narrative, namely that, after Nick and Helen met in Helen's dressing room, Helen returned to Nick's apartment and slept with him for \$300. So the spectator has to infer the cause of Nick's action of writing the cheque.
Later in the film, Nick offers Helen an apartment while her husband is in Europe. But we do not directly see or hear Helen agree with Nick's proposal. We know that she has taken up Nick's offer only when she returns to her own empty apartment to pick up the mail. As with the scene just described, this is an indirect representation of events that the censors found objectionable (namely, a married woman living with another man). This part of the film is indirectly stating that Helen is living with Nick in his apartment. But because we do not see on the screen Helen cohabiting with Nick, the censors cannot object. With only a small amount of information, the spectator can infer the cause of Helen's return to her own apartment to pick up the mail, namely that she took up Nick's offer to live in his apartment. Rather than happening on screen, the film prompts the spectator to infer the objectionable material.

During her fall - that is, when she runs away, taking her son Johnny - Helen resorts to prostitution. The censors objected to a number of scenes in the script where Helen walks the streets and solicits men, is arrested by an undercover cop and is then charged in court with soliciting. In the actual film, the scene of Helen walking the streets and soliciting has been removed. Nonetheless, she still appears in court (although she is arrested for vagrancy, not soliciting). Helen therefore appears in court without motivation - she is not shown being arrested or causing a nuisance. In one scene we see her and Johnny take a ride on a hay cart. Cut to a shot of a card from the bureau of missing persons which indicates that Helen has been sighted. Cut again to Helen being led into court on the charge of vagrancy.

An event consisting of what censors regarded to be objectionable material but which is crucial to the cause-effect logic of the film is eliminated, resulting in an ambiguous, elliptical sequence. Later in the film, we do see Helen soliciting (she picks up the undercover cop) but this scene is not motivated in order for Helen to gain money from sex; rather, it is motivated so that Helen can humiliate the undercover cop (obviously acceptable to the censors!).

Finally, we need to say something about the ending of Blonde Venus. In one version of the script, Helen's husband Ned is

reported to have had an affair with the housekeeper. This would then have given Helen sufficient reason to keep her son and to marry Nick Townsend. In this version of the ending, Helen retains her successful career in show business, keeps her son and marries the romantic lead. But the censors objected that this ending violated what they called the 'rule of compensating moral values', which states that all immoral actions must be compensated for in the film by means of the punishment of the immoral character or through the redemption of her immoral ways. But in this unfilmed ending of Blonde Venus, Helen's immorality (living with Nick, soliciting, etc.) is not compensated for; it is merely paired off with an immoral action performed by her husband. Sternberg's decision in the final script to end the actual film by pairing off husband Ned to his wife Helen was acceptable to the censors because it meant that Helen gives up Nick Townsend and her successful show business career in order to return to a domestic life for the sake of her son. Thus, Helen's illicit love affair and soliciting are compensated for at the end of the film by her maternal affections and her conformity to patriarchal values.

THE MELODRAMA OF THE UNKNOWN WOMAN

For Cavell, 'failure' is the defining characteristic of the melodrama of the unknown woman. This failure is an inability to recognize - the male character's failure to recognize a woman from the past with whom he had a brief love affair. But it is also a matter of the female character's failure to prove her existence to a man - that is, her failure to be recognized by a man with whom she had a brief love affair. The female character is in control of all the relevant information, whereas the male character is distinguished by his ignorance. The moral conflict and the secret and the dramatic knot of the melodrama of the unknown woman are generated by the male character's lack of recognition of the female character. The moral conflict in the melodrama of the unknown woman can be summed up by the following question: How should the unknown woman make her presence known to the man she once loved? Furthermore, does she reveal to him the secret that only she remembers? The dramatic knot of these films is represented as a struggle: 'The woman's struggle is to understand why recognition by the man

has not happened or has been denied or has become irrelevant' (Stanley Cavell, *Contesting Tears*, p. 30). Perhaps it would have been more accurate if Cavell called this subgenre the 'melodrama of the forgotten woman', because it clearly involves a loss of memory.

Cavell takes Gaslight (George Cukor, 1944), Letter From an Unknown Woman (Max Ophuls, 1948), Now, Voyager (Irving Rapper, 1942) and Stella Dallas (King Vidor, 1937) to be the quintessential melodramas of the unknown woman. But, as my own following analysis will attempt to demonstrate, Only Yesterday (John Stahl, 1933) is also a melodrama of the unknown woman, a film Cavell does not mention at all.

Only Yesterday opens on the day of the Wall Street Crash. Jim Emerson (John Boles) loses all his, and his friends', money. He goes into his study to commit suicide, but finds a long letter on his desk. The film then returns to the past to follow the story narrated in the letter. The letter begins with Jim, in uniform, meeting Mary Lane (Margaret Sullavan) at a party for soldiers. They leave the party together to walk by a lake. When they return to the party, they discover that everyone has left so Iim walks Mary home. Jim leaves to fight in the war without saying goodbye to Mary. Later, Mary talks to her mother, who is saddened and ashamed by the news that Mary tells her (we find out only later what the news is: that Mary is pregnant). Mary goes to New York to stay with her aunt Julia. Mary has a baby boy and, later, goes to greet Jim as he returns from the war. But Jim fails to recognize Mary, Mary, who continues to live with aunt Julia, brings up her son on her own, and also works successfully as a fashion designer. Several years later, Mary meets Jim again at a new year's party. Jim still does not recognize her. Soon afterwards, Mary falls ill and decides to write the letter to Iim. She finishes just before she dies. We then return to Jim reading the letter. He rushes to Mary's home, but is too late, as Mary has died. However, Jim introduces himself to his son.

What defines Only Yesterday as a melodrama of the unknown woman is Jim Emerson's inability to recognize Mary as he returns from war (or, from the opposite point of view, Mary's

failure to get herself recognized by Jim). This structure of unknownness is made more dramatic by the fact that Jim just happens to be the father of Mary's illegitimate child.

Mary's misfortune in becoming pregnant out of wedlock is therefore compounded by Jim's failure to recognize her. Mary could have become a fallen woman as well as an unknown woman if it wasn't for her broad-minded aunt Julia in New York. Julia remarks that 'this type of thing isn't even good melodrama' by which she presumably means nineteenth-century literary and theatrical melodrama, in which the sexually transgressive woman automatically becomes a fallen woman and an outcast from society. Aunt Julia prevents Mary from becoming a fallen woman, but she cannot prevent her from becoming an unknown woman.

There are a few seconds of dramatic tension during Jim's return from the war, as we see Mary's face in extreme close-up as she finally realizes that Jim does not recognize her, which becomes the crucial moment in the film's definition as a melodrama of the unknown woman. This crucial moment consists of a brutal discrepancy of knowledge between Jim and Mary, and, correspondingly, between Jim and the spectator, for the film is, of course, taking the point of view of the female victim. This discrepancy of knowledge is created by means of omniscient narration, a defining characteristic of melodrama. The whole of the film's narrative is then focused on the resolving of this discrepancy. However, this resolution is retarded through Mary's self-sacrifice (and later, through her realization that Jim has married another woman). The discrepancy is overcome only after Mary writes a letter to Jim on her deathbed.

Moreover, we must remember that the discrepancy of knowledge in the film is overlaid by an illicit sexual relationship that resulted in a pregnancy. Such a transgression must be punished, according to the censor's logic of compensating moral values. Punishment is realized in the melodrama of the unknown woman in the woman's death and/or in the death of the illicit child. Here we can note a fundamental difference between Max Ophuls's 1948 film *Letter From an Unknown Woman* and *Only Yesterday* (films which are otherwise quite

similar to one another). In Ophuls's film, both the unknown woman and her illegitimate child die, whereas in Only Yesterday, the child lives but the mother dies.

This difference between the two films is crucial for understanding the role of the father in the melodrama of the unknown woman. Because both the illegitimate child and the unknown woman die in Letter From an Unknown Woman, these two deaths can be compensated for only through the father's death and Letter From an Unknown Woman ends with the father preparing to fight a duel he will surely lose. In Only Yesterday, however, the illegitimate child lives, permitting the father to redeem himself by looking after the child, since the mother has recently died (as is common in melodramas, the father has arrived 'too late'). Mary's death at the end of Only Yesterday is a compensation for her illicit sexual transgression (as well as her success as a businesswoman). At the beginning of Letter From an Unknown Woman, we see the father, Stefan, preparing to leave Vienna, after being challenged to a duel. But after reading the letter from Lisa, the unknown woman, Stefan changes his mind and decides to fight the duel which will lead to his death. The opposite happens in Only Yesterday. Iim is just about to commit suicide after losing all his money (and all the money of his friends) during the Wall Street Crash. But after reading Mary's letter, Jim finds new hope and rushes off to see his son. The letter in both films therefore initiates a turning point in the film's narrative, for it dramatically changes the course of events for the male character. This is all the more noticeable in Only Yesterday, because it takes over 16 minutes of screen time before Mary's letter is discovered. The film has taken over a quarter of an hour to introduce a number of characters who have been affected by the Wall Street Crash, which leads us to believe that the rest of the film will be concerned with the aftermath of the Wall Street Crash and its effects on these characters. But then Mary's letter dramatically changes the course of the film by introducing a long flashback.

We need to return to the moment when the film communicates Mary's pregnancy to the spectator. The illicit affair and subsequent pregnancy is represented in an indirect manner,

as is the potentially offensive material in *Blonde Venus*. But unlike *Blonde Venus*, *Only Yesterday* contains moments that are simultaneously under-represented and over-represented. The illicit love affair and Mary's pregnancy is under-represented in the sense that it is never explicitly stated in the film that Mary is pregnant. The film openly acknowledges Mary's condition only when the baby is born. Nonetheless, Mary's condition is over-represented in the sense that, throughout several scenes, the film continually hints at Mary's illicit love affair and pregnancy.

As Mary and Jim walk towards the lake in the moonlight, there is a several second fade out. After the fade in, Jim and Mary are seen hurriedly walking away from the lake. They pause while Jim re-ties Mary's sash; the camera then cuts to a medium close-up of Mary's face, emphasizing her guilty expression. In effect, this part of the film – or, more precisely, the fade and Jim's action of re-tying Mary's sash – is indirectly saying that Mary and Jim have just had sexual intercourse.

After the scene in which Mary learns that Jim has gone to war, we cut to a scene in which Mary argues with her mother as her mother talks about the family being disgraced. Mary decides to stay with her broad-minded aunt Julia in New York, who talks about 'it' being just another one of those biological events. In total, Mary talks about her pregnancy with her mother and aunt Julia for over three and a half minutes of screen time, without actually mentioning the word 'pregnant'. Compare this long-winded form of indirect representation with the extremely short, elliptical narrative elisions in Sternberg's Blonde Venus. Additionally, like Blonde Venus, Only Yesterday is representing the problems and difficulties that women experience in a patriarchal society, but in the case of Only Yesterday, the difficulties involve pregnancy out of wedlock.

THE PARANOID WOMAN'S FILM

In the paranoid woman's film, a subgenre identified by Doane in her book *The Desire to Desire*, the active female character is inflicted with mental states such as paranoia. In addition to possessing some or all of the attributes of the melodrama, the paranoid woman's film also contains one or more of the following three attributes:

- It is based on a wife's fear that her husband is planning to murder her (the institution of marriage is haunted by murder).
- The husband has usually been married before, and his previous wife died under mysterious circumstances.
- It contains a space in the home not accessible to the female character.

The narrative structure of the paranoid woman's film derives from the gothic novel, from Ann Radcliffe to Daphne du Maurier and beyond. Indeed, the first paranoid woman's film, Alfred Hitchcock's Rebecca of 1940, is based on du Maurier's novel of the same title. Other films belonging to the genre include Gaslight (Cukor, 1944), Jane Eyre (Robert Stevenson, 1943), The Spiral Staircase (Robert Siodmak, 1945), The Two Mrs Carrolls (Peter Godfrey, 1947) and Secret Beyond the Door (Fritz Lang, 1947).

In terms of the first attribute, how does the wife begin to fear that her husband is planning to murder her? It is precisely from the other two attributes of the paranoid woman's film, the death of the first wife and the secret that the husband keeps locked behind closed doors (both attributes refer to the folk tale Bluebeard). In Hitchcock's film Rebecca, Rebecca was the first wife of the male lead Max de Winter. Like the first wife of the male leads in most paranoid woman's films, Rebecca died under mysterious circumstances. In Secret Beyond the Door, the first wife of Mark Lamphere, called Eleanor, also died under mysterious circumstances. In The Two Mrs Carrolls, the first Mrs Carroll suddenly dies when Mr Carroll (Humphrey Bogart) decides to marry Sally (Barbara Stanwyck). But after one and a half years of marriage, Sally falls ill and at the same time discovers that Mr Carroll has fallen in love with another woman. After the husband tells her a number of lies, Sally finally realizes that Mr Carroll is planning to murder her.

The secret kept behind a locked door is the second attribute that leads to the woman's paranoia. In Jane Eyre there is, of course, the secret locked in the tower room, which is concealed from Jane. In Gaslight, the locked room is the attic where

the husband searches for his dead aunt's jewels. It is precisely the husband's searching, which creates strange sounds and which dims the gaslight in the wife's room, that helps drive her paranoia. In Rebecca, both the boathouse cottage and Rebecca's bedroom are barred to the new Mrs de Winter. And in The Two Mrs Carrolls, it is the husband's painting studio that is kept locked. In the studio, Mr Carroll has painted a portrait of Sally, which he keeps out of Sally's view (for it is the custom of Mr Carroll to paint a 'death' portrait of his wife after he has decided to murder her). Mr Carroll inadvertently leaves the key to the studio with his daughter (the daughter of the first Mrs Carroll) and so Sally and the daughter (called Bea) decide to enter the studio when Mr Carroll is in London. It is entering the forbidden room in order to satisfy her curiosity that drives Sally paranoid, for she is confronted with her husband's unflattering 'death' image of her.

The main motivation that drives the narrative in the paranoid woman's film is for the second wife (the second Mrs Carroll, the second Mrs de Winter in Rebecca, Celia Lamphere, the second wife of Mark Lamphere in Secret Beyond the Door) to distinguish herself from the first wife in order to gain her own identity and avoid suffering the same fate as the first wife. Many commentators have noted that the gothic narrative emphasizes the closeness of mother and daughter and, also, emphasizes the daughter's fear of being like her mother. This is therefore one of the fears the paranoid woman's film represents. Perhaps we could argue that the function of the paranoid woman's film is very specific: to represent a woman's fear of being like her mother. And because the narrative of the paranoid woman's film is motivated by the second wife's attempts to distinguish herself from the first wife, we can argue that the function of the paranoid woman's film, as with gothic narratives in general, is to convince women that they are not their mothers.

Doane therefore defines the paranoid woman's film, not only in terms of its common attributes, but also according to its function, the way it addresses the fears and anxieties of the female audience.

Film noir

For many film critics film noir does not refer to a genre, but to a style within the thriller or gangster film. However, I think that film noir does have a sufficient number of attributes and a cultural function that can identify it as a legitimate genre. Here I shall review the common stylistic and narrative attributes of film noir and then, briefly, look at its social function.

In terms of mise-en-scène and mise-en-shot (the traditional way of identifying film noir), the film noir has the following attributes:

- expressionist devices, such as chiaroscuro lighting and skewed framing, creating a high contrast image made up of dense shadows, silhouettes, oblique lines and unbalanced compositions
- subjective techniques such as voice-overs and flashbacks
- equal emphasis given to actors and setting.

The film noir style uses the formalist techniques of image distortion discussed in Chapter 1. The film noir's use of these techniques is usually attributed to the influence of German expressionist films (such as The Cabinet of Dr Caligari, 1920) and partly to the fact that many films noirs were directed by European expatriate directors such as Edward Dmytryk, Fritz Lang, Robert Siodmak and Billy Wilder.

In terms of narrative and themes, the film noir has the following attributes:

- in terms of major characters, a femme fatale and an alienated hero, who is usually a private detective living on the edge of the law
- a network of minor characters (who nonetheless play a prominent role), most of whom are morally ambivalent and somehow interrelated
- convoluted and incoherent narratives, created by ambiguous character motivation, the detective following false leads and sudden reversals of action

- the foregrounding of a narrator or a commentator motivates the use of voice-over and flashbacks
- the representation of crime and its investigation
- an emphasis on realistic urban settings (which give some films noirs a semi-documentary look)
- the loss of hope, leading to despair, isolation and paranoia.

Spotlight

The femme fatale is the dominant attribute of the film noir. She is presented as a desirable but dangerous woman, who challenges patriarchal values and the authority of male characters. In fact, the film noir can be described as a struggle between the transgressive femme fatale and the alienated hero. Sometimes the hero is destroyed but, more often, he overcomes the desirability of the femme fatale and destroys her.

The alienated hero is usually a detective. Films noirs are based on the detective fiction of writers such as Dashiell Hammett, Raymond Chandler, Cornell Woolrich and James M Cain. What is significant about the film noir detective is that he is sharply distinguished from both the gentleman mastermind, such as Sherlock Holmes, and the compliant detective working for the professional police force. The private detective is a lone individual who embodies his own moral law. The emphases in the film noir are on the independent male fighting the criminals, the femmes fatales and the inefficient, corrupt and inhuman government organizations.

These two figures, the *femme fatale* and the alienated detective hero, are a symptom of the upheavals witnessed during the 1940s in North American society. Feminist film critics point out that the *femme fatale* is a 'masculine construct', since she reflects male concern and insecurity over women's changing roles during the Second World War, particularly women's entry into the traditionally male workplace. This signifies women's economic independence, the fact that many women no longer believed setting up a family to be their top priority and that there were fewer jobs available to the men who returned from war.

But the film noir is not simply a reaction to its immediate historical context. It is traditionally thought to reign from 1941 (beginning with John Huston's The Maltese Falcon) to 1958 (with Orson Welles's Touch of Evil). Yet the film noir emerged again in contemporary Hollywood, with films such as The Long Goodbye (Robert Altman, 1973), Chinatown (Roman Polanski, 1974), Body Heat (Lawrence Kasdan, 1981), Blood Simple (Coen Brothers, 1985), The Grifters (Stephen Frears, 1990), Pulp Fiction (Quentin Tarantino, 1994), L A Confidential (Curtis Hanson, 1997), Lost Highway (David Lynch, 1997) and the films of John Dahl, including Kill Me Again (1989), Red Rock West (1993) and The Last Seduction (1994). To end this section on film noir, we shall look at the way Dahl's neo-noir films develop and transform traditional attributes of film noir.

THE NEO-FILMS NOIRS OF JOHN DAHL

In Dahl's debut film Kill Me Again, Fay Forrester (Joanne Whalley-Kilmer) and Vince Miller (Michael Madsen) steal money from the Mafia. Fay double-crosses Vince and steals the money from him. To escape from both the Mafia and Vince, Fav hires a private detective, Jack Andrews (Val Kilmer), to pretend to kill her so that she can have a new identity. Jack is down on his luck and owes money to loan sharks. Yet he is shown to have an honest and integral character. Due to his debts, Jack takes the job, places himself on the margins of the law and becomes caught up in the web of evil spun by Fay, the femme fatale. Fay pays Jack \$5,000 before faking her murder and will pay him another \$5,000 afterwards (she says to Jack, 'I'll pay you \$10,000, half now and the other half after I'm dead', which echoes a similar line uttered in Orson Welles's film noir, The Lady From Shanghai).

After the fake murder, Fay escapes from Jack without paying him the second instalment. He eventually tracks her down in Vegas and they become romantically involved. They decide to run away together, so they plan to fake their own deaths (Fay asks Jack to 'kill me again'), which involves drowning in a lake. Jack hides the money near the lake, to be retrieved in their getaway. But upon retrieving the money, Fay double-crosses Jack, shoots him and takes the bag of money. She escapes, with

Vince, who has caught up with her. However, Vince and Fay are killed in a car crash. Jack survives the shooting and we see him carrying a different bag, which contains the money. He had obviously learnt not to trust Fay completely, so he switched the money to another bag. The film ends with him driving off with the money.

Kill Me Again contrasts the clear, bright, wide open spaces of the desert with the hazy, dark claustrophobic interiors. Unlike traditional films noirs, Dahl's neo-noirs are set away from the city in small towns, a location which irritates the femmes fatales, who want to live in the city. The film's credit sequence consists entirely of shots of the open desert landscape, an unconventional way to begin a film noir.

Fay is the typical femme fatale – she is desirable but dangerous and leads the luckless hero, the private detective Jack, into trouble. She clearly identifies his weaknesses and uses her knowledge of these weaknesses to manipulate him. Fay is relentless in her pursuit of money, doing almost anything to obtain it, switching her allegiance from Vince to Jack and back again when it suits her. She is even willing to shoot Jack when he has served his function.

Finally, it may be worthwhile noting that Dahl makes brief references to the work of Hitchcock throughout his films. In *Kill Me Again*, Jack stages the fake murder of Fay in a motel that looks remarkably like the Bates's motel in *Psycho*. Furthermore, when Jack dumps the car in a lake, it sinks only halfway. The scene is staged in the same way in *Psycho* when Norman sinks Marion's car in the swamp.

Like Kill Me Again, Dahl's second film, Red Rock West, focuses on the lone male, in this instance an injured war veteran Michael Williams (Nicolas Cage). The film begins in the same way as Kill Me Again, in a bright, clear, wide open landscape. Michael applies for a job with an oil drilling team, but his leg injury makes him unemployable. The fact that he refused to lie about his injury shows that, like Jack in Kill Me Again, he has an honest and integral character. But also like Jack, he gets himself into trouble. Out of work and with no money, Michael

ends up in a bar in the small town of Red Rock. Here he is mistaken by the bar's owner, Wayne (JT Walsh) for Lyle, a hired killer. Wayne has hired Lyle to kill his wife, Suzanne (Lara Flynn Boyle) for \$10,000 (\$5,000 before and \$5,000 after the murder). Due to his circumstances. Michael takes the money.

When he meets Suzanne, Michael warns her of her husband's plan. She offers Michael double the money to kill her husband. As the plot becomes increasingly complicated, Lyle, the real hired killer (played by Dennis Hopper) turns up and Michael discovers that Wayne and Suzanne stole \$2 million and are being sought by the FBI. But by this time, Michael has become romantically involved with Suzanne. At first, she is presented as the victim, but once Michael finds out about the money, he realizes that she is duplicitous.

The film comes to an end with Michael, Suzanne, Wayne and Lyle in a graveyard at night, where the money is hidden. When the money is dug up, Wayne is fatally injured and Suzanne shoots Lyle. Suzanne and Michael escape on a freight train with the money, but Suzanne turns her gun on Michael. Luckily for Michael, it is empty. The film ends with Michael throwing both Suzanne and the money off the train; police cars are shown heading towards Suzanne.

In terms of visual motifs, Red Rock West is similar to Kill Me Again. It contrasts the wide open landscapes and small town community with the city. Moreover, when it is not focusing on the landscape, most of Red Rock West takes place at night in dark claustrophobic rooms. In terms of narrative, Red Rock West is almost identical to Kill Me Again. Fay is transformed into Suzanne, Vince into Wayne and Jack into Michael. The films mainly focus on the couple (Fay and Vince/Suzanne and Wayne) stealing money and then double-crossing one another. The honest hero (Jack/Michael), down on luck and money, momentarily transgresses and becomes involved in the couple's conflict, or more accurately, becomes romantically involved with the femme fatale, who eventually double-crosses him once she has used him. But like most femmes fatales, she is punished in the end (in Kill Me Again, Fay dies in a car crash and in Red Rock West, Suzanne is arrested). In both films, the hero escapes.

But in *Kill Me Again*, Jack gets to keep all the money, whereas in *Red Rock West*, the money is lost (except for one batch of notes, which Michael keeps).

Finally, there are a few Hitchcockian moments in *Red Rock West*. Firstly, Michael is set up as 'the wrong man' and, secondly, in a scene on the road, Michael is almost run over, which is filmed in the same way that Roger Thornhill is almost run over in *North by Northwest* (after he escapes from the crop-dusting plane).

The Last Seduction, Dahl's third film, contains many of the noir attributes found in his first two films, but this time there is a change in the film's narrative focus, since The Last Seduction follows the femme fatale. The femme fatale is Bridget Gregory (Linda Fiorentino), who persuades her husband Clay, a doctor (Bill Pullman), to sell medicinal cocaine to a drugs gang for \$700,000. In characteristic Dahl style, Bridget double-crosses Clay and leaves the big city with the money for the small town, in this instance, Beston. Here she is picked up in a bar by Mike (Peter Berg), the naive, weak and luckless hero. She decides to become romantically involved with Mike in order to hide from Clay. She also gets a job in Beston together with a new identity (shades of Kill Me Again). But Clay, who owes money to loan sharks (more references to Kill Me Again), hires a private detective to track down Bridget. She manages to kill the detective and make it look like an accident. She then manipulates Mike in a plan to kill Clay in his apartment (and she achieves this not just by means of her desirability, but also by knowing Mike's weaknesses, particularly about his previous marriage). Just as Michael is unwilling to kill Suzanne in her home in Red Rock West, Mike is unwilling to kill Clay. However, Bridget murders Clay and double-crosses Mike by framing him for the murder. The film ends with Mike in jail and Bridget escaping with the money.

The differences between *The Last Seduction* and Dahl's previous two films are just as important as their similarities. *The Last Seduction* opens on the New York skyline, rather than the small town or countryside. Nonetheless, the small town plays a prominent role later in the film. As well as focusing on

the *femme fatale*, *The Last Seduction* shows her succeeding, for this time there is no attempt to make the film conform to the prescriptive system of compensating moral values. Bridget is not punished for stealing the \$700,000, for killing her husband, or for framing Mike.

There is a Hitchcockian moment near the beginning of the film. Bridget escapes with the money while Clay is having a shower. She leaves him a note, which she writes backwards, in mirror writing. This echoes a scene in *North by Northwest*, when Eve Kendall 'escapes' from Thornhill. As he pretends to have a shower, Eve answers a telephone call, makes a note of an address and leaves. Thornhill then reads the imprint of the note on the writing pad and follows Eve to the address.

The continuity of style and themes across John Dahl's first three films clearly identifies him as an *auteur*, but one who is making (or re-inventing) the genre of the *film noir*. Dahl makes smart, understated and unpretentious, independently produced films. They are modestly made, but are technically superb and, unlike most films today, they are based on strong scripts. *Kill Me Again* was written by Dahl and David Warfield, *Red Rock West* was written by Dahl and his brother Rick Dahl and *The Last Seduction* was written by Steve Barancik.

After *The Last Seduction*, Dahl expanded into other genres. In 1996 he directed *Unforgettable*, a science fiction thriller about a husband tracking down his wife's killer using an ingenious method of detection. He injects himself with his dead wife's brain fluid to experience her memory of her murder. The film never escapes this implausible, convoluted premise. *Unforgettable* seems to be imitating the Mad Scientist B-Movies (popular in the 1930s and the 1950s), but it lacks their ironic tone.

Dahl's next film was Rounders (1998), a drama focused on a clean-cut law student Mike (Matt Damon) who is also a gifted poker player. He helps out his restless loser friend 'Worm' (Edward Norton), who has just been released from jail, to pay off his debtors by playing and trying to win a large number of poker games in a short period of time. The film succeeds in creating the seedy atmosphere and texture of backroom poker

games, and occasionally reproduces the atmosphere of *film noir*. However, its main focus is on the psychology of his main character, Mike, and his search for his true vocation (a lawyer or a professional gambler). This is not an action film with numerous plot twists and turns. Most of the action takes place at the card table, and Dahl is occasionally successful at creating moments of great tension in these scenes.

Dahl's Joy Ride (aka Road Kill) (2001) is a hybrid thriller-noir-horror film consisting of three protagonists on a road trip across the United States who incite, and who are then relentlessly pursued by, an unseen truck driver. In every scene, Dahl uses an abundance of conventional clichés from the thriller-noir-horror genres, but to good effect: he creates well-paced, tense action scenes, updating other well-known films about the perils of cross-country driving, especially Steven Spielberg's Duel (1971), but also less accomplished films such as Kalifornia (1993) and Breakdown (1997).

John Dahl is now known more for his work in television, directing episodes of prestigious series such as *Dexter, Breaking Bad, The Vampire Diaries, Homeland, Hannibal, Justified* and the first two episodes of *Outlander*.

I hope this short study of Dahl's films shows that *auteurism* and genre study can be reconciled. There is no absolute opposition between *auteurism* and genre study, since they occupy different positions along a continuum. The more we study subgenres within genres, the more we narrow down the films we group together, until we reach very special subgenres (as do Cavell and Doane, for example), or the work of a particular director.

1950s science fiction

The science fiction film of the 1950s shares some of the paranoia and insecurities of the *film noir*. Indeed one film, *Kiss Me Deadly* (Robert Aldrich, 1955), combines attributes from both genres. It contains the attributes of *film noir*, from its expressionistic lighting to the conflict between a detective and a *femme fatale*. *Kiss Me Deadly* is dominated by a search for a mysterious glowing box which, by the end of the film,

the femme fatale opens, with deadly consequences. The box evidently contains nuclear material that, in the wrong hands, unleashes havoc on the world

The 1950s science fiction film is a favourite of genre critics who undertake the task of interpreting the function of genre films. Before we discuss the function of this genre, we shall briefly have a look at some of its common attributes. It usually consists of:

- a meditation on the implications and consequences of scientific and technological advances
- space travel and/or contact with aliens
- a setting in the distant future.

These three attributes are obviously linked, since the genre considers how science and technology in the future can take humanity into the distant realms of the universe and possibly come into contact with other life forms. This then leads to a number of science fiction films taking on some of the attributes of the horror film as the aliens, codified as monsters, become a 'supernatural' threat to humanity.

However, the science fiction films of the 1950s are not usually set in the future, but in the present, since they meditate on the implications and consequences of scientific and technological advances in the newly created nuclear power. The implications and consequences are usually (but not always) coded as negative. In Them! (Gordon Douglas, 1954), for example, a race of giant ants is found to be living in the desert of the American Southwest. The cause of these giant ants, which threaten humankind's existence, is identified as nuclear fallout from atomic tests. Similarly, in When Worlds Collide (Rudolph Maté, 1951), earth is threatened and, in the end, destroyed by a runaway star. The star can be read as an allegory of an approaching nuclear war and the destruction of the earth is the inevitable consequence. In these, and many other science fiction films of the 1950s, humanity is indirectly identified as the ultimate cause of the threat unleashed upon it. Humans are their own worst enemy. The fear manifest in 1950s science fiction films is a fear that, for the first time in history, humankind

is able to destroy itself, by means of its own science and technology. Humanity has become decentred and vulnerable to extinction. Such films can therefore be read as reflecting the anxieties of the American public in the 1950s.

However, the threat is not always read by genre critics as a threat from 'humankind', but as a threat from a part of it, namely, communists. The science fiction films can therefore be understood as allegories of the Cold War. Ants are an appropriate metaphor for communists in *Them!* because ants are a war-like mass of undifferentiated, regimented soldiers, who are depicted in the film as threatening the lives of the American public. Such was the ideological image of communists perpetuated in America during the Cold War.

But the most celebrated film to be read as an allegory of the Cold War is *Invasion of the Body Snatchers* (Don Siegel, 1956). The film depicts the inhabitants of a small town in California being gradually replaced by pod people, who grow out of pods and look exactly like the people they replace, but with one crucial difference: they lack emotions and feelings. One message this film seems to perpetuate is that communists may look just like us, but they lack a crucial human trait. The film indirectly represents the result of a communist invasion and takeover of American minds by means of communist ideology. In effect, the film is depicting the result of communist brainwashing: one will become an emotionless robot passively conforming to the totalitarian state.

This, at least, is the standard way to read *Invasion of the Body Snatchers*. But is it the only way? It is certainly possible to give the film an almost opposite reading: it can be interpreted as a criticism of placid conformity to American Cold War ideology. The ideology perpetuated by the American government about the threat of communism to the American way of life instilled fear in the American public. The American government's ideology (as with all ideology) imposed a restriction on the way the public thought about and lived their everyday lives. This ideology established hysteria about an imminent invasion of America by Soviet communists, who would be aided by members of the communist party in America. This ideology

encouraged the American public to root out the communists (the aliens) living among them, because they posed a threat to national security. Each individual's allegiance to the American way of life had to be affirmed and demonstrated, otherwise they were considered to be a traitor to the American way of life, for which they must be marginalized and punished.

For an ideological position to be successful, it must appear to be natural. During the 1950s, the 'Red Scare', as it came to be known, was very pervasive, which allowed the American government to justify its 'witch hunt' of communists, as well as its stockpiling and testing of nuclear weapons.

But not everyone bought into this ideology. Both Don Siegel, the director of Invasion of the Body Snatchers, and the scriptwriter, Daniel Mainwaring, were highly critical of the process of 'podlike' social conformity, the repression of free speech and the loss of individuality that American Cold War ideology produced. Mainwaring was associated with communism in the 1930s, while Siegel's films of the 1950s depict a recurrent theme: the lone individual's defiance towards conformity, which shows Siegel to be a director with a liberal social conscience. From this perspective, the pods in Invasion of the Body Snatchers can be read as representing the American public's complacent conformity to their government's Cold War ideology, not as a threat of communist ideology to the American way of life. However, both Siegel and Mainwaring could not risk openly opposing the Cold War ideology, so they disguised their opposition in an allegorical science fiction story. Allegorical stories flourish in a time of censorship and repression.

The fact that the same film can be read from two completely different political perspectives raises problems about genre study.

One of the biggest problems with the external approach to film studies, of which genre studies is the representative example, is being able to establish a causal link between a film and its social and historical context. As we saw with *Invasion of the Body Snatchers*, the same film can be given an opposite meaning when related to its context (in this example, American society of the

1950s). *Invasion of the Body Snatchers* can be read as either supporting or opposing American Cold War ideology. What role does the film's historical and social context play? Does the film's context constitute evidence that supports an argument?

The purpose of the functional approach to genre studies is to bring a film back into the realm of the everyday, or, more accurately, to relate a fiction film to its non-fictional context. Genre critics do this in order to answer the questions: How do films speak to us? What events in our everyday lives are they indirectly representing? These questions are necessary because they explain why millions of people go to the cinema every week. The answers genre critics give to these questions are plausible but not conclusive. Additional work needs to be carried out into the cultural meanings of the cinema.

Dig deeper

Alloway, Lawrence, 'Iconography of the Movies', *Movie* 7 (1963), pp. 4–6.

Altman, Charles [Rick], Film/Genre (London: British Film Institute, 1999).

An important book that has the virtue of being organized around a series of problems relating to the study of genre. Moreover, these problems are stated in the title of each of the 12 chapters, for example, 'Where do genres come from?', 'Are genres stable?', 'Why are genres sometimes mixed?', 'What role do genres play in the viewing process?' and 'What can genres teach us about nations?'

Byars, Jackie, All That Hollywood Allows: Re-Reading Gender in 1950s Melodrama (London: Routledge, 1991).

A feminist reading of popular melodrama from the 1950s, especially Douglas Sirk's *Magnificent Obsession*, *All That Heaven Allows*, *Written on the Wind* and *Imitation of Life*, as well as the male melodramas of James Dean: *Rebel Without a Cause*, *East of Eden* and *Giant*.

Cavell, Stanley, Contesting Tears: The Hollywood Melodrama of the Unknown Woman (Chicago: University of Chicago Press, 1996).

Cavell's idiosyncratic (and rather unevenly written) study of a genre he has christened the melodrama of the unknown woman.

Copjec, Joan (ed.), Shades of Noir (London: Verso, 1993).

This theoretically informed anthology reassesses the status of *film noir* as a genre, and argues that such a reassessment is necessary for two reasons: the re-emergence of *film noir* in contemporary Hollywood and the uneasy sense that *film noir* was never adequately discussed in the first place.

Doane, Mary Ann, *The Desire to Desire: The Woman's Film of the 1940s* (London: Macmillan, 1988).

Doane's book is a sophisticated and lucid study of four types of 1940s women's films – films dominated by medical themes, the maternal melodrama, the classic love story and the paranoid woman's film.

Gledhill, Christine (ed.), Home Is Where the Heart Is: Studies in Melodrama and the Woman's Film (London: British Film Institute, 1987).

A seminal collection of (occasionally difficult) essays on the melodrama, including Thomas Elsaesser's foundational essay 'Tales of Sound and Fury: Observations on the Family Melodrama'.

Grant, Barry Keith (ed.), Film Genre Reader (Texas: University of Texas Press, 1986).

A comprehensive anthology of 24 essays, divided evenly into theoretical approaches and studies of individual genres.

Jacobs, Lea, *The Wages of Sin: Censorship and the Fallen Woman Film: 1928–1942* (Wisconsin: University of Wisconsin Press, 1991).

An articulate and well-researched study of the representation of fallen women in the 1930s melodrama, demonstrating how censorship has influenced the genre.

Kaplan, E Ann (ed.), Women in Film Noir, Second Edition (London: British Film Institute, 1998).

This is the authoritative guide to the way women are represented in *film noir*. It is concise, lucid and accessible. Essential reading.

Klinger, Barbara, Melodrama and Meaning: History, Culture, and the Films of Douglas Sirk (Bloomington: Indiana University Press, 1994).

Klinger looks at the way Douglas Sirk's films have been promoted and discussed in reviews, by fans and by academics, and studies in detail Rock Hudson's star image.

Lynch, David and Gifford, Barry, Lost Highway [script] (London: Faber and Faber, 1997).

Neale, Steve, *Genre and Hollywood* (London and New York: Routledge, 2000).

This book offers a detailed investigation into existing accounts of genre, plus a new account of film noir and melodrama. It is organized into three distinct parts: 1) definitions and concepts of genre; 2) a comprehensive examination of all the major genres, plus the way they have been previously studied; 3) theories, descriptions and industry accounts of Hollywood genres.

Neale, Steve, 'Melodrama and Tears', Screen, 27, 6 (1986), pp. 6–23.

An important essay explaining why we cry when watching melodramas.

Palmer, R Barton (ed.), Perspectives on Film Noir (New York: G K Hall & Co., 1996).

This anthology republishes a representative set of French and Anglo-American essays that first identified *film noir* as a distinct style or genre of film-making.

Focus points

- ★ Genre studies is divided up into a descriptive approach and a functional approach.
- * The descriptive approach classifies films within a particular genre according to the common attributes they possess.
- The functional approach attempts to relate a film to its historical and social context and argues that genre films embody the basic anxieties and values of a society.
- * The film melodrama is frequently defined as a woman's genre because it represents the anxieties women experience living in a patriarchal society.
- * Recent studies of melodrama have identified the following subgenres: the fallen woman film, the unknown woman film and the paranoid woman's film.
- ★ The film noir is dominated by a femme fatale and an alienated detective hero; both are symptoms of the upheavals witnessed during the 1940s in North American society.
- ★ The science fiction films of the 1950s meditate on the implications and consequences of scientific and technological advances in the newly created nuclear power and on the 'threat' of communism to the American way of life.

arrica fració

5

The non-fiction film: five types of documentary

In this chapter you will learn about:

- the common assumptions film spectators hold about documentary films
- the differences between fiction and documentary films
- five types of documentary film (as identified by Bill Nichols): expository, observational, interactive, reflexive and performative.

What kind of world do we inhabit, with what risks and what prospects? Tales we label fiction offer imaginative answers; those we label non-fiction suggest possibly authentic ones.

Bill Nichols, Blurred Boundaries, p. ix

What makes a film a documentary? We can begin to answer this question by identifying some of the basic premises film spectators normally hold about documentaries:

- ▶ First, the events filmed must be unstaged; that is, the events must exist above and beyond the activity of filming them. In fiction films, by contrast, events are staged for the express purpose of being filmed. The unstaged nature of the events in documentaries therefore suggest that the events have an existence independent of the cinema. This is what gives them their authenticity.
- Secondly, documentaries are conventionally understood to be non-fiction films. In other words, they must be sharply distinguished from fiction films. The world depicted in the documentary is real, not imaginary.
- ▶ Thirdly, it is often assumed that the documentary film-maker simply observes and makes an objective record of real events.

In recent times, all three assumptions have come under attack. In this chapter, I shall question in particular the third point. It is now commonplace to argue that the very presence of the camera influences the filmed events. Moreover, documentary film-makers employ a wide variety of techniques in putting their films together; they do not simply point the camera towards their subject and let the camera roll. The documentary film-maker cannot simply observe and objectively record because he or she makes technical choices – selecting the camera angle, camera lens, film stock, deciding how to edit shots together and so on. This seems to make the documentary personal and subjective.

Spotlight

The selection and emphasis of particular events by means of film techniques seems to betray the documentary film-maker's particular perspective on the filmed events. What is valorized by the auteur critics in relation to Hollywood fiction films is condemned in documentary films.

But by what standard of objectivity are documentary films being judged? All films necessarily involve selection and editing. No film is therefore purely objective, if by objectivity we mean that the events are seen from no particular perspective. This is an unreasonable standard by which to judge documentary films. The issue is not so much whether they are based on selection but how the selections made by the documentary film-maker manipulate the events. Because all documentary films 'manipulate' events, then it may be better to use a more neutral term, such as 'shape' events. We can reserve the term 'manipulation' for documentaries that can be categorized as propaganda - those that hide from the spectator the processes they use in shaping events.

Spotlight

The Times of Harvey Milk (Robert Epstein, 1984) was a breakthrough documentary. It portrays the life and assassination of gay activist and politician Harvey Milk, the first openly gay man to be elected to the San Francisco Board of Supervisors. The film won the 1984 Academy Award for best documentary.

In the following sections, we shall see how Bill Nichols has divided up the documentary cake into five slices. Each type of documentary is defined and distinguished according to how it shapes the events being filmed by means of particular techniques selected by the film-maker. This is similar to the process of genre study outlined in the previous chapter. Whereas particular genres are defined in terms of their invariant iconic

and narrative attributes, types of documentary are identified according to the particular techniques they use. I shall follow Nichols's theoretical discussion of the five types of documentary, although I have endeavoured to summarize and simplify his conceptual discussion and have added case studies to give substance to each category.

The five categories Nichols identifies are: the expository, observational, interactive, reflexive and the performative documentary. I shall illustrate each respective category with the following: Coalface (Alberto Cavalcanti, 1935), High School (Frederick Wiseman, 1968), Roger and Me (Michael Moore, 1989), Bowling for Columbine (Michael Moore, 2002), Man with a Movie Camera (Dziga Vertov, 1929) and The Thin Blue Line (Errol Morris, 1988).

Expository documentary

Voice-of-God commentary and poetic perspectives sought to disclose information about the historical world itself and to see that world afresh, even if these views came to seem romantic and didactic.

Bill Nichols, Representing Reality, pp. 32-3

Nichols's definition of expository documentary emphasizes its typical characteristics: a disembodied and authoritative voice-over commentary combined with a series of images that aim to be descriptive and informative. The voice-over addresses the spectator directly, offering a series of facts or arguments that are illustrated by the image track. The voice-over either provides abstract information that the image cannot carry, or comments on those actions and events in the image that are unfamiliar or presumably unintelligible to the target audience. The aim of the expository documentary is to be descriptive and informative, or to provide a particular argument. For example, it may celebrate a set of common values, or a particular lifestyle. Below we shall see how *Coalface* celebrates a day in the life of the miner.

Expository documentary is the 'classic' mode of documentary, which is now more commonly used in TV documentaries, where abstract information is conveyed via the voice-over commentary. The overall effect of the expository documentary is one of objectivity, of direct and transparent representation.

The British documentary film movement (1927-39), founded by John Grierson, made expository documentaries that were also poetic and aesthetic, rather than simply descriptive and informative. The movement operated in two government departments: firstly, the Empire Marketing Board and then, from 1933, the General Post Office. The most prestigious films of the movement include Alberto Cavalcanti's Coalface (1935). John Grierson's Drifters (1929), Humphrey Jennings's Spare Time (1939), Harry Watt's North Sea (1938), Basil Wright's Song of Ceylon (1934) and Harry Watt and Basil Wright's Night Mail (1936). Due to the financial restrictions imposed upon it by civil servants, the documentary film movement also made films for outside bodies, such as the gas board and the Ceylon tea company. The aim of all these documentaries was to function as a public service, to inform the 'general public' about the everyday working of the industries and corporations that shaped their lives. These documentaries therefore served to improve the public image of large corporations.

The prevailing ideology of 1930s Britain in some ways resembled the ideology prevalent in 1980s Britain. In 1929, the Balfour Committee on Industry and Trade recommended that the government encourage corporate expansion, rather than state control. That is, the emphasis shifted towards unregulated capitalist expansion, rather than state intervention. The setting up of a documentary film movement, funded and regulated by the government, ran contrary to this ideology. This explains the difficulties the movement faced when it came to funding and, indeed, with its very existence. However, it also explains the rise in large corporations commissioning public relations films.

The position of the documentary film movement can be identified with centre-progressive pressure groups ('middle

opinion') of the 1930s, which held the following beliefs as shown by Ian Aitken:

In the first place, there was a belief in the essential soundness of established society; in the second place, there was a belief in the need for State regulation and intervention; and, in the third place, there was a rejection of the option of a socialist or fascist transformation of society. These political and cultural parameters framed what some critics have described as a 'social democratic consensus', which developed in opposition to orthodox economic liberalism and marxism during the inter-war period, and which became the most influential reform movement of the period.

Film and Reform, p. 168

However, these pressure groups communicated their ideas to a middle-class audience:

... the documentary movement was primarily dedicated to the communication of ideas to governing elites and intellectuals, and although Grierson used a rhetoric of mass communications, the reality behind the rhetoric was that the movement functioned, inevitably, as a means of minority, and not mass communication.

Film and Reform, p. 173

The middle-class bias is particularly evident in the way the movement represented the working classes. One can argue that, in films such as *Coalface* and *Spare Time*, the film-makers are glorifying the working classes, exalting them by presenting them as heroic labourers, rather than exploited, degraded and poorly paid workers, living with extreme social hardships.

Coalface is an expository documentary. It consists of an authoritative voice-over that rapidly presents to the spectator statistical data on the British coal industry (the location of collieries, the amount of coal produced, the number of miners employed, injured and so on). A number of the images simply illustrate the voice-over. But others go far beyond the aim of

being descriptive and informative. In a sequence depicting the miners underground, a montage of shots contrasts the half-naked bodies of the miners with the coal and the machinery. The close-ups of the miners' bodies in particular aim to represent their work as a heroic struggle against nature. This reading is strongly reinforced by the soundtrack, which consists of singing (the *Colliers' Chant* by W H Auden) and orchestral sound effects (the musical score by Benjamin Britten).

At the end of the shift, there is an extraordinary sequence of shots depicting the machinery of the pit, particularly the winding gear that brings the miners to the surface. These shots do not aim to be descriptive and informative. They are close-ups of the machinery abstracted from their surroundings, which has the effect of isolating the rhythmic movement of the machinery rather than illustrating its function. Moreover, the cutting is very quick – 32 shots are presented in only 39 seconds – which again emphasizes movement and rhythm, rather than function. These shots represent an abstract film inserted into the documentary. A standard expository documentary would simply consist of a few functional shots of the winding gear. But the use of close-ups and rapid cutting in this sequence from *Coalface* creates an abstract effect that takes this sequence far beyond the merely descriptive and illustrative.

The following sequence shows the miners leaving the pit and walking home. It consists of the following shots:

- Three shots of miners leaving the pit.
- ► Two shots of a street of identical houses; the camera angle emphasizes the similarity of the houses.
- One shot of a house situated in an open space; a washing line is to the right.
- ► Two shots of chimney stacks and winding gear silhouetted against the sky; in the second shot, the camera pans left to tree branches blowing in the wind.
- One shot of a washing line, smoke stacks appear in the background.
- ▶ One shot of a coal mine; the camera pans left to a tree blowing in the wind.

- One shot of a ruined house, with winding gear in the background.
- One shot of the tree blowing in the wind; the camera pans up to the sky.

As with the previous sequence, the shots are not merely descriptive and illustrative. They evoke a number of pastoral and romantic clichés: silhouettes, the wind blowing through the trees, ruins, the 'end of the day', and so on. These shots offer a counterpoint to the voice-over, which does not talk about the wind blowing through the trees, but offers a series of statistics, or specific knowledge, such as the way the Davy lamp works. In summary, these shots do not merely depict the life of the miner; they present a pastoral, almost a mythological, image of a 'good and honest' life.

Does the film privilege the coal industry or the miners? As with the other films of the British documentary movement, *Coalface* does not attempt to present the miners as individual people, but simply as examples of a particular type of worker, together with the way they interact with their workplace and their home setting. Some critics argue that the film represents the coal industry in terms of necessity and inevitability (John Corner, *The Art of Record*, p. 61). What this means is that a coalminer's job, however harsh, is necessary. *Coalface* therefore exalts and glorifies those who carry out the work. More generally, the aesthetic approach of the British documentary movement presents a distanced view of working-class culture, a view that treats it as both exotic and strange.

The prestigious films of the documentary film movement are constructed according to modernist or formalist aesthetics; that is, they exploit the transformative nature of film, rather than its mimetic or naturalistic potential. Grierson's philosophy consisted of using the aesthetic nature of film for social purposes. He argued that 'there is every reason to believe that industrial and commercial films require an even greater consideration of visual effects than the average dramatic film. They have indeed little else on which to subsist' (Grierson, quoted in Ian Aitken, *Film and Reform*, p. 100). This privileging of the aesthetic over the naturalistic is evident in *Coalface*.

But the centre-progressive philosophy of the documentary movement is evident in its choice of subject matter. The very act of representing the intrinsic values (both positive and negative) of working-class life is radical in itself.

John Corner asks:

'How far are the two impulses [modernist aesthetics and social theme] integrated in Coalface and how far are they contradictory ambitions, mutually compromising each other's integrity and success?'

The Art of Record, p. 620.

For Corner, the film combines aesthetic ambitions with public communication: to make visible to the broader public the workings of a vital national industry, and the way the lives of the ordinary workers are influenced and determined by the industry they work for. Due to these two influences, the film itself is inherently ambiguous.

Observational documentary

An observational mode of representation allowed the filmmaker to record unobtrusively what people did when they were not explicitly addressing the camera.

... But the observational mode limited the film-maker to the present moment and required a disciplined detachment from the events themselves.

Bill Nichols, Representing Reality, p. 33

The observational mode of documentary is characterized by the non-intervention of the film-maker in the filmed events. The observational mode is more notable for what it does not contain: there is no voice-of-God commentary, no intertitles and no interviews. The emphasis is to present a slice of life, or direct representation of the filmed events. The film-maker attempts to be completely invisible, that is, an uninvolved bystander. The

observational documentary film-maker therefore aims to simply observe unfolding events. For this reason, emphasis is placed on recording events as they unfold in real time. This is why observational documentary is also called direct cinema.

In technical terms, the observational documentary tends on occasions to use long takes (where the camera is filming continuously, as described in Chapter 1). Sound is also direct and is simply recorded while the camera is rolling. These techniques are evident in the work of one of the most famous film-makers of observational documentaries, Frederick Wiseman. In his documentary *High School*, filmed in the Northeast High School in Philadelphia in 1968, Wiseman aims to observe and capture the typical, day-to-day events that take place in this school. There are no dramatic or unusual events to film here. The aim is simply to record everyday events, primarily of different classes in progress.

The observational mode establishes an 'intimate' relation to the filmed events and establishes a sense of place by refusing to manipulate or distort the events. The observational documentary is therefore attempting to persuade the spectator that the film is an accurate slice of life; that what is filmed is a transparent record of what took place in front of the camera. In other words, it is meant to be neutral and non-judgemental.

These, at least, represent the ideals of observational cinema. In practice, it is possible to discern a number of strategies that illustrate the director's intervention in the filmed events in the observational documentary, both within scenes and between scenes. Yet this intervention is played down in the observational documentary. It is possible to detect an implicit agenda at work in a number of observational documentaries. What is Wiseman's purpose in making *High School*? Did he simply want to show how schools function, or is he attempting to undermine the school by exposing the teachers as out of touch with the youth of the 1960s? We can look at the way observational documentaries intervene in the filmed events and see how this intervention reveals an implicit agenda.

As Kristin Thompson and David Bordwell point out (*Film History*, p. 581), Wiseman films only one aspect of school life, namely, the interaction and conflict between pupils and teachers, with the

teachers invariably imposing discipline. Wiseman has therefore decided to emphasize one particular event (namely, conflict) and downplay other events. Moreover, he has made definite choices about how to film these conflicts, with an emphasis on close-ups. Scene transitions may also suggest an implicit meaning. In one scene, a Spanish teacher is seen to wave her arms about, drilling the students. Wiseman then cuts to a music teacher conducting percussion musicians. The repetition of the action suggests that the students are simply being drilled, rather than taught.

Although Wiseman does not present himself as a political film-maker, many political commentators detect a socialist agenda in his films, an implicit critique of American institutions such as school. But by using the observational mode, Wiseman is downplaying his own critical perspective and seems to be presenting the case that, by simply filming inside institutions such as schools and showing the power struggles that take place there, the liberal-minded spectator will inevitably develop a critical attitude towards the filmed events. Because he does not attempt to intervene in the events, Wiseman would not claim responsibility for any typecast images of the people he films; he would argue that such images are already present in the events themselves. For example, the oppressive behaviour of the teachers in *High School* is a result of the American educational system, not of the presence of Wiseman's camera.

Interactive documentary

Interactive documentary ... arose from the ... desire to make the film-maker's perspective more evident. Interview styles and interventionist tactics arose, allowing the film-maker to participate more actively in present events.

Bill Nichols, Representing Reality, p. 33

The observational mode of documentary attempts to hide the presence of the film-maker from the spectator. By contrast, interactive documentary makes the film-maker's presence prominent, as he or she interacts with the people or events being filmed. In other words, all interactive documentaries by definition

draw the filmed people and events into direct contact with the film-maker. The content of the interactive documentary is based primarily on interviews, which draw out specific comments and responses from those who are filmed. A well-made interactive documentary will allow the filmed people to express their opinions and views, and the film-maker may juxtapose one opinion with a contrary opinion, therefore offering the spectator a balanced view.

Sometimes the film-maker is the main person on screen, which may serve to hold the documentary together. Compare this with the expository documentary, in which the disembodied voice of the narrator holds the film together, and the observational documentary where the events themselves have to hold the film together, with a little help from the film-maker who edits the shots and scenes together.

There is a number of ways in which the film-maker may interact with the people he or she is filming. The film-maker may appear on screen and will, formally or informally, ask the interviewee questions. Here, both film-maker and interviewee share the same space and the spectator can see them interacting with one another. The film-maker therefore clearly acts as a mediator between the interviewee and the spectator. Or the film-maker may remain off-screen, in which case we may or may not hear the questions. All we see is the interviewee addressing answers to someone just beyond the frame. Furthermore, if the filmmaker remains off-screen, he or she has the choice of allowing the questions to be heard by the spectator or of editing out the questions altogether. Although in these examples the film-maker is not seen and may not be heard, he or she still shares the same space as the interviewee, and still plays the role of mediator, but his or her presence is less evident.

Interactive documentaries show the process of interaction taking place. The act of gathering information by means of interviews is clearly shown, including the negotiation of the terms and conditions under which the interview is to take place. The result is that the spectator can see what effect the interview is having on the interviewee. Unlike expository or observational documentaries, the interactive documentary shows the process by which it is made. We must remember that
in all documentaries, there is a power relation involved, between the film-makers and those who are filmed. This power relation is masked by the expository and observational documentary, but is apparent in the interactive documentary (as well as the reflexive documentary, to be discussed below).

The ethical question about filming someone is made apparent in the interactive documentary. But the film-maker can, nonetheless, simply use the interviews for his or her own purposes. Interaction and juxtaposition of shots and scenes, together with the use of archival footage, constitute the main tools of the interactive documentary film-maker. The film-maker uses these tools in order to present an argument. What is important from an ethical perspective is the manner in which the film-maker presents the interviewees. How does the film-maker prompt the interviewee? Is the film-maker provocative? Or does the film-maker allow interviewees to put their case fully? How are the interviews used in the final film? We shall begin to approach these questions by looking at one of the most controversial interactive film-makers working today, Michael Moore, and consider two of his films, Roger and Me (1989) and Bowling for Columbine (2002).

A description of the content of Roger and Me cannot convey the irony, humour and anger that the film can arouse in the spectator. But briefly, the film is about the decline of the town of Flint in Michigan, which was dependent on the continuing presence of General Motors to sustain it. But the chairman of General Motors, Roger Smith, initiated a series of closures of General Motors factories in Flint in order to move production to Mexico, where the workers are paid less than their American counterparts. The result was that Flint became one of the poorest towns in America. The film depicts Moore's repeated attempts to interview Smith about the closures and to invite him to Flint to see the effects his policy is having on the town. Interspersed with these repeated attempts to interview Smith are Moore's interviews with various people in Flint.

Most of Moore's attempts to interview Roger Smith fail. But these moments are not left out of the film. Indeed, the process of attempting to interview Smith adds humour to the film. But humour is also added by the constant presence of Moore on

screen as he interviews various people in a deadpan and ironic manner. Roger and Me is far from the observational mode of documentary. Moore is not an observer, but a participant. He therefore has no intention of remaining neutral and hidden (not least because he was born and grew up in Flint). His film represents the victims of 1980s corporate activity and he tries to make the chairman of one such corporation accountable for his actions. The difficulties Moore has in interviewing Smith strengthen the film's message that chairmen and women of large corporations simply avoid being accountable for the social devastation that their policies bring about.

Moore conveys this strong social message by means of editing. He comments on the rich and famous people of Flint by juxtaposing interviews with them with scenes of the poor people of Flint being evicted from their homes. The first time this editing strategy is used is approximately 18 minutes into the film, where Moore interviews a number of wealthy people at the Annual *Great Gatsby* party, held at the home of one of General Motors' founding families. When Moore asks what are the positive aspects of Flint, the final interviewee replies, 'Ballet, hockey. It's a great place to live.' Moore then immediately cuts to the sheriff's deputy, Fred Ross, evicting a poor family from their home.

The second time this editing strategy is used is approximately 27 minutes into the film, when Moore interviews Miss Michigan. Asked to comment on the job losses in Flint, Miss Michigan simply replies, 'I'm for employment and working in Michigan.' This is then followed by another eviction (after Moore has shown the result of the 1988 Miss America contest, which was won by Miss Michigan). The third time, approximately 49 minutes into the film, is when Moore cuts to the evictions directly after interviewing a group of upper-class women playing golf.

But the most poignant use of this editing strategy is saved for the end of the documentary, when Smith is shown giving a speech on the spirit of Christmas, which Moore intercuts with shots of a family in Flint being evicted from their home on Christmas Eve. Moore uses the images of eviction as a form of critical commentary, to show how the rich and powerful (most notably, Smith) do not understand the effect of unemployment on the poor.

Despite its strong social message, the film has been criticized for 'manipulating' and 'misrepresenting' events. In some ways, the agenda of *Roger and Me* resembles the agenda of the British documentary movement – to represent the underclasses on film, those who do not usually have a voice. But, just as the British documentary movement romanticized the lives of the working class by elevating their lifestyle, we need to see how Moore has used the events in Flint for the purposes of his film.

Moore has been criticized for manipulating the chronology of events in Flint. The discrepancies in the film's chronology became apparent in an interview with Moore conducted by Harlan Jacobson in the journal *Film Comment* (November/ December 1989). Corner sums up the four main discrepancies:

- 1 Ronald Reagan, depicted visiting laid-off auto workers, was a presidential candidate, not the president, when he made his visit. (The film does not describe him as president, but the assumed chronology of the scene and the projected effect of the footage works with the idea that he is.)
- 2 The evangelist who is depicted visiting the city after the *Great Gatsby* society party in 1987 actually visited in 1982, several years before the crucial 1986 lay-offs.
- 3 The three big civic development projects which are seen in the film as more or less concurrent attempts to counter the effects of the 1986–7 lay-offs (Hyatt Regency Hotel; Autoworld theme-park; Water Street shopping pavilion) had all closed before these lay-offs.
- 4 The number of jobs lost during the 1986–7 closures seem to be far less than indicated in the film. The spread of losses from 1974 onwards is closer to the film's estimate. (The figure of 30,000 is given in an edited clip from a CBS news broadcast, which may be referring to motor industry closures of which those in Flint are only a part.)

The Art of Record, pp. 165-6

In the interview with Jacobson in which these discrepancies became apparent, Moore argued that the film is about a town that died in the 1980s; it is not just about the 1986–7 lay-offs. And other reviewers argued that the broader picture presented in the film (corporate greed, wasteful capital expenditure) is more important than the fine details.

However, Roger and Me does raise questions about the implicit boundaries that govern the making of documentaries and whether the film-maker should make the spectator aware that the rules (such as sticking to the chronology of events) are being broken. It is not immediately apparent in Roger and Me that the rules of documentary are being broken. In his equally controversial Bowling for Columbine, Moore is seen going through a process of discovery. In his usual laidback, sarcastic manner, he appears larger than life for most of the film, creating awkward situations for those involved with promoting the USA's love affair with guns - from militia and National Rifle Association President Charlton Heston, to public relations spokespeople at Kmart (the store that sold ammunition to the teenagers who carried out the shootings at Columbine High School in 1999). Moore's invasive interview technique gets results. The Kmart spokespeople eventually announce that the store will stop selling ammunition. Similarly, Heston decides to walk out in the middle of his interview with Moore rather than discuss or justify the USA's obsession with gun culture.

Yet Moore does not end up calling for gun control as he discovers that Canada has as many guns as the USA. He therefore begins to dig deeper into the American psyche to find out why more Americans shoot one another than any other nation. Moore doesn't have any definitive answers, but is shown on screen almost thinking aloud, following dead ends, broadening his scope to include US foreign policy, investigating the news media's obsession with gun violence, creating unusual montage sequences, and showing the actual footage of the shooting at Columbine.

In the end, it is not so much a coherent argument but simply Moore himself who becomes the key element that holds the film together. As Philip French wrote in his review of the film:

[Moore's] chief instrument is his own personality – an apparently ordinary guy in unfashionable horn-rimmed glasses, bowling jacket, plaid shirt, blue jeans and baseball cap, more than a little overweight and sporting facial hair that's a long way from designer stubble, but still short of being a bohemian beard. He's a blue-collar, politically-committed Louis Theroux, capable of getting anyone – from backwoods militia men to bank managers handing out free rifles to new depositors – to open up to him.

'Oh Yeah - You and Whose Armoury?' The Observer, 17 November 2002

Reflexive documentary

Reflexive documentary arose from a desire to make the conventions of representations themselves more apparent and to challenge the impression of reality which the other three modes normally conveyed unproblematically.

Bill Nichols, Representing Reality, p. 33

In the interactive mode of documentary, we saw that the film-maker on screen participates in the events being filmed. In the case of *Roger and Me*, Moore interviews the people of Flint and attempts to interview Roger Smith, chairman of General Motors. In interactive documentary, therefore, the film-maker does not attempt to conceal his presence, unlike the practice in expository and observational documentary.

In reflexive documentary, the film-maker goes one step further than interactive documentary, attempting to expose to the spectator the conventions of documentary representation, with the effect of challenging the documentary's apparent ability to reveal the truth. Rather than focus on the events and people filmed, the reflexive documentary focuses on how they are filmed. In the reflexive documentary, the properties of the film and the film-making process become the main focus of attention.

The reflexive documentary does not pretend to simply present a slice of reality, since it also tries to demonstrate to the spectator how film images are constructed. Whereas the interactive mode makes the film-maker's presence known to the spectator, the reflexive documentary makes the whole process of film-making known to the spectator.

Reflexive documentary challenges the documentary's status as objective and illustrates the subjective choices involved in film-making. But a lack of objectivity does not necessarily reduce the significance or impact of a documentary. A documentary that acknowledges its limitations and its own perspective is more valuable than a film that pretends to be neutral and objective. Moore makes no attempt to be neutral or objective and his personal involvement in the story – he was born in Flint – partly explains why he decided to make *Roger and Me*. A reflexive documentary goes much further than the interactive documentary in making the spectator aware of all the stages involved in making a documentary. One of the most celebrated examples of a reflexive documentary is Dziga Vertov's *Man with a Movie Camera* (1928).

Vertov is generally regarded to be the father of radical documentary, a type of film-making that challenges normative and common-sense views of reality. Like the British documentary film movement, Vertov's work was funded by the state. But whereas the British documentaries of the 1930s reflected the opinions of centre-progressive pressure groups ('middle opinion'), Vertov, an iconoclast of Soviet film-making during the revolutionary period, attempted to change the audience's perception of everyday reality through radical techniques that attempt to raise each spectator's consciousness.

In terms of content, *Man with a Movie Camera* is a documentary because it shows unstaged events, scenes from everyday life that add up to represent the working day, from waking up, going to work and, finally, to leisure activities. However, Vertov does not simply film these events, but transforms them by means of specific film techniques. He not only shows everyday life, but also shows how it has been filmed.

Throughout *Man with a Movie Camera*, Vertov shows the camera recording events, the editor rearranging shots on the editing table, a film being projected and an audience in a cinema watching a film. In addition, he uses the specific qualities of film – montage, fast and slow motion, freeze frame, out-of-focus shots, double exposure and reverse motion – to remind us that what we see is a reconstructed reality mediated through film.

Vertov's working methods are therefore divided up into two principles, what he calls the 'Film-Truth' principle, the process of capturing life-as-it-is, and the 'Film-Eye' principle, the procedure of constructing a film out of these shots by means of the specific qualities of film. In *Man with a Movie Camera*, each shot itself is a fragment of reality. But Vertov treats each shot as the raw material from which to make a film. Vertov calls the individual shots the 'bricks' of film. The film-makers then have a choice of building a modest house or a mansion from these bricks.

Vertov is interested in building only the filmic equivalent of a mansion. He offers us another perspective on reality, a perspective filtered through the specific qualities of film. Moreover, Vertov does not hide the fact that the view he gives the spectator is constructed, since he shows the spectator the process of construction. This is why *Man with a Movie Camera* is a reflexive documentary.

Performative documentary

Performative documentaries (1980s–90s): stress subjective aspects of a classically objective discourse.

 possible limitations: loss of referential emphasis may relegate such films to the avant-garde; 'excessive' use of style.

Bill Nichols, Blurred Boundaries, p. 95

The fifth and final category, performative documentary, has a paradoxical status because it deflects attention from the world and towards the expressive dimension of film. That is, reference to the world is marginalized and the poetic and

expressive dimensions of film are emphasized. The performative documentary does not capture the world in the same way as the other forms of documentary. It aims to represent the world indirectly.

The performative documentary evokes the mood or atmosphere traditionally found in fiction films. It aims to present its subject matter in a subjective, expressive, stylized, evocative and visceral manner. The result is that the subject matter is rendered in a vivid way that encourages the spectator to experience and feel it. But, at the same time, we have to ask ourselves whether the events become distorted as a result of the way they are represented.

The subject matter in the performative documentary remains intact, but its meaning is shown to be variable. In The Thin Blue Line (Errol Morris, 1988), for example, the subject matter is the murder of Dallas police officer Robert Wood in 1976. A drifter named Randall Adams was convicted of the murder, while the chief witness against him, David Harris, had been sentenced to death for another murder. Who actually shot Robert Wood, and how this event took place, is open to question. The film is based on the testimony and memory of witnesses who purportedly saw the events. But these testimonies and memories do not add up. They are faulty and inconsistent. Morris explores these inconsistencies by re-enacting the murder. Each time a testimony reveals a new or inconsistent fact about the murder, Morris shows a re-enactment which incorporates the new or inconsistent fact. The Thin Blue Line is not, therefore, about what really happened, but about memory, lies and inconsistencies. Furthermore, these re-enactments are rendered in a vivid, stylized and evocative manner characteristic of performative documentaries.

The first re-enactment of the murder takes place in the first five minutes of the film. I shall therefore describe the film's opening:

- ▶ Shots of the cityscape of Dallas at night (four shots).
- Shot of Randall Adams talking about his journey to Dallas in 1976.
- Close-up of a police light flashing. It creates a visceral, pulsating effect.

- ▶ Shot of David Harris talking about his journey to Dallas in 1976. He talks about stealing a car and a pistol. Cut to...
- a photograph of a pistol.
- Shot of Harris talking.
- ► Cityscape of Dallas at night (three shots).
- Shot of Randall Adams. He talks about how he met David Harris (Adams's car ran out of gas and he was picked up by David Harris).
- Aerial shot of Dallas (Harris's voice appears over the image).
- Map of Dallas.
- ▶ Closer shot of the map (followed by two additional closer shots of the map, creating a jump cut effect as the camera focuses on the street in which Adams and Harris met).
- Shot of a hotel sign (motivated by the voice-over of Harris: 'I followed him [Adams] to his room').
- Interestingly, behind the motel sign is a billboard that reads 'Change your life'. The events being narrated certainly changed Randall Adams's life.
- Shot of Harris speaking.
- ▶ Shot of a drive-in movie sign (Harris: 'We went to a movie that night').
- ▶ Shot of Adams. He says, 'I get up. I go to work on Saturday. Why did I meet this kid? I don't know. Why did I run out of gas at that time? I don't know. But it happened. It happened.'
- ► This is then followed by the re-enactment of the murder of Robert Wood. The re-enactment begins with:
 - ▷ a high-angle shot of a police car that has pulled up behind a car parked on the side of the road. At first, it seems that this car may be Randall Adams's car that has run out of gas. After all, in the previous shot, Adams mentions that he ran out of gas. So the editing initially links the car to Adams. This is followed by:

- an abstract shot inside the parked car. The shot consists of the rear-view mirror, and a hand readjusting it. The shot is heavily backlit, turning everything in the shot into a silhouette. (The use of backlighting is a technique favoured by Hollywood directors such as Steven Spielberg.) Cut to...
- be the police car. The first police officer gets out. The police lights on top of the car shine directly into the camera as they spin round, creating a strobe lighting effect that turns the screen red at brief intervals. The lights are emphasized even more by the soundtrack which, together with Philip Glass's hypnotic music, consists of a swishing sound synchronized with the lights. The overall effect is visceral, pulsating and hypnotic.
- ► Close-up of a hand on the steering wheel inside the parked car. Again, it is heavily backlit.
- ▶ Shot of the police car. The second police officer gets out. She shines the torch at the parked car/in the direction of the camera. The flashing lights on the police car have the same prominence as previously.
- ▶ High-angle shot of the road, heavily backlit. The shadow of the first police officer enters from the top of the image as he walks towards the parked car.
- Extreme low shot of the parked car's back wheel, filmed from underneath the car. The police officer's feet are seen as he walks by.
- Close-up of a gun pointing towards the camera's direction. The gun is fired.
- Shot of a drawing of a hand, showing a bullet entry point.
- Shot of the gun firing.
- Shot of a drawing of a body, showing bullet entry points.
- Close-up of the gun firing.
- Another close-up of the gun, this time as it points downwards and fires a shot.

- Shot of a drawing of a body, showing bullet entry points.
- Close-up of the gun, pointing downwards and firing a shot.
- Close-up of a drawing of a body, showing bullet entry points.
- Shot of the gun being withdrawn into the car.
- Close-up of a car's pedal and the driver's foot.
- ▶ Shot of the police officer lying in the road. The car pulls away.
- ▶ Head-on shot of the police car. The second police officer enters the centre of the frame and fires her gun.
- Low shot of the car pulling away.
- Close-up of the police officer's gun, with the flashing, pulsating police lights in the background.

This re-enactment is followed by an additional drawing showing the bullet entry points, two portraits of the actual murdered police officer (one shot of him alive, one shot of him dead), two shots of his police uniform, showing the bullet entry points, a shot of a newspaper whose headline reads 'Officer's killer sought' and, finally, three extreme close-ups of extracts from the newspaper story.

The dominant performative elements in these opening minutes include the following: the re-enactment itself; close-ups of guns, maps, newspaper headlines and pulsating police lights (whose prominence creates a vivid effect that far exceeds their function); rapid editing (the jump cut effect created by the closer shots of the map; the cutting from the gun discharging to the shots of the drawings is very rapid); exaggerated camera positions (high camera angles, low camera positions); and the soundtrack (Glass's hypnotic music; the swishing sound synchronized with the lights, the loud gun shots). Other performative elements appear elsewhere in the film, including the filming of some events in slow motion, together with the fact that the re-enactments are repeated on several occasions.

The performative elements of *The Thin Blue Line* create the same mood and atmosphere found in Hollywood thrillers – suspense and poised anticipation, complete with highly stylized images and soundtrack. Through these techniques Morris encourages us to experience and feel the events, rather than simply watch them from a distance. However, by doing so he also hypes the events for entertainment purposes. This raises an ethical question about Morris's manipulation of the events. Does he lose sight of the events themselves in favour of giving the spectator a thrilling experience? That is, does he lose sight of the documentary's purpose of being informative and authentic?

Despite its performative elements, Morris's film did influence the reality it filmed. *The Thin Blue Line* shows that the testimonies of the main witnesses are unreliable and inconsistent, particularly Harris's original testimony. Indeed, at the end of the film, Harris indirectly admits to committing the murder of Robert Wood. Soon after *The Thin Blue Line* was released, Adams's conviction was overturned.

I hope that this chapter has dispelled the common-sense idea that documentaries are simply objective records of real events. It may sound extreme, but it is possible to argue that the documentary film has no privileged relation to reality since both fiction and documentary films employ the same technologies - mechanics, optics and photochemistry. A fiction film such as The Maltese Falcon is therefore an 'objective record' of what a group of actors, such as Humphrey Bogart, and film technicians, such as director John Huston, achieved on a Warner Bros. sound stage in 1941. What distinguishes fiction from non-fiction is the belief that the events filmed in a documentary are unstaged and therefore non-fictional. Furthermore, by using the work of Nichols, I have tried to emphasize that the realm of the documentary consists of five modes or genres with their own invariant traits that distinguish them from one another.

Dig deeper

Aitken, Ian, Film and Reform (London: Routledge, 1990).

A well-researched, in-depth study of the British documentary film movement.

Corner, John, *The Art of Record: A Critical Introduction to Documentary* (Manchester: Manchester University Press, 1996).

Accessible case studies of classic documentary films from the 1930s to the 1980s. A good starting point for anyone who wants to pursue documentary further.

Nichols, Bill, Blurred Boundaries: Questions of Meaning in Contemporary Culture (Bloomington: Indiana University Press, 1994).

A companion volume to *Representing Reality*, offering case studies (the Rodney King video tape, reality television, Eisenstein's *Strike*, Oliver Stone's *JFK*, and performative documentary). As with *Representing Reality*, a difficult but important book.

Nichols, Bill, Representing Reality: Issues and Concepts in Documentary (Bloomington: Indiana University Press, 1989).

An important but densely written book. The chapter on documentary modes of representation has been used as the foundation for this chapter. My aim has been to make this important chapter of Nichols's book accessible to the general reader.

Rothman, William, *Documentary Film Classics* (Cambridge and New York: Cambridge University Press, 1997).

This book contains a series of close, detailed readings of a select number of important and well-known documentaries: Nanook of the North (Robert Flaherty, 1922); Land Without Bread (Luis Buñuel, 1933); Night and Fog (Alain Resnais, 1955); Chronicle of a Summer (Rouch and Morin, 1961); A Happy Mother's Day (Richard Leacock and Joyce Chopra, 1963); and Don't Look Back (D A Pennebaker, 1967).

Thompson, Kristin and Bordwell, David, Film History: An Introduction, Second Edition [Boston: McGraw-Hill, 2003].

Thompson and Bordwell's comprehensive history of world cinema.

Focus points

- * It is often assumed that the documentary film-maker simply observes and makes an objective record of real events. But documentary film-makers do not simply point the camera towards their subject and let the camera roll; they employ a wide variety of techniques in putting their films together.
- * The expository documentary employs the following techniques: a disembodied and authoritative voice-over commentary, plus a series of images that aims to be descriptive and informative.
- * The observational documentary tries to present a 'slice of life', or a direct representation of the filmed events. The film-maker attempts to be completely invisible, that is, an uninvolved bystander.
- * The interactive documentary makes the film-maker's presence prominent, as he or she interacts with the people or events being filmed. These interactions primarily take the form of interviews, which draw out specific comments and responses from those who are filmed.
- * The reflexive documentary attempts to expose to the spectator the conventions of documentary representation. Rather than focus on the events and people filmed, the reflexive documentary focuses on how they are filmed. The effect is that the reflexive documentary challenges the documentary's apparent ability to reveal the truth.
- * Performative documentary deflects attention from the world and towards the expressive dimension of film. That is, reference to the world is marginalized and the poetic and expressive dimensions of film are emphasized.

6

The reception of film: the art and profession of film reviewing

In this chapter you will learn about:

- the four main functions of film reviewing
- the four main elements of a film review
- how film critics evaluate films
- how film reviews of The English Patient and Interstellar were written.

The role of the critic is to help people see what is in the work, what is in it that shouldn't be, what is not in it that could be. He is a good critic if he helps people understand more about the work than they could see for themselves; he is a great critic, if by his understanding and feeling for the work, by his passion, he can excite people so that they want to experience more of the art that is there, waiting to be seized. He is not necessarily a bad critic if he makes errors of judgement. (Infallible taste is inconceivable; what could it be measured against?) He is a bad critic if he does not awaken the curiosity, enlarge the interests and understanding of his audience. The art of the critic is to transmit his knowledge of and enthusiasm for art to others.

Pauline Kael, I Lost it at the Movies, p. 308

Film reviewing, indeed criticism in general, is commonly called 'professional fault finding', particularly by those whose work is frequently reviewed. My aim in this chapter is to analyse the functions and components of the film-reviewing profession and the conventions that determine how reviewers evaluate films. The first part of the chapter will outline four functions of film reviewing and its four components. The final part will consist of a comparative analysis of three reviews of Interstellar (Christopher Nolan, 2014), with the aim of charting the similarities and differences in the film's reception. In academic terms, this chapter takes a reception-studies approach to films. That is, it does not analyse films themselves (the internal approach to film studies, explored in Chapters 1, 2 and 3), but investigates the way a film is received and evaluated. Reception studies explores various responses to films, both written and oral (including interviews with individual spectators). In this chapter, I have limited the responses to Interstellar to one privileged group of spectators, namely, professional film reviewers, who earn their living by writing on current film releases. That their work is defined as 'fault finding' is simply an outsider's view of their profession, a profession that has its own standards, conventions and rituals. My aim here is to begin to make these standards, conventions and rituals more explicit.

The four functions of film reviewing

In his book *Making Meaning* (p. 35), David Bordwell argues that a film review can have up to four functions. It can act as:

- journalism
- advertising
- criticism
- rhetoric (writing).

Spotlight

A 'Quote Whore' is a journalist who will provide a studio with a positive sound bite to advertise a new film, regardless of the film's quality. The practice is, of course, mainly used to bolster the publicity for bad movies. Sometimes the studio that produced the film will write a short quote, and then ask a willing journalist to put their name to it. The practice is strongly condemned by professional film journalists.

As journalism, film reviewing presents to the reader news about the latest film releases and, more specifically, significant aspects of a particular film. For example, the film may have a noteworthy theme (topical subject matter, for instance); it may have a significant star (an old star returning to the screen, the debut performance of a new star, or an established star taking on a significantly different role); or the production may be noteworthy. For example, the fees of the film's main stars may be very high, or the cost of production excessive, as with *Interstellar*, the budget was officially listed as \$168 million, and this does not include its worldwide marketing budget (see www.imdb.com).

More specifically, we can identify two types of film journalism:

- Journalism of opinion, in which the journalist presents a carefully thought-out position on a film, backed up with a set of arguments and background information.
- Journalism of taste, in which the journalist presents a simple evaluation of a film.

In-depth reviews of films combine these two types of journalism. Below I shall outline in more detail the various components of a film review.

As advertising, a review functions to publicize a film and encourage its readers to go to the cinema. Film reviewing can therefore be seen as a service industry, since it functions as a service to both the studio that financed and produced the film (by advertising its film), and as a service to filmgoers, by functioning as a consumer's guide to the best and worst films currently available.

Occasionally, a reviewer may write a condescending review, allowing the reader to feel superior to the film. The review therefore informs the reader of films he or she should know about, but without recommending that the reader go and see it. Here, the review is certainly not functioning as advertising, quite the reverse. This usually applies to reviews of the summer blockbusters in the highbrow press. However, most of the summer blockbusters are review-proof anyway; that is, the audience has already decided to see the film because it has a 'must-see' status attached to it and it achieves this status primarily through positive 'word of mouth'.

As criticism, a review involves the description, analysis and evaluation of films. Much of this chapter will be taken up with the task of describing film reviewing as criticism.

Finally, as writing, reviews become essays and are read for their own intrinsic literary merits, which may lead to them being republished in a single authored anthology; for example, James Agee's Agee on Film, Manny Farber's Negative Space, Pauline Kael's numerous collections, Andrew Sarris's Confessions of a Cultist, Jonathan Rosenbaum's Placing Movies: The Practice of Film Criticism, and so on. See Greg Taylor's book Artists in the Audience (described at the end of this chapter) for an account of the literary and artistic merits of the film reviews of Manny Farber and other critics such as Parker Tyler.

The four components of film reviewing

Above, we saw that film journalism can be divided into a journalism of opinion (informed reviews) and a journalism of taste (which simply passes judgements). In this section, we shall identify in more detail the major components that go to make up a film review.

Bordwell (*Making Meaning*, p. 38) emphasizes that a review usually consists of the following four components:

- a condensed plot synopsis
- background information
- a set of abbreviated arguments about the film
- an evaluation.

The condensed plot synopsis is simply a description of the film's plot. Most synopses tend to emphasize the big moments in the film, although being careful not to reveal the film's ending. The background information includes genre, stars, director, anecdotes about the film's production and reception and so on (this is where the review functions as news). The set of abbreviated arguments about the film is the reviewer's main focus, as he or she analyses and comments on the film. Finally, the reviewer offers an evaluation of the film, and (implicitly or explicitly) a recommendation to see/not to see the film. The evaluation is the result of the reviewer's activity and is backed up by his or her set of abbreviated arguments and knowledge about the film's background.

The reviewer can arrange these components in any order, but the most common structure seems to be this:

Open with a summary judgement; synopsize the plot; then supply a string of condensed arguments about the acting, story logic, sets, spectacle, or other case-centred points; lace it all with background information; and cap the review by reiterating the judgement.

David Bordwell, Making Meaning, p. 38

Of course, the reviewer's judgement, writing style and decisions about how much background information and condensed arguments to give the reader are determined by the projected readership and perceived character of the paper, magazine or website. A broadsheet newspaper, such as The Observer for example, has a projected readership that is perceived to be highly literate and knowledgeable of debates in the arts, culture and society. A film review in such a newspaper (an example from The Observer is printed below) will therefore be strong on background information and condensed arguments, while making an evaluative judgement implicit. It conforms to a journalism of opinion. A review in a tabloid newspaper, on the other hand, emphasizes plot information and summary judgements. It is a journalism of taste. In my comparative analysis of three reviews of Interstellar (Christopher Nolan, 2014), my examples from newspapers will concentrate on the more detailed reviews that appear in the broadsheet newspapers. The next section reproduces an actual film review, Philip French's review of The English Patient (Anthony Minghella, 1996) for The Observer. I then analyse this review to see how it is organized according to the four components listed above.

PHILIP FRENCH ON THE ENGLISH PATIENT

By my reckoning, out of around 160 novels short-listed for the Booker prize since it began in 1969, 25 have been turned into films for the cinema or television. Interestingly, the three made with sizeable budgets provided by Hollywood are all set during the Second World War and their unusual perspectives make us reconsider a conflict that still overshadows our lives. The first two, Thomas Keneally's Schindler's List (winner in 1982 as) Schindler's Ark and J G Ballard's Empire of the Sun (runner-up in 1984), are relatively straightforward chronological narratives – one biographical, the other autobiographical.

Michael Ondaatje's *The English Patient* (winner in 1992), however, is an immensely complex piece of storytelling, looking at the war from the viewpoints of four sharply

contrasted characters living at a shattered villa in Tuscany during the months leading up to VE day in May 1945. It is a subtle meditation on history, nationality, warfare, loyalty and love, but it is also a gripping mystery story.

Like Ondaatje, who was born in Sri Lanka, grew up in Britain and lives in Toronto, the villa's physically and psychically wounded occupants come from three continents. Hana (Juliette Binoche) is a nursing officer with the Canadian army who has lost her fiancé. When her unit moved north, she staved behind at the villa to care for the dying English patient (Ralph Fiennes), who received appalling burns in a plane crash and is in fact Almásy, a Hungarian aristocrat educated in Britain. The third figure is Caravaggio (Willem Dafoe) a suave Canadian thief, whose criminal skills and knowledge of Italian had been employed by military intelligence, and who is in pursuit of Almásy, whom he suspects of treason. The quartet is completed by Kip (Naveen Andrews), a Sikh from India, risking his life daily as a bomb disposal officer with the Royal Engineers. Another continent enters into the story, for half of the movie takes place in Cairo and the North African desert in the Thirties where Almásy had been a member of a Royal Geographical Society cartographical expedition and had a passionate affair with Katharine (Kristin Scott Thomas), the wife of a colleague. All four have endured terrible crises and looked death in the face. Now, as the war approaches its end, they are coming to terms with its contradictions and absurdities.

Ondaatje has written poems about the cinema (his Late Movies With Skyler and King Kong Meets Wallace Stevens are included in my anthology The Faber Book of Movie Verse) and his fiction is intensely cinematic. But like other novelists of whom the same can be said – Graham Greene, for instance, or Salman Rushdie – his work is fiendishly difficult to adapt, and the writer-director Anthony Minghella has done a remarkable job in making a coherent movie that retains the themes, motifs and density of the original.

Moving back and forth in time from the shimmering desert to the rain-drenched Tuscan countryside, The English Patient is a richly visual experience. Old biplanes fly over a desert landscape that looks like a woman's body. The sands of the Sahara dissolve into the crumpled sheets that cover the disfigured Almásy's bed. The thunder of approaching war in Egypt becomes the thunder of an oncoming rain storm in Tuscany. A powerful central image is the copy of Herodotus (the father of history) that Almásy has turned into a scrapbook so that it incorporates the story of his own life. The picture is also swooningly romantic and one can see what attracted the author of Truly Madly Deeply, another story of a transcendent love. There is grandeur in the shot of Almásy carrying the crippled Katherine, wrapped in the parachute that will be her shroud, along a mountain ledge in the desert, and there's magic in the scene where Kip hoists Hana up to the ceiling of a Tuscan church so that she can look at a Piero della Francesca fresco by the light of a flare. All the performances are first-class, with Binoche and Scott Thomas playing two of the most radiant heroines of recent cinema. Technically, The English Patient is a miracle. John Seale's cinematography can stand up to comparison with Freddy Young's on Lawrence of Arabia Walter Murch's editing is exemplary. This thoughtful and exhilarating movie is a credit to everyone involved in its making.

The Observer, 16 March 1997

As with many of French's longer film reviews, the first paragraph of this review begins with some very general background information, in this instance, the Booker Prize and the number of short-listed books that have been filmed. French notes how many books short-listed for the Booker Prize have been filmed (25) and how many are set during the Second World War (three, including *The English Patient*).

In the second paragraph, French notes that *The English Patient*, winner of the Booker Prize in 1992, is different from the other two Booker books set during the Second World War in that it has a complex plot structure. This paragraph, together with

the third, then gives a plot synopsis of the film. This synopsis is quite long because the film's plot is long and complex. French concentrates on the film's four main characters, together with the plot lines in which they are involved.

The final paragraph presents an analysis, or a set of abbreviated arguments about the film. These relate specifically to what French calls the film's 'richly visual experience'. In particular, French notes how the transitions from the present to the past are signified by means of sound and image: 'The sands of the Sahara dissolve into the crumpled sheets that cover the disfigured Almásy's bed. The thunder of approaching war in Egypt becomes the thunder of an oncoming rain storm in Tuscany.' French also writes about four striking scenes and shots in the film:

- b the shots of the old biplanes flying over the desert (which French describes as looking like a woman's body)
- the shots of Almásy's copy of Herodotus's book on history, which Almásy also uses as a scrapbook
- the shot of Almásy carrying the crippled Katharine along a cliff ledge
- the scene where Kip hoists Hana up to the ceiling of a Tuscan church so that she can see a fresco lit by a flare

French presents two additional arguments: firstly, that the performances are first class (French singles out the acting of Juliette Binoche and Kristin Scott Thomas) and secondly, the film is technically miraculous (singling out the cinematography of John Seale and the editing of Walter Murch).

Finally, the review ends with an evaluation: the film is thoughtful and exhilarating. Yet, the rest of the review also contains brief evaluations, particularly in the adjectives and nouns that French uses. From beginning to end, the review contains the following evaluative statements (emphases added): "... a subtle meditation..."; "a gripping mystery story"; "Minghella has done a remarkable job...'; 'a richly visual experience'; 'A powerful central image...'; 'swooningly romantic'; 'There is a grandeur in the shot...': 'there's magic in the scene...': 'all performances are first-class'; '... the most radiant heroines';

'Technically, The English Patient is a miracle'; 'Murch's editing is exemplary'. Furthermore, it is obviously a compliment for John Seale's cinematography to be compared with Freddy Young's desert cinematography in David Lean's visually stunning film Lawrence of Arabia.

The boundaries between the four components of French's review (indeed of most reviews) are not always clear-cut. However, French's reviews do contain all four components and they usually follow the same order: background information, condensed plot synopsis, a set of abbreviated arguments about the film and an evaluation.

Evaluation

What are reviewers looking for when they evaluate a film? Reviewers are looking for some, or all, of the following:

- the motivation of what happens in a film
- entertainment value
- social value.

MOTIVATION

In relation to motivation, reviewers are looking for the relevance of or justification for a particular narrative event or technical skill such as an elaborate camera movement or special effects. David Bordwell (*The Classical Hollywood Cinema*, p. 19) has identified four types of motivation in the cinema:

- compositional
- ▶ realistic
- ▶ intertextual
- artistic.

Compositional motivation refers to the formal structure of the film's narrative. An action or event in the narrative is motivated if it constitutes part of the film's cause–effect logic, as discussed in Chapter 2. If an action or event falls outside the cause-effect logic, it is deemed to be unmotivated. In contemporary

Hollywood cinema, this usually applies to the many prolonged action sequences and special effects that appear on screen as if for no other reason than to overwhelm the audience's senses and shock their nervous system.

Realistic motivation does not necessarily mean that the action or event under question is literal or true to life. It can also mean that, within the world of the film's fiction, the action or event is plausible or believable. For example, in *The Lost World: Jurassic Park* (Steven Spielberg, 1997), it is plausible for a T-Rex to eat Eddie (as he tries to pull the trailer up from the cliff face). But it is not plausible if the T-Rex started to talk English. However, within the context of everyday life, it is implausible for a T-Rex to eat Eddie (or anyone else for that matter), because the T-Rex is an extinct species and has not (as yet) been brought back to life through genetic engineering. So realistic motivation not only means 'authentic', or 'corresponding to everyday life' (this applies only to the artistic movement known as Realism), but also means 'plausible' and 'believable within the boundaries of the film's fiction'.

Following realistic motivation is intertextual motivation, which includes the relation between the film and its source (such as a famous novel), and the relation between the film and the genre to which it belongs. If a film is based on a famous novel, reviewers will invariably look for the similarities and differences between the two. In his review of The English Patient, French writes that 'writer-director Anthony Minghella has done a remarkable job in making a coherent movie that retains the themes, motifs and density of the original [novel]'. In terms of genre, conventions motivate a particular action in one film, but not in another. For example, if two characters walking along a street suddenly burst into song, accompanied by the sounds of a 50-piece orchestra, this would be motivated in a musical, but would look rather odd in a film noir. In the musical, the action of singing is motivated generically, whereas in the film noir it would be unmotivated. Sometimes a reviewer will attempt to place an unusual film within a genre in order to make sense of it. For example, Star Wars was described, on its initial release in 1977, as a Western in outer space, with several parallels to John Ford's The Searchers (1956).

Finally, artistic motivation means that a particular filmic technique is motivated for aesthetic reasons. For instance, an elaborate camera movement may serve the function of creating an unusual pattern, or simply demonstrating the virtuosity of the director. Although such virtuosity is occasionally displayed in Hollywood films (as auteur critics argued: see Chapter 3), it is more systematically displayed in independently produced American films and in European Art Cinema. Reviewers who are strongly inclined to look only for compositional, realistic or intertextual motivation will argue that such displays are simply unmotivated and pretentious. However, reviewers who appreciate independently produced American films and European Art Cinema are more sympathetic to these displays, and can justify them in terms of artistic aims and intentions.

Why is a reviewer's evaluation of a film usually guided by the search for motivation? Because motivation creates a sense of unity and coherence. When a critic complains that a particular event or technique in a film is not motivated, he or she is arguing that it does not contribute to the overall coherence of the film, but distracts from that coherence because it appears arbitrary. A critic looking for compositional, intertextual and realistic motivation will perceive many events and the technical virtuosity in a European Art film or an American independent film as arbitrary. However, a critic familiar with the artistic intentions of European and independent American directors can see the relevance of these events and techniques, that is, they will see the motivation behind such events and techniques. We can therefore distinguish critics according to the different types of motivation they are looking for in a film, which in turn determines the type of film they will evaluate positively and recommend to the reader and the type to which they will give the thumbs down.

Critics who look only for compositional/realistic/intertextual motivation, while debunking artistic motivation, can be called 'conservative' critics, while those who also seek out and praise artistic motivation are 'radical' critics. Conservative critics try to cultivate common-sense rationalism, by suggesting that a film must not disturb our common-sense ideas. A good film, they argue, must have a wide appeal, and must entertain. This is a consensus view of films, a view that argues that films must

simply reinforce our everyday ideas, rather than challenge us. The opposite is the case with radical critics. They champion a film that challenges our everyday assumptions and shows us the world from a new perspective. However, this opposition between conservative and radical is not clear-cut. In reality, most critics fall somewhere in between; we can call these the 'liberal' critics.

The debates in the British press over David Cronenberg's film *Crash* (1996) clearly separated the conservative critics from the radicals and the liberals. *Crash* is based on the novel by J G Ballard and was a controversial winner of the Special Jury Prize at the Cannes Film Festival in 1996. The film charts the relationship between five characters who are sexually aroused by car crashes. It depicts both the car crashes and sexual encounters between the various characters in graphic detail, while forgoing any attempt to depict character psychology or narrative motivation.

The conservative critics in the British press, such as Alexander Walker in the London Evening Standard and Christopher Tookey of the Daily Mail, believe that the film is depraved. In looking for motivation, they can assign it only to the genre of pornography. The radicals, including Suzanne Moore, Salman Rushdie and Martin Amis (all writing in The Independent), together with a number of writers for Sight and Sound (Mark Kermode, Julian Petley and Leslie Dick), thought that it was an important piece of film art, or a social satire metaphorically commenting on the role of technology in modern society. Finally, the majority of critics (the 'liberal' critics) thought that, although many may find the film distasteful, filmgoers must still be given the opportunity to see it.

ENTERTAINMENT VALUE

A review that looks for entertainment value considers whether the film functions as an escapist experience for the audience. But what makes a film entertaining? Hollywood film producers would like an answer to this \$64,000 question. Here I can present only some speculative ideas. A film is entertaining if it is successful in holding audiences' attention and arousing their emotions. One important way this is achieved is by encouraging spectators to identify with a character or set of characters within the film. Under these circumstances, the character must be

'well rounded', that is, three-dimensional (rather than a two-dimensional cartoon character), with a complex psychology. A film must therefore give the time and space to express and develop a character's psychology, and needs to use techniques of narration (such as restricted narration, discussed in Chapter 2) to encourage spectators to identify with characters. Complexity and inner tensions created by complex character psychology become key in holding spectators' attentions and arousing their emotions.

However, it is equally possible to answer that a film is entertaining if it takes the audience on a roller-coaster ride, offering them an experience that amazes their senses and startles their nervous system. What is important is not the film's ability to hold the audience's attention and draw out their emotions, but to overwhelm them. Complex character psychology and structures of narrative and narration are deemed unimportant, as emphasis is placed upon spectacle (extraordinary action sequences and special effects) and sound (loud explosions, stereo and surround sound, and so on).

SOCIAL VALUE

In complete contrast to entertainment value, a film reviewer may evaluate a film positively if it depicts an important social issue. One of the all-time greats is Gillo Pontecorvo's *The Battle of Algiers* (1966), a fiction film that depicts Algeria's struggle for independence from France. Occasionally, Hollywood films depict a social issue that is not usually discussed, such as the traumas of a victim of gang rape, as in Jonathan Kaplan's *The Accused* (1988). During the mid-1990s a series of films about Northern Ireland and Irish Independence were made, including *The Crying Game* (Neil Jordan, 1992), *In the Name of the Father* (Jim Sheridan, 1993), *Nothing Personal* (Thaddeus O'Sullivan, 1995), *Michael Collins* (Neil Jordan, 1996) and *Some Mother's Son* (Terry George, 1996).

REDEMPTION

Now that we have considered the key influences on film evaluation, it is worth considering in passing another common practice that reviewers indulge in, namely, looking for good points in an otherwise bad film. This can be put as a question: What redeems a bad film for a reviewer?

It is very common for reviewers to criticize a film's script or, more generally, the lack of coherence of a film's narrative. Here, reviewers are looking for compositional, realistic and/or intertextual motivation, but fail to find it. Some reviewers may even attempt to rewrite the script, making suggestions about how it could have been improved. Reviewers looking for artistic motivation may argue that the film is saved by the technical virtuosity of the camerawork, editing or set design. *Auteurist* critics looking only for formal similarities between a director's work may ignore the script altogether (thus following François Truffaut's lead in his essay 'A Certain Tendency of the French Cinema', discussed in Chapter 3). If the film is dealing with an important social issue, then reviewers are inclined to overlook technical mistakes, unless they are so overwhelming as to distract from the film's themes.

In a bad film, a reviewer may single out any strong acting roles, then make the point that the talent of the particular actor is wasted in this film. Finally, the set design may be the strongest point and may even be the star of the film, that is, it may upstage the actors and the narrative, if they are not strong enough to compete with the lavish sets. This is the case with Paul Anderson's film *Event Horizon* (1997), in which the technomedieval design of the interior of the *Event Horizon* spaceship is far superior to the acting of the characters, who are let down by a poor script. I will illustrate many of these points in more detail in the next section, when I survey reviews of *Interstellar*.

Three reviews of Interstellar

One productive way to read film reviews is to read several reviews of the same film, one after another, and then examine the similarities and differences between them. From this exercise you will discover the common elements that all reviewers identify in a particular film. (You can easily find dozens of reviews of the same film on the websites listed at the end of this chapter.) In this section, I shall examine three reviews of *Interstellar* using the framework outlined in the first part of this chapter. Moreover, I shall refer to online versions of the reviews, so that you can gain easy access to them. (However, note that

some sites will archive their reviews in a different location after some time.)

Todd McCarthy, 'Christopher Nolan Aims for the Stars in this Brainy and Gargantuan Sci-fi Epic', *The Hollywood Reporter*, 27 October 2014 http://www.hollywoodreporter.com/movie/interstellar/review/744059

Todd McCarthy, former chief reviewer for *Variety*, and now reviewer for its rival, *The Hollywood Reporter*, seamlessly blends plot synopsis, background information, abbreviated arguments and evaluation. That is, as a skilful writer, he does not simply present a plot synopsis, for example, but also combines it with background information and evaluation.

McCarthy begins by writing that 'Interstellar so bulges with ideas, ambitions, theories, melodrama, technical wizardry, wondrous imagery and core emotions that it was almost inevitable that some of it would stick while other stuff would fall to the floor'. Here he develops a set of abbreviated arguments followed by an evaluation. The review opens by arguing that the film's content, scope and ambitions are so prolific that they cannot be contained or shaped into a coherent whole. McCarthy's initial evaluation of Interstellar here (and in the rest of the review) is qualified: on the one hand, he praises the film for its ambitious aims and possibilities (the film tries to offer an intimate portrait of individuals in crisis, but also tries to speculate on humanity in general and its place in the cosmos), but, on the other, he does not think the film completely succeeds in meeting its own lofty aims.

The remainder of the review is mainly structured around a plot synopsis, focusing on Cooper (Matthew McConaughey), his relationship to his ten-year-old daughter Murph (Mackenzie Foy), and the narrative's various machinations through space and time. However, this plot synopsis is enriched with background information: we learn that the film was written by Christopher Nolan and his brother Jonathan; Hans Zimmer provided the 'often soaring, sometimes domineering and unconventionally orchestrated wall-of-sound score'; theoretical physicist Kip Thorne provided the technical knowledge on relativity theory and black holes; and Dylan Thomas's poem 'Do

Not Go Gentle Into That Good Night' is quoted several times in the film. Evaluation of acting is also carefully interspersed with this plot synopsis.

The review ends on another abbreviated argument and evaluation: overall, McCarthy argues, the film provides 'a healthy belief in mid-20th century-style Yankee gumption and a can-do attitude', a belief he questions as an insufficient attitude for a film that (McCarthy reminds us earlier) is about the possibility of human extinction.

In terms of evaluation, McCarthy's main concern is with compositional motivation: as I pointed out above, the review begins by arguing that *Interstellar* is unable to contain and bring together all its multifarious elements. In addition (and like all other reviewers), he briefly mentions intertextual motivation – that is, the relation between *Interstellar* and other films: most notably, influences such as 2001 (1969), *Forbidden Planet* (1956) and *The Wizard of Oz* (1939).

Mark Kermode, 'Interstellar Review – If it's Spectacle You Want, This Delivers', *The Observer*, 9 November 2014 http://www.theguardian.com/film/2014/nov/09/interstellar-review-sci-fi-spectacle-delivers

Whereas Todd McCarthy looks for compositional motivation in evaluating a film, Mark Kermode seeks entertainment value, and places compositional motivation, a film's coherence, a distant second. But, like McCarthy, Kermode's evaluation of Interstellar is qualified: the review opens by praising the film's scale and ambition, but also acknowledges its narrative flaws. Throughout his review, Kermode maintains this careful balance between praising the film as an awe-inspiring spectacle and acknowledging its weak points, such as occasional clunky dialogue and plot holes. The plot synopsis is fairly brief, and much of it is summarized via a convincing argument comparing Interstellar with Contact (Robert Zemeckis, 1997). Kermode notes the similarities: not only the presence of Matthew McConaughey in both, but also the dominance in these science fiction films of the theme of love, and the importance of daughters propelling the narrative forward (Jodie Foster's character Ellie in Contact, and Mackenzie Foy's character

Murph in *Interstellar* both detect the presence of aliens, which kick-starts the space exploration).

As background information, Kermode informs us that Nolan worked with a new cinematographer (Hoyte van Hoytema) on *Interstellar*, and that his previous cinematographer, Wally Pfister, directed *Transcendence* (2014), which Kermode judges to be a 'nostalgically ambitious directorial debut', in contrast to many other reviewers who evaluated the film negatively. Hans Zimmer and Kip Thorne are mentioned in passing, as is Jonathan Nolan, who we are informed initially developed *Interstellar* for Spielberg.

In terms of intertextuality, Kermode devotes a lot of his review to mentioning numerous other science fiction films, all the way from Georges Méliès's A Trip to the Moon (1902) to When Worlds Collide (1951), 2001 (1969) and Gravity (2013). He ends his review on another abbreviated argument: Nolan is a leading auteur of the blockbuster in the same class as Spielberg, Cameron and Kubrick.

Stephanie Zacharek, 'Interstellar May Be Grand, But It Doesn't Connect', *The Village Voice*, 29 October 2014 http://www.villagevoice.com/2014-10-29/film/the-fault-in-his-stars/

Stephanie Zacharek begins her strongly opinionated review with her key abbreviated argument, that the characters in *Interstellar* are dwarfed by the film's sheer open spaces and grand themes. This leads her to evaluate the film negatively. She develops her argument towards the end, assessing the way Nolan directs the key actors. She argues that none of them are used effectively, even Matthew McConaughey, whose acting in the film has generally received favourable comments from other reviewers. Her most direct abbreviated argument is that 'Nolan lacks the human touch': his films are full of ideas and special effects, but his characters lack intimacy. She directs praise only at the film's technical dimensions: the editing, sound design and camerawork (while condemning what she calls Hans Zimmer's 'droney, churchy organ score').

The central part of the review consists of a sporadic synopsis of the plot, in which she simply lists actions and events, giving the impression the film is incoherent. In addition, Zacharek supplements her plot synopsis with emphatic comments that

effectively back up her negative evaluation of the film. She also dwells on small details rarely mentioned by other reviewers, such as David Gyasi (who plays, in her words, the 'token black' astronaut) is seen wearing a plaid Redd Foxx bathrobe (a reference to the black comedian and actor Redd Foxx, aka John Elroy Sanford).

There are only a few references to other films and film-makers (Kubrick of course, and Alfonso Cuarón's *Gravity*) and brief background information (Jonathan Nolan's role as screenwriter, Kip Thorne's consultancy role and Dylan Thomas's poem 'Do Not Go Gentle Into That Good Night' is unnecessarily quoted three times).

Spotlight

Whereas small-scale independent films rely on film reviewers to promote them, the Hollywood blockbuster is almost review proof, since the fans of the franchise it is based upon will see the film anyway, regardless of what the reviewers say.

Dig deeper

Bordwell, David, Making Meaning: Inference and Rhetoric in the Interpretation of Cinema (Cambridge, Mass: Harvard University Press, 1989).

An in-depth study of how films are interpreted. Bordwell spends a few pages discussing film reviewing, which I have used for this chapter.

Bordwell, David, Staiger, Janet and Thompson, Kristin, *The Classical Hollywood Cinema: Film Style and Mode of Production to 1960* [London: Routledge, 1985].

The undisputed, authoritative heavyweight study of classical Hollywood cinema, covering the history of film style, technology and mode of production.

Haberski, Raymond J, It's Only a Movie: Films and Critics in American Culture (Kentucky: The University Press of Kentucky, 2001).

An informative and readable historical account of the rise of the 'golden age' of American film criticism in North America, the age

of Andrew Sarris and Pauline Kael in the 1960s, together with their attempts to confer cultural respectability on popular movies. The book also charts the decline of the golden age in the 1970s.

Kael, Pauline, I Lost it at the Movies: Film Writings 1954–1965 (London: Marion Boyars, 1994).

Kael's first book (originally published in 1965), containing reviews and provocative essays on film.

Taylor, Greg, Artists in the Audience: Cults, Camp, and American Film Criticism (Princeton: Princeton University Press, 1999).

This book nicely complements Haberski's book (described above). Taylor offers a selective history of a number of post-Second World War North American film critics, especially Manny Farber and Parker Tyler, who creatively sanctioned popular movies as a contemporary art form. In Taylor's words, 'Beginning in the 1940s, key vanguard critics pioneered new models of film appreciation, providing a vision of critic as creative artist, as opposed to distanced judge: now even seemingly unexceptional movies could be matched to highbrow aesthetic norms' (p. 7). These vanguard critics, Taylor argues, were not interested in presenting their reviews as a consumers' guide to the movies (reviews as advertising) but as a creative response to movies (film reviewing as writing).

Metacritic.com http://www.metacritic.com

This website collects together a broad cross-section of reviews for new film, DVD, video game and music releases. Like rottentomatoes.com, the film section at Metacritic.com summarizes the film reviews and offers hyperlinks to the full review. Furthermore, each movie is assigned a Metascore, which the website describes as 'a weighted average of each of the individual reviews for that film. This number, on a 0–100 scale, lets you know at a glance how each movie is reviewed. *Interstellar* received a metascore of 74.

Rotten Tomatoes http://www.rottentomatoes.com

This website is similar to metacritic.com, except many of the hyperlinks on this site link to film reviews published exclusively online, rather than to reviews also published in print media. *Interstellar* received a rating of 73 per cent.

Focus points

- * There are two types of film journalism: journalism of opinion and journalism of taste.
- * Film reviewing can function as journalism, advertising, criticism or writing.
- Film reviews consist of a condensed plot synopsis, background information, a set of abbreviated arguments and an evaluation.
- * In evaluating a film, reviewers are looking for motivation (divided into compositional, realistic, intertextual and artistic motivation), entertainment value (derived either from narrative or from spectacle) or social value.

Luton Sixth Form College Learning Resources Centre

regella a metra pito di considera armestressi que desprimas Par
Taking it further

Film studies on the internet

One of the problems with the internet is that it yields too much information, much of which remains unverified. The problem is to sort the information carefully. The following list represents a good starting point for researching film on the internet.

THE ALFRED HITCHCOCK SCHOLARS/'MACGUFFIN' SITE

http://www.labyrinth.net.au/~muffin

A specialist site for those interested in Alfred Hitchcock's films. with an emphasis on serious scholarship. It is useful for its description of recent publications, a FAQ (frequently asked questions) page devoted to Hitchcock, and for long, scholarly articles on specialized topics about Hitchcock's films.

BOX OFFICE GURU

http://www.boxofficeguru.com

This website, maintained by Gitesh Pandya, keeps you informed of what is being released every week at the North American box office. It is updated three times each week: Thursday (offering a summary of the upcoming weekend), Sunday (post-weekend analysis with estimates) and Monday night (actual box office results). What makes this site highly readable is Pandva's informative commentaries on and predictions about the box office potential of each release. There is also a listing of the top 20 box office hits, and a large database of previous box office figures, all-time box office hits, and so on.

DAILY VARIETY

http://www.variety.com

The famous trade newspaper Daily Variety is available online. Non-subscribers have a limited access to the newspaper's stories, while subscribers have full access. As I am reluctant to pay for information on the internet, I do not know what you get by subscribing. But as a non-subscriber, you receive shortened versions of news stories, reviews and the latest information on the American box office. This is definitely one site you should visit in order to gain insider information on what is happening in Hollywood on a daily basis.

ENTERTAINMENT WEEKLY

http://www.ew.com/ew

This is the website for the popular magazine *Entertainment Weekly*. In the movie section you will find reproduced much of the content of the print version of the magazine, including reviews, box office figures and a 'coming soon' section.

FILM FESTIVAL RESEARCH NETWORK

http://www.filmfestivalresearch.org

This network brings together academics researching and professionals working in the film festival industry. The website includes a detailed bibliography.

FILM-PHILOSOPHY

http://www.film-philosophy.com

This website links you to the *Film-Philosophy* journal and discussion salon. It offers a philosophical review of cinema and film studies, and is notable for its large archive of informed and original book review articles, plus its lively e-mail discussion salon.

FILM STUDIES FOR FREE

http://filmstudiesforfree.blogspot.co.uk/

A comprehensive web-archive that collects examples of and links to free film studies scholarship freely available on the web.

THE HOLLYWOOD REPORTER

http://www.hollywoodreporter.com

Much of what I said about *Daily Variety* also applies to *The Hollywood Reporter*. This is another well-respected trade

newspaper, which you may want to read in conjunction with *Daily Variety* in order to read about the same stories from a slightly different angle.

THE INTERNET MOVIE DATABASE LTD

http://uk.imdb.com

http://www.imdb.com

This is a standard and authoritative reference site for finding out the basic information on almost every film made.

ROGEREBERT.COM

http://www.rogerebert.com

This site collects together Roger Ebert's reviews from 1985 to his death in 2013. The site also features reviews of current films by a team of collaborators.

SCOPE: AN ONLINE JOURNAL OF FILM STUDIES

http://www.scope.nottingham.ac.uk

This online journal, based at the University of Nottingham, Britain, publishes feature articles, book and film reviews, plus conference reports. It has a broad editorial policy, focusing on film history, theory and criticism, and publishes the work of new as well as established writers.

SCREENDAILY

http://www.screendaily.com

A comprehensive, online version of the weekly British trade magazine *Screen International*. This website offers global film industry news, reviews and an extensive list of events.

SCREENING THE PAST

http://www.screeningthepast.com

A scholarly journal that investigates in depth the social and historical dimensions of film, photography, television and new media. It has several sections: feature articles, classics and reruns (republication of notable articles), and reviews of film, television, new media, books and conferences.

SENSES OF CINEMA

http://www.sensesofcinema.com

This Australian website describes itself 'an online film journal devoted to the serious and eclectic discussion of cinema'. The quarterly journal lives up to this description, publishing a wide variety of writing styles (personal, academic, critical) on numerous topics: film, book and festival reviews, news and current events, feature articles, special dossiers, plus a critical database on great directors.

Bibliography

This bibliography collects together all the books and essays cited at the end of each chapter.

Aitken, Ian, Film and Reform (London: Routledge, 1990).

A well-researched, in-depth study of the British documentary film movement.

Alloway, Lawrence, 'Iconography of the Movies', *Movie 7* (1963), pp. 4–6

Altman, Charles [Rick], 'Towards a Historiography of American Film', Cinema Journal, 16, 2 (1977), pp. 1–25.

An invaluable outline of various approaches that have been adopted in film studies.

Altman, Charles [Rick], Film/Genre (London: British Film Institute, 1999).

An important book that has the virtue of being organized around a series of problems relating to the study of genre. Moreover, these problems are stated in the title of each of the 12 chapters, for example, 'Where do genres come from?', 'Are genres stable?', 'Why are genres sometimes mixed?', 'What role do genres play in the viewing process?' and 'What can genres teach us about nations?'

Andrew, J Dudley, *The Major Film Theories* (New York: Oxford University Press, 1976).

This book is still the most accessible introduction to the work of the formalists (Hugo Münsterberg, Rudolf Arnheim, Sergei Eisenstein, Bela Balazs), the realists (Siegfried Kracauer, André Bazin) as well as the film theories of Jean Mitry, Christian Metz, Amédée Ayfre and Henri Agel.

Arnheim, Rudolf, Film as Art (London: Faber and Faber, 1958).

Arnheim's formalist statement on film art.

Bazin, André, Orson Welles: A Critical View (California: Acrobat Books, 1991).

A concise and lucid analysis of Welles's early films. For me, this book contains Bazin's clearest defence of the techniques of the long take and deep focus.

Bazin, André, What is Cinema?, 2 volumes (Berkeley: University of California Press, 1967, 1971).

Bazin's seminal collection of essays that defends a realist film aesthetic.

Bordwell, David, Making Meaning: Inference and Rhetoric in the Interpretation of Cinema (Cambridge, Mass: Harvard University Press, 1989).

An in-depth study of how films are interpreted.

Bordwell, David, Narration in the Fiction Film (London: Routledge, 1985).

A long and wide-ranging book that discusses both how spectators comprehend narrative films and various historical modes of narration (Hollywood cinema, Art cinema, Soviet cinema, the films of Jean-Luc Godard).

Bordwell, David, Staiger, Janet and Thompson, Kristin, The Classical Hollywood Cinema: Film Style and Mode of Production to 1960 (London: Routledge, 1985).

The undisputed, authoritative heavyweight study of classical Hollywood cinema, covering the history of film style, technology and mode of production.

Branigan, Edward, Narrative Comprehension and Film (London: Routledge, 1992).

This book is similar in some respects to Bordwell's *Narration* in the Fiction Film, in that it discusses how narrative is comprehended by film spectators. However, Branigan's book focuses on more specific issues (such as 'levels of narration' and 'focalization'), and discusses them in great detail; it is a very erudite, sophisticated and complex book.

Buckland, Warren, Directed by Steven Spielberg: Poetics of the Contemporary Hollywood Blockbuster (New York and London: Continuum, 2006).

In this book I examine Spielberg's film-making practices – the choices he makes in placing or moving his camera, framing a shot, blocking the action, editing a scene, designing the sound, and controlling the flow of story information via a multitude of narrational techniques.

Buckland, Warren (ed.), Puzzle Films: Complex Storytelling in Contemporary Cinema (Oxford: Wiley-Blackwell, 2009).

This volume identifies and analyses contemporary cinema. 'Puzzle Films' – a popular cycle of films from the 1990s that rejects classical storytelling techniques and replaces them with a complex storytelling. Films include, Lost Highway, Memento, Charlie Kaufman's screenplays, Run Lola Run, Infernal Affairs, 2046; Suzhou River, The Day a Pig Fell into a Well and Old Boy.

Buckland, Warren (ed.), *Hollywood Puzzle Films* (New York: Routledge, 2014).

A sequel to *Puzzle Films* (2009), focusing on contemporary Hollywood films that use techniques of complex storytelling, including *Inception* (2010), *Source Code* (2011), *The Butterfly Effect* (2004), *The Hours* (2002) and films based on the science fiction of Philip K. Dick, including *Minority Report* (2002) and *A Scanner Darkly* (2006).

Byars, Jackie, All That Hollywood Allows: Re-Reading Gender in 1950s Melodrama (London: Routledge, 1991).

A feminist reading of popular melodrama from the 1950s, especially Douglas Sirk's Magnificent Obsession, All That Heaven Allows, Written on the Wind and Imitation of Life, as well as the male melodramas of James Dean: Rebel Without a Cause, East of Eden and Giant.

Carroll, Noël, *Philosophical Problems of Classical Film Theory* (Princeton: Princeton University Press, 1988).

A dense philosophical examination of the work of Arnheim, Bazin and Perkins.

Caughie, John (ed.), *Theories of Authorship* (London: British Film Institute, 1981).

A representative sample of essays on the various schools of *auteurism*, although Caughie has taken the liberty of shortening a number of the papers, in some cases quite drastically.

Cavell, Stanley, Contesting Tears: The Hollywood Melodrama of the Unknown Woman (Chicago: University of Chicago Press, 1996).

Cavell's idiosyncratic (and rather unevenly written) study of a genre he has christened the melodrama of the unknown woman.

Cook, Roger and Gemünden, Gerd (eds), The Cinema of Wim Wenders: Image, Narrative, and the Postmodern Condition (Michigan: Wayne State University Press, 1997).

A wide-ranging collection of essays that serves both as an introduction to Wenders's cinema and a detailed discussion of specific films (including *Until the End of the World* and *Wings of Desire*).

Copjec, Joan (ed.), Shades of Noir (London: Verso, 1993).

This theoretically informed anthology reassesses the status of *film noir* as a genre, and argues that such a reassessment is necessary for two reasons: the re-emergence of *film noir* in contemporary Hollywood, and the uneasy sense that *film noir* was never adequately discussed in the first place.

Corner, John, The Art of Record: A Critical Introduction to Documentary (Manchester: Manchester University Press, 1996).

Accessible case studies of classic documentary films from the 1930s to the 1980s. A good starting point for anyone who wants to pursue documentary further.

Corrigan, Timothy, A Short Guide to Writing About Film, Fourth Edition (New York: HarperCollins, 2000).

A concise and practical guide for students on how to write about films, from taking notes during screenings to the style and structure of essay writing.

Doane, Mary Ann, The Desire to Desire: The Woman's Film of the 1940s (London: Macmillan, 1988).

Doane's book is a sophisticated and lucid study of four types of 1940s women's films – dominated by medical themes, the maternal melodrama, the classic love story, and the paranoid woman's film.

Douchet, Jean, Alfred Hitchcock (Paris: 1967; Cahiers du Cinéma, 1999).

Eisenstein, Sergei, Writings, Volume 1: 1922–1934 (ed. and trans. Richard Taylor) (London: British Film Institute, 1988).

The first of three authoritative volumes of Eisenstein's collected essays.

Elsaesser, Thomas, 'Germany's Imaginary America: Wim Wenders and Peter Handke' (1986), available from the author's website: http://www.thomas-elsaesser.com/index.php?option=com_content&view=article&id=78&Itemid=68

Elsaesser, Thomas and Buckland, Warren, Studying Contemporary American Film: A Guide to Movie Analysis (London: Arnold; New York: Oxford University Press, 2002).

Detailed analyses of nine contemporary American films from different theoretical perspectives.

Gledhill, Christine (ed.), Home Is Where the Heart Is: Studies in Melodrama and the Woman's Film (London: British Film Institute, 1987).

A seminal collection of (occasionally difficult) essays on the melodrama, including Thomas Elsaesser's foundational essay, 'Tales of Sound and Fury: Observations on the Family Melodrama'.

Gottlieb, Sidney (ed.), *Hitchcock on Hitchcock* (California: University of California Press; London: Faber and Faber, 1995).

A comprehensive collection of Alfred Hitchcock's writings on the cinema.

Grant, Barry Keith (ed.), Film Genre Reader (Texas: University of Texas Press, 1986).

A comprehensive anthology of 24 essays, divided evenly into theoretical approaches and studies of individual genres.

Haberski, Raymond J, It's Only a Movie: Films and Critics in American Culture (Kentucky: The University Press of Kentucky, 2001).

An informative and readable historical account of the rise of the 'golden age' of American film criticism in North America, the age of Andrew Sarris and Pauline Kael in the 1960s, together with their attempts to confer cultural respectability on popular movies. The book also charts the decline of the golden age in the 1970s.

Hayward, Susan, Cinema Studies: The Key Concepts, Third Edition (London and New York: Routledge, 2006).

More than a glossary, this invaluable reference book includes both shorter entries and mini essays on the industrial, technical and theoretical concepts that currently dominate film studies.

Hillier, Jim (ed.), Cahiers du Cinéma, the 1950s: Neo-Realism, Hollywood, New Wave (Cambridge, Mass: Harvard University Press, 1985); The 1960s: New Wave, New Cinema, Reevaluating Hollywood (1986).

The first two volumes in a three-volume series publishing representative essays from *Cahiers du Cinéma*. An indispensable collection.

Hillier, Jim, The New Hollywood (New York: Continuum, 1993).

My account of women film directors working in Hollywood is indebted to Hillier's chapter, 'Unequal Opportunities: Women Filmmakers', pp. 122–42.

Jacobs, Lea, *The Wages of Sin: Censorship and the Fallen Woman Film:* 1928–1942 (Wisconsin: University of Wisconsin Press, 1991).

An articulate and well-researched study of the representation of fallen women in 1930s melodrama, demonstrating how censorship has influenced the genre.

Jenkins, Henry, 'Historical Poetics' in Joanne Hollows and Mark Jancovich (eds), *Approaches to Popular Film* (Manchester: Manchester University Press, 1995), pp. 99–122.

Jenkins offers an overview to the internal (or poetic) approach to the cinema. A useful supplement to the first part of this book.

Jermyn, Deborah and Redmond, Sean (eds), *The Cinema of Kathryn Bigelow: Hollywood Transgressor* (London: Wallflower Press, 2003).

A series of academic essays on Kathryn Bigelow, including a detailed case study of *Strange Days*.

Kael, Pauline, I Lost it at the Movies: Film Writings 1954–1965 (London: Marion Boyars, 1994).

Kael's first book (originally published in 1965), containing reviews and provocative essays on film.

Kaplan, E Ann (ed.), Women in Film Noir, Second Edition (London: British Film Institute, 1998).

This is the authoritative guide to the way women are represented in *film noir*. It is concise, lucid and accessible. Essential reading.

Klinger, Barbara, Melodrama and Meaning: History, Culture, and the Films of Douglas Sirk (Bloomington: Indiana University Press, 1994).

Klinger looks at the way Douglas Sirk's films have been promoted and discussed in reviews, by fans and by academics, and studies in detail Rock Hudson's star image.

Lane, Christina, 'From *The Loveless* to *Point Break*: Kathryn Bigelow's Trajectory in Action', *Cinema Journal*, 37, 4 (1998), pp. 59–81.

A scholarly examination of the first four films of Bigelow's career, focusing on gender issues.

Lynch, David and Gifford, Barry, *Lost Highway* [script] (London: Faber and Faber, 1997).

McMahan, Alison, Alice Guy Blaché: Lost Visionary of the Cinema (New York: Continuum, 2002).

A detailed history of the work of the first woman film-maker.

Neale, Steve, *Genre and Hollywood* (London and New York: Routledge, 2000).

This book offers a detailed investigation into existing accounts of genre, plus a new account of *film noir* and melodrama. It is organized into three distinct parts: 1. Definitions and concepts of genre; 2. A comprehensive examination of all the major genres, plus the way they have been previously studied; 3. Theories, descriptions and industry accounts of Hollywood genres.

Neale, Steve, 'Melodrama and Tears', Screen, 27, 6 (1986), pp. 6-23.

An important essay explaining why we cry when watching melodramas.

Nichols, Bill, Blurred Boundaries: Questions of Meaning in Contemporary Culture (Bloomington: Indiana University Press, 1994).

A companion volume to *Representing Reality*, offering case studies (the Rodney King video tape, reality television, Eisenstein's *Strike*, Oliver Stone's *JFK*, and performative documentary). As with *Representing Reality*, a difficult but important book.

Nichols, Bill, Representing Reality: Issues and Concepts in Documentary (Bloomington: Indiana University Press, 1989).

An important but densely written book. The chapter on documentary modes of representation has been used as the foundation for Chapter 5. My aim has been to make this important chapter of Nichols's book accessible to the general reader.

Palmer, R Barton (ed.), *Perspectives on Film Noir* (New York: G K Hall & Co., 1996).

This anthology republishes a representative set of French and Anglo-American essays that first identified *film noir* as a distinct style or genre of film-making.

Perkins, Victor, Film as Film: Understanding and Judging Movies (Harmondsworth: Penguin Books, 1972; New York: Da Capo Press, 1993).

An important book on the criticism and evaluation of narrative films. Perkins combines the approaches of both the realists and formalists (see Chapter 1 of this book) by arguing that film is a hybrid medium, consisting of both realist and formalist tendencies. To be evaluated as good, each film needs to create a balance between realism and formalism. A film can achieve this balance, according to Perkins, by firstly producing images that conform to the realist principles of credibility (of being 'true-to-life'), and secondly, by unobtrusively adding symbolic meanings (or significant form) to these realistic images.

Rohmer, Eric and Chabrol, Claude, Hitchcock: The First Forty-Four Films (New York: Ungar, 1979).

The first book-length study of Alfred Hitchcock's films, first published in French in 1957 by these two prominent writers for *Cahiers du Cinéma*.

Rothman, William, *Documentary Film Classics* (Cambridge and New York: Cambridge University Press, 1997).

This book contains a series of close, detailed readings of a select number of important and well-known documentaries: Nanook of the North (Robert Flaherty, 1922); Land Without Bread (Luis Buñuel, 1933); Night and Fog (Alain Resnais, 1955); Chronicle of a Summer (Rouch and Morin, 1961); A Happy Mother's Day (Richard Leacock and Joyce Chopra, 1963); and Don't Look Back (D A Pennebaker, 1967).

Salt, Barry, Film Style and Technology: History and Analysis, Second Edition (London: Starword, 1992).

The research carried out for this book is phenomenal and simply overwhelming. Salt has analysed literally thousands of films shot by shot from each decade of the cinema, noting the stylistic parameters of each shot and scene, and representing this information statistically (including bar charts of shot scales of individual films). The book is also packed with information on the history of film technology.

Sarris, Andrew, *The American Cinema: Directors and Directions:* 1929–1968 (New York: Da Capo Press, 1996).

First published in 1968 and fortunately republished by Da Capo Press, this is the bible of *auteur* studies. The 11 categories in which Sarris places various directors ('Less than meets the eye', 'Make way for the clowns!') may be a little quirky, but the dictionary-length and mini essays on predominately American directors are invaluable.

Sharff, Stefan, The Elements of Cinema: Toward a Theory of Cinesthetic Impact (New York: Columbia University Press, 1982).

A concise and informative study of cinematic structure through the close analysis of several significant film scenes.

Shivas, Mark, 'Minnelli's Method', Movie, 1 (1962), pp. 17-18.

Shivas examines how Vincente Minnelli's films transcend their scripts via *mise-en-scène*.

Taylor, Greg, Artists in the Audience: Cults, Camp, and American Film Criticism (Princeton: Princeton University Press, 1999).

This book nicely complements Haberski's book (described above). Taylor offers a selective history of a number of post-Second World War North American film critics, especially Manny Farber and Parker Tyler, who creatively sanctioned popular movies as a contemporary art form. In Taylor's words, 'Beginning in the 1940s, key vanguard critics pioneered new models of film appreciation, providing a vision of critic as creative artist, as opposed to distanced judge: now even seemingly unexceptional movies could be matched to highbrow aesthetic norms' (p. 7). These vanguard critics, Taylor argues, were not interested in presenting their reviews as a consumers' guide to the movies (reviews as advertising) but as a creative response to movies (film reviewing as writing).

Thompson, Kristin, Storytelling in the New Hollywood: Understanding Classical Narrative Technique (Cambridge, Mass: Harvard University Press, 1999).

A detailed investigation into the narrative techniques used in contemporary Hollywood films. Thompson argues

that contemporary Hollywood films use similar narrative techniques found in the classical period of Hollywood (1920s to the 1950s) – techniques that continue to create clear, unified narratives. She then presents detailed analyses of ten contemporary Hollywood films, ranging between Alien, Back to the Future and The Hunt for Red October.

Thompson, Kristin and Bordwell, David, Film History: An Introduction, Second Edition (Boston: McGraw-Hill, 2003).

Thompson and Bordwell's comprehensive history of world cinema.

Truffaut, François, 'A Certain Tendency of the French Cinema' in Bill Nichols (ed.), *Movies and Methods* (Berkeley: University of California Press, 1976), pp. 224–37.

Truffaut's celebrated and controversial attack on the French 'tradition of quality' and his promotion of the film director as auteur.

Truffaut, François, *Hitchcock* (New York: Simon and Schuster, 1967).

The most famous book on Alfred Hitchcock, based on more than 50 hours of interviews between Truffaut and Hitchcock.

Vincendeau, Ginette (ed.), Encyclopedia of European Cinema (London: Cassell, 1995).

A comprehensive and informative reference book with a slight bias towards French cinema. The longer entries are particularly valuable.

Walker, Michael, *Hitchcock's Motifs* (Amsterdam: Amsterdam University Press, 2005).

The author painstakingly enumerates the major themes and motifs that recur in Alfred Hitchcock's films.

Wollen, Peter, Signs and Meaning in the Cinema, Second Edition (London: Secker and Warburg, 1972).

This is a key book in the history of film studies. Wollen was the first author to present a sophisticated theoretical exposition in

English of Sergei Eisenstein, film semiology, plus a structuralist version of *auteur* criticism.

Wood, Robin, Hitchcock's Films (London: Zwemmer, 1965).

Wood's celebrated *auteurist* study of Hitchcock, revised and updated several times since its first publication in 1965.

Index

A.I.: Artificial Intelligence 39
Aitken, Ian 158, 160
Alice in the Cities 101, 105-6
Altman, Charles 2
American Cold War ideology 146-8
American culture, and Wenders
99-101
analysis x-xi
approaches to cinema study 2-3
Arnheim, Rudolf 22
artistic motivation 190
associations 24
auteurism xiv, 22, 78-93, 111-12,
116, 120-1, 193
axis of action line 15

The Battle of Algiers 192
Battleship Potemkin 24-5
Bazin, André 22-3
Before Sunrise 13
The Big Sleep 43, 44-5
Bigelow, Kathryn 107-11
The Birds 16
Blade Runner 4
Blonde Venus 126-30, 134
Blue Velvet 38
Bordwell, David 15, 162
A Bout de Souffle/Breathless 87-93
Bowling for Columbine 168

Cahiers du Cinéma journal 80–5, 93 camera angles 22 Casablanca 85 Caughie, John 91–2 cause-effect logic 34–6, 37, 41, 109, 126 Cavell, Stanley 22, 125, 130 censorship 126, 129, 130–1

Citizen Kane 8-10, 12

Coalface 156, 158-61
colour, use of 13
colour film developing 13
compositional motivation 188,
195
condensed plot synopsis 183-4
confession and guilt, in Hitchcock
films 97
confined space shooting 96-7
contextual criticism xiv
continuity editing 14-16, 24
Corner, John 161
Crash 191
critics' role 180
Curtiz, Michael 85

Dahl, John 139–44

Dead Men Don't Wear Plaid 21

Deeley, Michael 4
deep focus photography 8–14, 22
description x

The Desire to Desire 134
diegetic sound 20
directional continuity 15–16
director's role 83
documentary types 154–76

Double Indemnity 41

Douchet, Jean 94

editing
continuity editing 14–16, 24
Hitchcock 95
in Jurassic Park 19
versus long take 17–18
Eisenstein, Sergei 7, 22, 23, 24–5
The English Patient 184–8, 189
ethics in documentaries 165
European Art Cinema 99, 104

Event Horizon 193 exposition 62, 72 expository documentary 156–61 eyeline match 15–16

fallen woman films 126–30 fast motion 22 female directors 107–8 feminist films 110–11 femme fatales 137, 138, 140, 145 film advertising 181–2 film aesthetics, theoretical analysis of 21–7

Film Comment journal 167 film criticism 181–2 film journalism 181–2 film noir 41, 137–44, 189 see also neo-films noirs film review 180–97

abbreviated arguments about film 183, 187 background information 183, 186 components of 183–8 condensed plot synopsis 183–4 The English Patient 184–8, 189 entertainment value 191–2 evaluation 188–93 functions of 181–2 Interstellar 193–7 motivation types 188–91

film rhetoric 181–2 film sound 20–1 Film-Eye principle 171 Film-Truth principle 171 flashbacks 41 formalists 22, 26 French New Wave 82, 84, 90–2 French, Philip 168–9, 184–8, 189

redemption 192-3

social value 192

gangster films 5–6 Gaslight 135–6 genre

approaches 120–1
fallen woman films 126–30
films as myth 122–4
hybrid genres 122
melodrama 124–36
paranoid woman's films 134–6
German Expressionism 95
Gilda 64–5
Godard, Jean-Luc 87–93
Gone With the Wind 6
Grant, Barry Keith 123

Handke, Peter 100 High School 162–3 Hitchcock, Alfred 17–18, 20–1, 26, 33–4, 40, 42, 43, 93–9 hybrid genres 122

image, and narrative 104 interactive documentary 163–9 Interstellar 180, 181, 193–7 intertextual motivation 189 Invasion of the Body Snatchers 146–8

Jacobson, Harlan 167–8

Jane Eyre 135

Jaws 11

journalism of opinion 181

journalism of taste 181

Joy Ride 144

Jurassic Park 19

Kermode, Mark 195–6 Khondji, Darius 13 Kill Me Again 139–43 Kiss Me Deadly 144

Lady in the Lake 50
The Last Seduction 142-3
Leigh, Mike 12
Letter From an Unknown Woman 133
Linklater, Richard 13

Little Caesar 5 long takes 7–14, 22, 96–7 Lost Highway 69, 122 The Lost World: Jurassic Park 12, 189 The Loveless 108–10 Lynch, David 38, 59, 69, 122

McCarthy, Todd 194-5 MacGuffins 40 The Magnificent Ambersons 8-10 Magnificent Obsession 52-5 Mainwaring, Daniel 147 male bonding 102-4 male melodramas 125 male-female relationships 102-4 The Maltese Falcon 17, 176 Man with a Movie Camera 170-1 match on action cut 15-16 meaning through pattern 84 Meet Me in St Louis 6 melodrama 124-36 Memento 55 metteur-en-scène 79, 85 Mildred Pierce 41 Minnelli, Vincente 82, 85-6 mise-en-scène 4, 10, 78-9, 82-3, 96, 104, 137 mise-en-shot 4, 7-19, 78-9, 82-3, 84, 96, 104, 137 montage 22, 23-7, 95

narration

Moore, Michael 165-8

Movie magazine 84-6, 95

Mulholland Dr. 32, 40, 41, 59-74

The Big Sleep 44-5
Magnificent Obsession 52-5
Mulholland Dr. 59-74
North by Northwest 50-2
omniscient 41-74
Pulp Fiction 55-9
restricted 41-74
Taxi Driver 45-50

narrative, and image 104 narrative chronology 55-9 narrative stages 37-8 narrative structure 32-41, 112 narrative techniques, Hitchcock 97-9 narrative turning points 37-8 neo-films noirs 139-44 New German Cinema 99, 100 Nichols, Bill 154-6 Nolan, Christopher 55 non-diegetic sound 21 non-linear structure 55-8 North by Northwest 36-8, 47, 50-2, Northern Ireland in film 192 Notorious 17-18

observational documentary 161–3 omniscient narration 41–74 *Only Yesterday* 130–4

paranoid woman's film 134–6 Paris, Texas 102–3 perfect murder, in Hitchcock films 97

performative documentary 171-6 Perkins, Victor 83 point-of-view cutting 15-16 point-of-view shots 48, 50, 61, 95-6 Psycho 20-1, 26, 33-4, 39-40, 42, 94 The Public Enemy 5 Pulp Fiction 32, 41, 55-9

Quote Whores 181

Ray, Nicholas 85 Realism 189 realistic motivation 189 realists 26 Rear Window 94 Rebecca 135–6 Red Rock West 141–2 reflexive documentary 169–71 repetition of events 60 restricted narration 41–74 road movies, Wenders 101–2 Roger and Me 165–8 Rope 96 Rounders 143

Salt, Barry 7-9, 18 Sarris, Andrew 86-7, 95 Schindler's List 19 science fiction (1950s) 144-8 Scott, Ridley 4 script quality 81 Secrets and Lies 12 set design 4-6 MGM 6 Warner Bros. [1930s] 5-6 Siegel, Don 147 significant form x, xiii slow motion 22 Spielberg, Steven 11-12, 19, 39 storyboards 19 suspense, in Hitchcock films 97

Tarnished Angels 125
Taxi Driver 45–50
technical constraints 96

Them! 145
The Thin Blue Line 172–6
Thompson, Kristin 162
The Times of Harvey Milk 155
Todorov, Tzvetan 37–8
Truffaut, François 43, 80–4, 193
The Two Mrs Carrolls 135, 136

unknown woman melodrama 130–4 *Until the End of the World* 101–2, 104

Vertov, Dziga 92-3, 170-1 Vincendeau, Ginette 80, 87

Welles, Orson 8–10
Wenders, Wim 99–106
When Worlds Collide 145
Where No Vultures Fly 23
Wings of Desire 103, 105
Wiseman, Frederick 162–3
The Wizard of Oz 6
Wood, Robin 95
Written on the Wind 125
wrong man, in Hitchcock films 97

Zacharek, Stephanie 196-7

Notes